FEAST
CONTEMPORARY JEWELRY FROM THE SUSAN BEECH COLLECTION

FEAST

CONTEMPORARY JEWELRY FROM THE SUSAN BEECH COLLECTION

Susan Cummins, Toni Greenbaum,
Barbara Paris Gifford, Damian Skinner

arnoldsche

CONTENTS

THE MAKING OF A COLLECTOR
SUSAN CUMMINS
PAGE 8

AN ARGUMENT FOR THE NARRATIVE
TONI GREENBAUM
PAGE 38

REDEEMING BEAUTY
BARBARA PARIS GIFFORD
PAGE 60

AT HOME WITH SUSAN BEECH
DAMIAN SKINNER
PAGE 82

CONTEMPORARY JEWELRY FROM THE SUSAN BEECH COLLECTION
PAGE 110

ACKNOWLEDGMENTS
PAGE 220

AUTHOR BIOGRAPHIES
PAGE 222

PHOTOGRAPHY CREDITS
PAGE 223

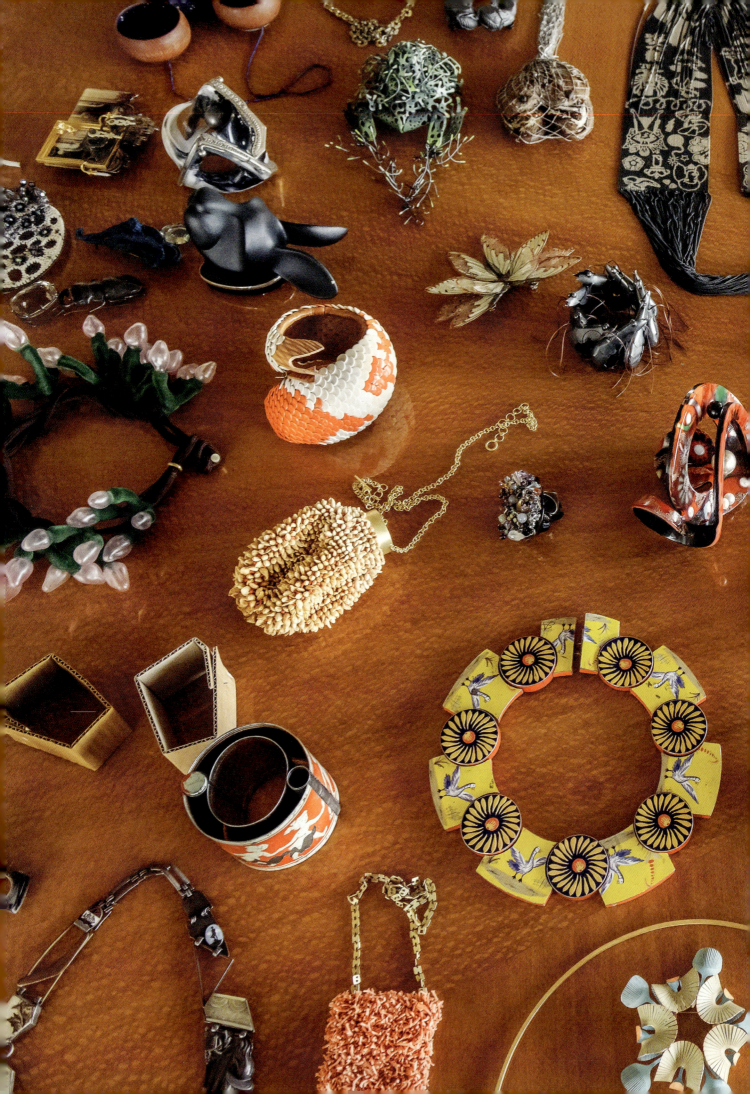

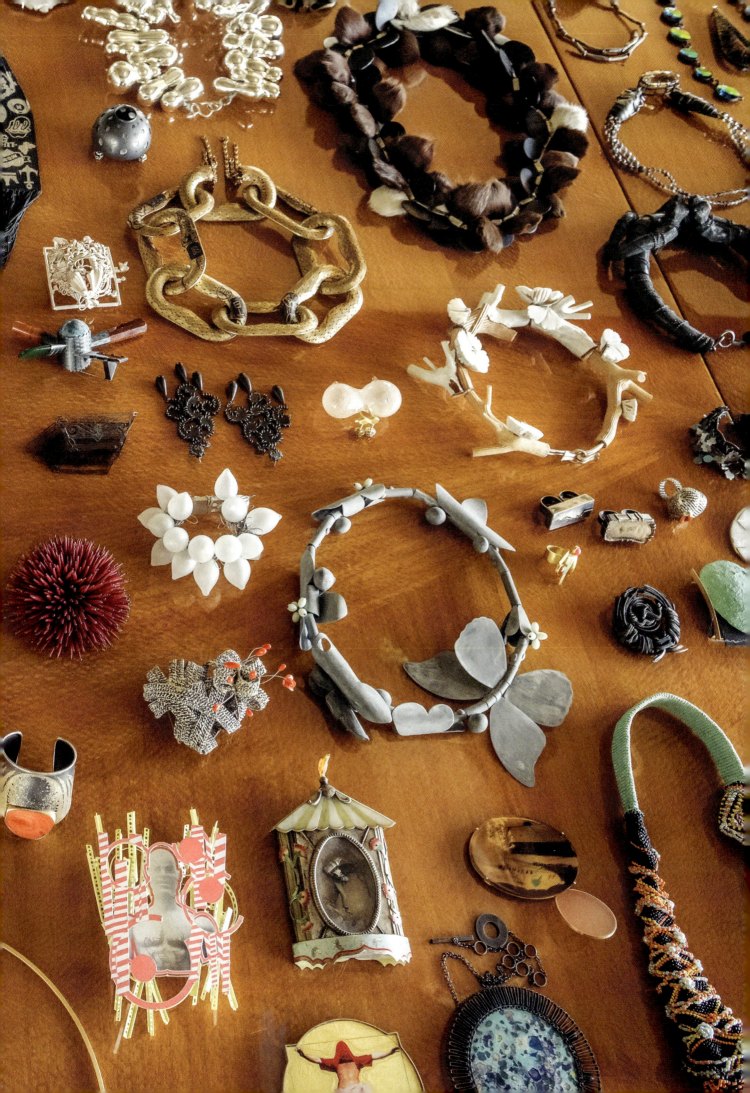

THE MAKING OF A COLLECTOR

SUSAN CUMMINS

WHY DO I WEAR CONTEMPORARY JEWELRY? IT GIVES ME A GREAT DEAL OF JOY. EACH PIECE IS FULL OF MEMORIES.
—SUSAN BEECH

As best I can determine, it happened one day in 1989. I was the art dealer in a small town north of San Francisco who showed an alternative art form known as craft, and the usual art form known as painting, and Susan Beech walked into my gallery. I don't really remember that first meeting, apart from a strong sense of how Susan looked. It was how she has always looked. She was elegant. She had on a brown or camel jacket with slacks, accentuated with a scarf, straight blond hair cut in a bob, and red lipstick. She was beautiful, and she was curious.

My gallery, which I had opened ten years previously, was located near the center of town, on the main street. It had two rooms. In one, the bigger space with clean white walls, I displayed artworks, usually figurative and narrative paintings by local or regional artists. The kind of stories that I preferred to show in the gallery were strange and often twisted tales of unique characters in puzzling or humorous situations. For example, imagine a topless woman reclining on a vivid pink sofa, her lower body swathed in a transparent skirt covered with Salvador Dalí-esque eyes, as she looks up at an unpeeled banana held daintily in her fingers. The scene takes place in a bare room with wooden floorboards and a lit fireplace, while a giant mouse stands on its hind legs in the background, its fur silvered from the light streaming in through the window. (This is Lucy Gaylord-Lindholm's *Green Girl, Yellow Banana*, which Susan purchased from me in 1999, the same year it was painted.)

In the back area of the gallery was a large desk with a raised front like a counter, and cases to display the contemporary jewelry I showed in a mixture of solo and group exhibitions. I was lucky enough to represent jewelers such as Keith Lewis, Jamie Bennett, Kim Overstreet and Robin Kranitzky, Myra Mimlitsch-Gray, Sondra Sherman, and Kiff Slemmons—all Americans, and in my opinion the best of the jewelers educated and working in the United States at that time. I also had a rotating selection of well-priced handmade multiples that appealed to the casual customers who would stop by the gallery looking for something to wear that was unusual but not challenging.

Susan's curiosity led to a sustained look at everything, but what really caught her eye was the jewelry. It was different than the jewelry she had inherited from her mother, but, in these early days, not too different. These handmade multiples were not run-of-the-mill jewelry, but they used gold or more conventional materials and some themes common to traditional jewelry. Some of what Susan bought from me belonged in this category of handmade multiples, and it hasn't made it into what she now considers to be her collection of contemporary or art jewelry. In the early days Susan was primarily looking for jewelry she could wear, that suited her aesthetic. She continues to use these criteria to this day, but her taste and ideas have also expanded.

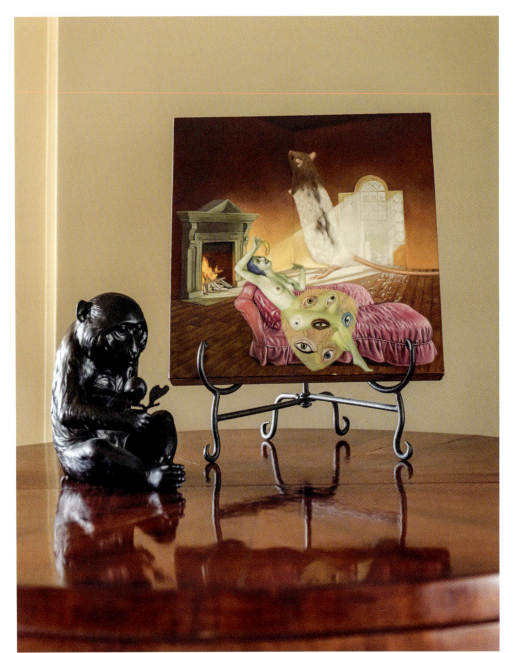

1.1
(Painting)
LUCY GAYLORD-LINDHOLM
Green Girl, Yellow Banana
1999
Oil on linen
13.75 × 13.5 inches
Susan Beech Collection

Susan was already collecting fine art and ceramics before she found her way into my gallery, and she had a clear sense of what she liked and appreciated. We bonded over our similar attraction to what you could call surreal storylines or scenarios, often ambiguous but with sufficient clues to encourage the viewer to try to create a narrative about what was going on, and sometimes a little sexy or perverted. We loved the challenge of puzzling these images out. It's like detective work.

The paintings that Susan purchased from my gallery found themselves at home with similar artworks she was buying from other dealers. One, Olga Dollar, had a gallery in downtown San Francisco. She was a fascinating woman, and an interesting dealer. She had married into old San Francisco money, and she dressed in sharp suits with leather boots that would clack as she moved over the wooden floors of her gallery. Like me, she had a penchant for figurative and somewhat unsettling art, which also appealed greatly to Susan.

Paintings that Susan bought from Olga still hang in pride of place in Susan's home, including the triptych in the dining room in which a painting featuring a contemporary retelling of Leda and the

1.2
Left to right: CHIKAKO OKADA, *Beauty Is in the Eye of the Beholder* (1992), FRANCESCA SUNDSTEN, *The Swan* (1991), CHIKAKO OKADA, *Things Won't Be the Same* (1994)

Swan, by Francesca Sundsten, sits between two portraits of women, by Chikako Okada. It's a classic example of Susan's ability to create combinations of objects that add up to more than the sum of their parts. All these women are self-contained and inscrutable, even the one who looks directly at the viewer. Two of the paintings make art historical references to classical themes (Leda and her swan lover, whose beak tugs at the bathing suit string at the back of her neck) and early Renaissance paintings (the van Eyck of a man in a turban that hangs on the wall behind the woman reclining on the couch). Susan's sly humor is present in the coincidence that two of the women wear bathing suits, and her eye for visual sympathies is found in the crisp realist style that links the three paintings.

But when it came to jewelry, I was lucky enough to be able to introduce Susan to more ambitious work, and to watch as her tastes developed. Sometimes the appeal was easy to understand as an extension of her preferences in fine art. Take Keith Lewis's *Spit Polish*, which was made in 1998, and purchased by Susan that same year. The figure has a spray nozzle for a head and is standing in a classical art historical pose with one hand on his hip and the other holding a cloth. The tension and humor here is between the cloth he holds and his penis. Shouldn't it be covering him up? The phrase "spit and polish" usually refers to trying to make something look its best, and here the figure has used the cloth to clean his pecs and stomach, showing them off. Seeing such a powerful and unusual subject matter in contemporary jewelry was part of the draw for Susan, but she was equally taken by the frisson that occurred when a well-dressed heterosexual white woman chose to wear something this provocative on her lapel. *Spit Polish* was a wearable and therefore public extension of the themes that would otherwise only be seen by visitors lucky enough to be invited into her house.

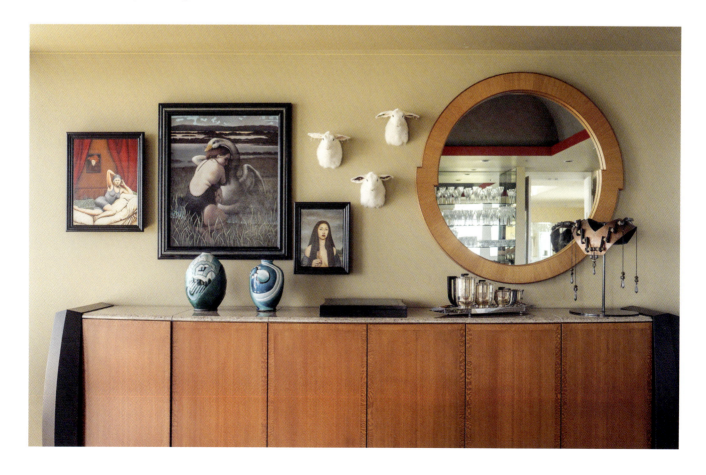

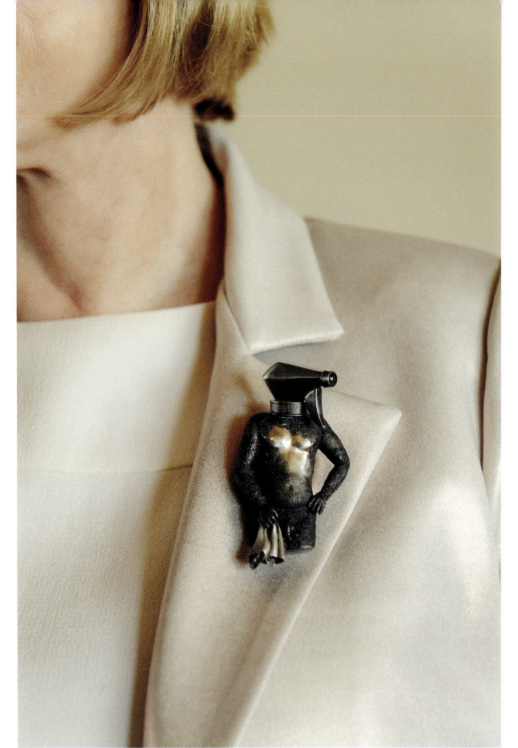

1.3
KEITH LEWIS
Spit Polish
Brooch
1998
Sterling silver
3.5 × 2.25 × 1.5 inches
Gift to the Renwick Gallery, Smithsonian American Art Museum

 Other purchases from this time were less figurative but just as engaged with serious cultural issues, usually with a sharp intelligence and wicked sense of humor. *Electric Claws* (1999), by Kiff Slemmons, is one of Susan's favorite pieces from her collecting activities in the 1990s. Using a selection of black Art Deco-style Bakelite knobs from mid-century kitchen appliances, the piece evokes the talismanic spiritual power of the Native American bear claw necklace. The stove knobs replace the claws and teeth of dangerous animals that many human societies have worn as amulets to claim and absorb the creature's power on behalf of the wearer. No longer functional, these symbols of modernity and of the home become claws usually hidden behind a polite veneer of domesticity. That transformation appealed to Susan. *Electric Claws* suited her perfectly, and it remains not only a key piece in her collection, but a necklace she continues to wear.

I closed my gallery in 2002, and by then Susan and I had become friends. When I started to develop my own collection of contemporary jewelry in the following years, we became fellow collectors—and when we both saw something we really wanted to buy, friendly rivals. Sometimes I suggested we travel together somewhere for a conference or a fair, and sometimes she agreed to come. We were learning together and helping each other understand what we were seeing and hearing and buying.

1.4
KIFF SLEMMONS
Electric Claws
Necklace
1999
Sterling silver, Bakelite
9.5 × 9.5 × 0.75 inches
Susan Beech Collection

CASTING PEARLS BEFORE SWINE IS THE PIECE THAT I SAY TOOK ME FROM JUST BUYING CONTEMPORARY JEWELRY WITHOUT TOO MUCH THOUGHT TO BECOMING WHAT YOU MIGHT CALL A COLLECTOR.
—SUSAN BEECH

Each collector takes their own road to learning about the field, and to thinking of themselves as a collector. Often there is an "origin story," a specific event that they identify as the moment they became a collector rather than someone who buys a lot of jewelry. Susan's origin story takes place in Seattle in 1998, on a trip organized by Art Jewelry Forum (AJF) to visit galleries and the studios of local jewelers.

Arriving at her hotel, she opened the packet of information that every trip member received. Among the itineraries, brochures, and restaurant menus was an invitation for the Travers Gallery

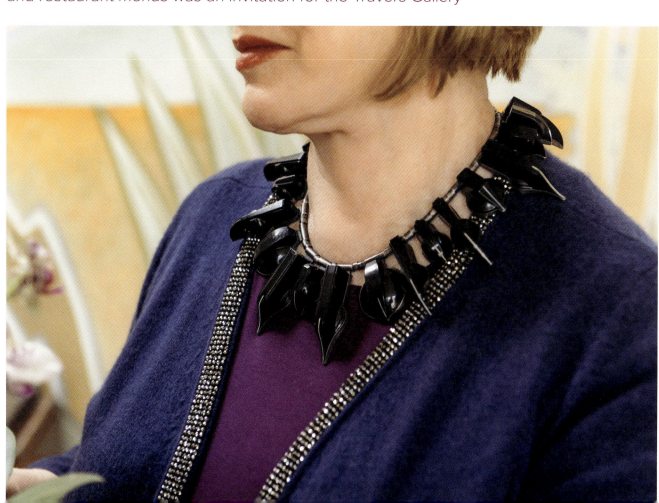

featuring an image of a large necklace being worn by a muscular, naked man, his face raised and eyes closed. It was quite provocative, and Susan loves provocative. The caption indicated that the necklace, made by Nancy Worden in 1997, was called *Casting Pearls before Swine*. The title was an amusing concept, but the necklace and its presentation left a deep impression on Susan, who just couldn't get it out of her mind. That day, she went straight to the Travers Gallery and bought it. She didn't know if she would ever wear it, and it didn't matter. Somehow, with this one piece, Susan's sense of the boundaries of what jewelry could be and do totally changed. Even though she had started buying work by serious American jewelers before this trip to Seattle, she wasn't yet a collector in her mind. After the encounter with *Casting Pearls before Swine*, there was no doubt that she had become one. Never before had she purchased jewelry that marked her out as adventurous, someone that people would stare at because of what she was wearing.

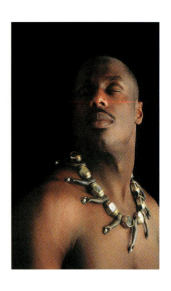

1.5
Invitation, Travers Gallery, 1998

At first glance, *Casting Pearls before Swine* is a simple series of innocent mother-of-pearl buttons on one side, and American quarters on the other, held in place between brass cups, but the jolt comes from the Barbie-doll arms thrown out between the cups, holding small pearls as if casting (as in fly fishing) them. Then when you look closer and turn the buttons over, the word SWINE appears cut out of the coins. Depending on which side is showing—the buttons or the quarters—the necklace expresses a different message. The title is a complex visual and verbal pun: the Barbie doll arms are cast brass, and hold real pearls in their hands, which, because of the way the necklace has been constructed, look like they are being thrown (or cast) outward, while the buttons are made of mother-of-pearl or nacre, the iridescent lining of oyster shells, and oysters, of course, produce pearls.

Worden's inspiration for this necklace was her anger. Strongly held beliefs or opinions often propelled her to create jewelry. In this case she had a close relationship with Ken Cory, a fellow jeweler who had been her professor at Washington State University, in Ellensburg, Washington, and remained a friend until his untimely death at the age of 50. She and Cory's sister hired an author to write a book about him, but Worden felt the author was rude and disrespectful during the process, and she felt betrayed. She had given this precious opportunity to write about a man she very much admired to an author who didn't deserve it. The pearls of Cory's life and work were being cast before a swine who couldn't appreciate their value and was, she thought, only in it for the money.

Of course, Susan didn't know any of this when she bought the necklace. She only knew it was strange and different. She bought it on impulse, partly based on the seduction of the way it was presented in the photograph: the delicious contrast between the muscled, naked body and the Barbie arms and pearls. But she also had what she would later describe as a feeling of excitement in the pit of her stomach—perhaps you could call it a type of lust—which she experiences when she first sees an extraordinary piece of jewelry. Seeking out that sensation, and more often than not giving in to it, would shape Susan's life.

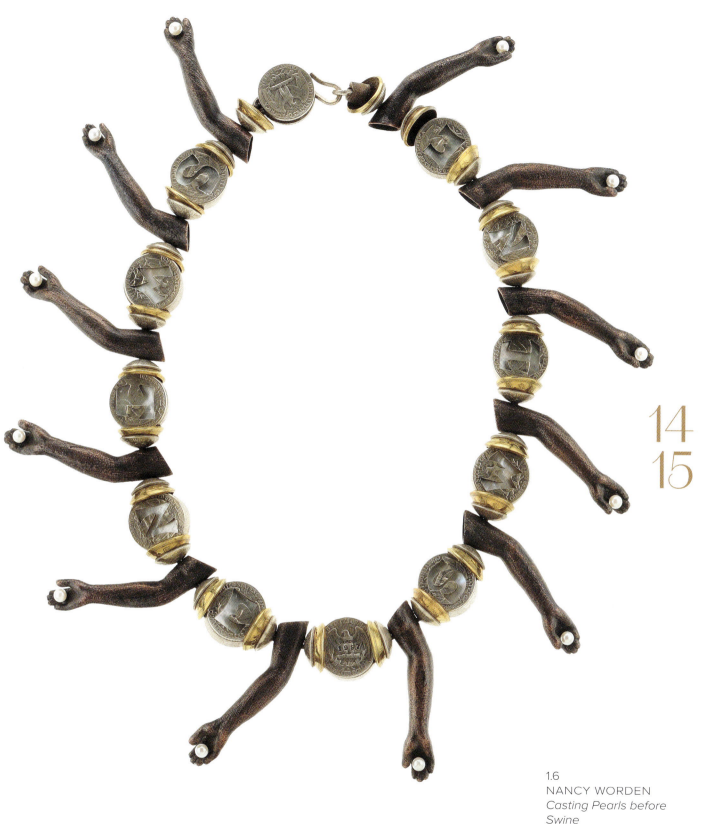

1.6
NANCY WORDEN
Casting Pearls before Swine
Necklace
1997
Silver, copper, brass, pearls, mother-of-pearl buttons
23.5×3×1 inches
Gift to the Renwick Gallery, Smithsonian American Art Museum

ANOTHER TURNING POINT IS LINKED TO A NECKPIECE BY TINA RATH. THE ROLE I HAD IN HELPING THE MUSEUM EXPAND THEIR JEWELRY COLLECTION STARTED FROM WEARING THAT PIECE TO A GALA.
—SUSAN BEECH

In 2001, Susan and her husband, Bill, attended the Mint Museum Gala in Charlotte, North Carolina. Over a simple black outfit, she wore Tina Rath's *Purple Mink Hanging Wrap Necklace* (2001). It is a very large, opulent, and impressive necklace that covers the entire upper body. Elaborate hanging individual puffs of black Persian lamb are topped with purple streaked silver fox and capped with purple satin ribbons that hang off a long cord of black suede. Some of the puffs have bright-green mink tucked under the cascading silver fox, a little surprise. Both the museum's curator and director approached her that evening and asked if they might have it for their growing collection of contemporary jewelry. They made a huge fuss, which got Susan thinking that she might have an eye for jewelry that museums could want in their permanent collections. Giving in to the museum's entreaties, she donated Rath's necklace to the Mint Museum, and this became another turning point for her. She realized she could contribute to museum collections with her jewelry. What she was doing was recognized by others; it was a serious undertaking.

The donation led Susan to develop a relationship with Mark Leach, the Mint Museum's chief curator, and the two of them attended many fairs and jewelry events together and purchased numerous works for the museum's jewelry collection. Susan learned a lot from Leach about composition and how different elements worked together (or didn't) and how objects stood the test of time. It was a valuable lesson for her, to see how a museum professional evaluated potential acquisitions, and to understand how this process was different from the criteria she used to form her own collection. In turn, she educated Leach about some of her favorite jewelers, including Evert Nijland, Daniel Kruger, Ruudt Peters, and Vera Siemund. One result of this collaboration was that Susan received the McColl Award from the Founders Circle of the museum in 2008. It was a huge honor, and many friends and jewelers attended the event to celebrate.

One time, Susan was at Collect, a craft fair in London, with Leach's assistant, Melissa Post, and they were looking for work to buy for the museum. After they strolled through the fair, Post decided she really wanted a Daniel Kruger necklace with fancy silver domes covered in dark garnet beads tied with red thread. (This is *Untitled* from 2003.) When they came back around to talk to the dealer, Susan was mad at herself for not deciding to get it for her own collection. Such were the hazards of buying for someone else.

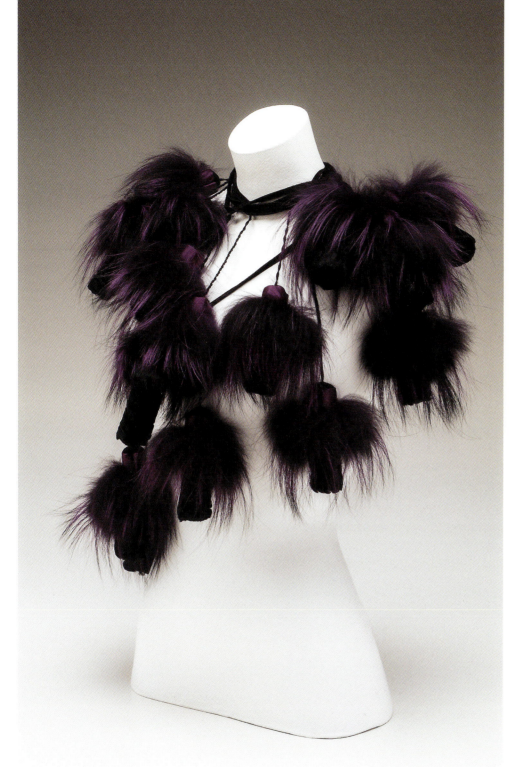

1.7
TINA RATH
Purple Mink Hanging Wrap Necklace
2001
Persian lamb, mink, fox, satin, cord, leather
Each piece: 3×3×3 inches, overall: 62 inches long
Collection of the Mint Museum, Gift of Susan C. Beech, 2002.57

While Susan's primary relationship as a donor was with the Mint Museum, periodically she would give pieces to other institutions. In 2012 she donated David Bielander's *Python Necklace* (2011), which she had purchased the year before, to the Museum of Fine Arts, Boston. This long but lightweight snake made from anodized titanium slithers around the wearer's body. In 2019 she gave a Helen Britton brooch to the Museum of Arts and Design, in New York City. Called *Poison Island* (2006), the brooch features enameled floral elements and embedded faux stones and pearls; one of the stones has a skull and crossbones drawn on it, giving rise to the title.

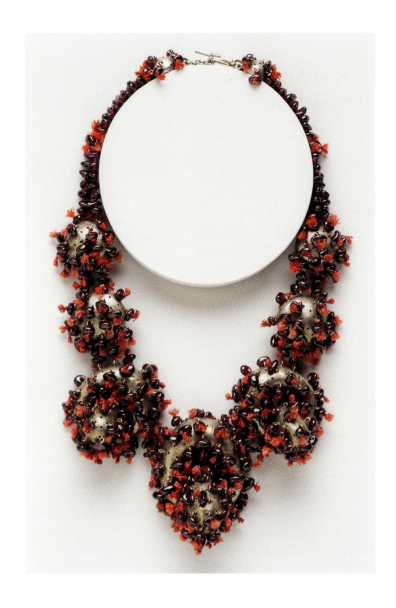

1.8
DANIEL KRUGER
Untitled
Necklace
2003
Sterling silver, garnet, silk
6 inches in diameter
Collection of the Mint Museum, Museum Purchase: Funds provided by Founders' Circle (Susan C. Beech) and Museum Exchange Funds from the gifts of Dr. Walter P. Scott, Mr. and Mrs. R.R. Sitzler, William P. McClain, Mr. and Mrs. Allen Lundy, Dr. and Mrs. Francis Robicsek, and Edwin L. Jones, Sr., 2006.37

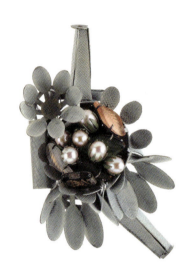

1.9
HELEN BRITTON
Poison Island
Brooch
2006
Hand-engraved silver, vintage German glass, cultured pearls
4 × 2.25 × 1.5 inches
Museum of Arts and Design, New York; gift of Susan C. Beech, 2019, 2019.19

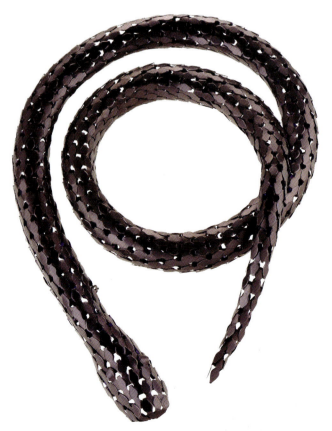

1.10
DAVID BIELANDER
Python Necklace
2011
Anodized titanium
96 inches long
Collection of Museum of Fine Arts, Boston, Gift of Susan C. Beech, 2017.1505

FOR A NUMBER OF YEARS ALL I KNEW WAS AMERICAN JEWELRY, SO THAT WAS ALL I BOUGHT.
—SUSAN BEECH

Throughout the 1990s and the early 2000s Susan continued to buy almost exclusively American jewelry, but she had started attending the SOFA craft fair in Chicago, where she saw some European jewelry on display in the booths of Charon Kransen and Helen Drutt. She was also learning more about some of the major European jewelers and their work from books. Curious but not necessarily ready to buy jewelry from other countries, she attended the first Collect fair, at the Victoria and Albert Museum, in London, in 2004, and everything changed. Collect was sponsored by the UK's Crafts Council and featured all kinds of craft. This experience transformed her buying. Although she was traveling with a group of American collectors, Susan ended up skipping the rest of the itinerary in London so she could return each day to Collect and immerse herself in the jewelry on display.

 Perhaps the strongest impact was made by Galerie Marzee, where all the jewelry was laid out on tables and hung on the wall where it could be encountered and handled directly, not locked away behind glass panels that required the dealer to provide access. There was also a lecture program, and Susan would attend the talks, staying on to meet the jewelers afterward, and then heading back to the gallery booths to see work by the person who had just presented, handling it and trying it on, asking more questions of the dealer. She loved every minute of it.

 Looking back on this time, Susan's main regret is that she didn't buy more jewelry. It was the first year of Collect, and it seemed like all the dealers had decided to show their very best work. Susan was still looking for jewelry she could wear, but her choices were becoming so much more interesting. She chose bold jewelry, she was taking risks, buying necklaces and brooches that she thought might be hard to wear but were so stimulating, appealing, and challenging that she didn't want to let them go. She was buying work by jewelers she didn't

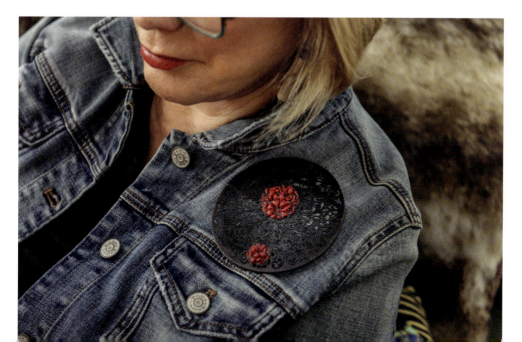

1.11
DORIS BETZ
Untitled
Brooch
2004
Plastic, silver, steel
4.125 inches in diameter
Susan Beech Collection

know or hadn't heard of, being convinced by the excitement in the pit of her stomach, her elevated heartbeat, the physical sensations that told her something needed to become part of her collection.

Looking through Susan's collection, it is possible to reconstruct some of what she saw, and what she purchased, during this exhilarating trip to London. Who was Doris Betz? Susan didn't know, but at Galerie Louise Smit's booth she saw a brooch. She liked it, it impressed her, but she didn't buy it. She returned the next day and ran to the gallery to see if it was still available. After thinking about it overnight she had realized it was an exciting work, a piece that demanded to be purchased. *Untitled* (2004) is large, more than four inches in diameter, with a beautiful floral pattern cut out of the steel circle. Pressed into the pattern are two red blobs of bubble gum-like plastic. In a way, it looks like something unpleasant stuck to the bottom of a nice pair of shoes. It is both elegant and humorous, the beauty gently undercut by the plastic extrusions. For Susan, that was the perfect combination.

She was familiar with Peter Chang from books she had read and people she saw wearing his iconic bracelets. His jewelry was on display in the booth of The Scottish Gallery. This *Untitled* brooch made in 2003 called out to Susan as she strolled by, attracting her attention by its large scale and bright colors. In fact, several pieces of his called out to her during her time at Collect, and she ended up buying all of them. The brooch has the sensuality of a languidly swimming fish, with the psychedelic coloring of an acid trip. Strange, doubled protrusions and breast-like forms are covered with inflamed pustules, colored yellow with irritated red rims. The result is delicately poised between disgusting and beautiful, which again appealed to Susan's sensibility. Chang's jewelry is feather-light but also very fragile, created from resin with highly polished surfaces that are easily scratched and damaged, so Susan had to be careful when wearing these pieces. It was a risk, but one she felt compelled to take.

1.12
PETER CHANG
Untitled
Brooch
2003
Resin, sterling silver
5 × 2.5 inches
Susan Beech Collection

I MET A BUNCH OF ARTISTS IN LONDON WHEN I FIRST WENT TO COLLECT. BUT GOING TO AMSTERDAM AND MUNICH ALLOWED ME TO SEE THEM WORKING IN THEIR STUDIOS, ASK PERSONAL QUESTIONS, SIT AND TALK TO THEM AT DINNER. IT WAS AN EXPERIENCE THAT I COULD NEVER HAVE HAD AT AN ART FAIR.

—SUSAN BEECH

In 2005 Susan and I made a decision: let's go to Europe and meet all the famous jewelers! What better way to understand who was who, and to see what they made? We invited two friends who were also interested in contemporary jewelry to join us. We decided to go to Amsterdam and Munich, which at the time were the centers of jewelry-making in Europe. They had the best schools, galleries, museums, and lots of great jewelers' studios to visit. We had read books and knew some of the names of people we wanted to meet,

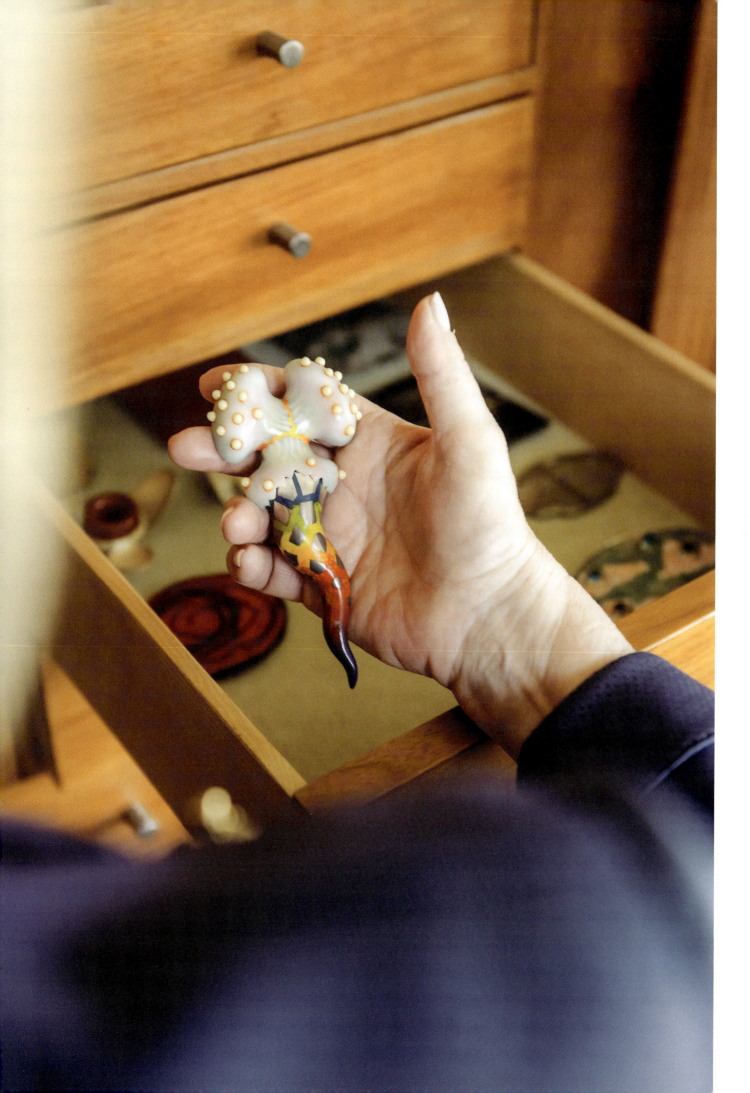

but knowing we were quite capable of mangling the pronunciation of their names (languages have never been strong suits for either of us), we realized we needed guides who could make sure this in-person education was a success, and who also knew more than we did about who we should see. I asked two American jewelers I knew to set up the trip. Tina Rath had studied in Amsterdam for several years, and Sondra Sherman had studied and lived in Munich for ten years, so they knew their way around each city and, more importantly, they knew the jewelers and could use their contacts to get us into the places we really wanted to go.

Sondra and Tina set up meetings with important jewelers and we visited their studios. Sometimes they showed us a slide show of their work and sometimes they just had it all laid out, beautifully displayed on a table. They talked about it and explained what they were trying to say with each piece. We were in awe. We didn't really care how something was made. Our eyes were glued to the jewelry and sometimes to the jeweler. We only have vague memories of their studio spaces or what they were wearing, but we have almost photographic memories of what we saw on the tables and what we had to have for our collections. In Amsterdam we saw at least seven or eight studios, including those of Ruudt Peters, who became a favorite of Susan's, and Ted Noten, who served unbelievably strong coffee and was extremely entertaining.

There is one particular moment from this trip that reflects how adventurous Susan was becoming, and the lengths to which she would go to acquire something she really wanted. While we were visiting Noten's studio, Susan wanted to buy an acrylic resin "handbag" with a taxidermy bird inside. Noten told her he wanted to be paid in cash, which Susan didn't have on her. A week later, having spent the time in Munich carefully hoarding notes and raiding the cash supplies of her friends, Susan had a large envelope of euros. She flew back to Amsterdam and checked her bags for the international flight home. Noten phoned, and she met him outside airport security, where she handed over the big wad of bills and received a large, wrapped package in return.

It felt like an illegal transaction, and Susan told Noten not to open the envelope and count the cash in case they were being observed by one of the airport officials or a security camera. A little unnerved, Susan headed back to security, but the line had become extremely long, so she walked to another area, thinking the queue would be shorter. It wasn't. Now she was totally panicked. She had visions of missing her plane with an illegal dead bird in her possession, and no plausible story to tell the security personnel and customs officers, all the time imagining their disbelieving faces when she told them it was art. Somehow, she pushed her way to the front of the line, made it through security, and ran to the gate just in time to catch the plane home. It remains to this day the most effort she has ever made to acquire a piece of jewelry for her collection.

In Amsterdam we also spent time at Galerie Louise Smit and Galerie Ra, with a side trip to Nijmegen to see Galerie Marzee. We visited the Sandberg Instituut, a graduate school run at that time by Marjan Unger. She served us a terrible meal and then introduced us to the students and told them we would critique their work. This, of course, was not at all expected. I had done these kinds of critiques

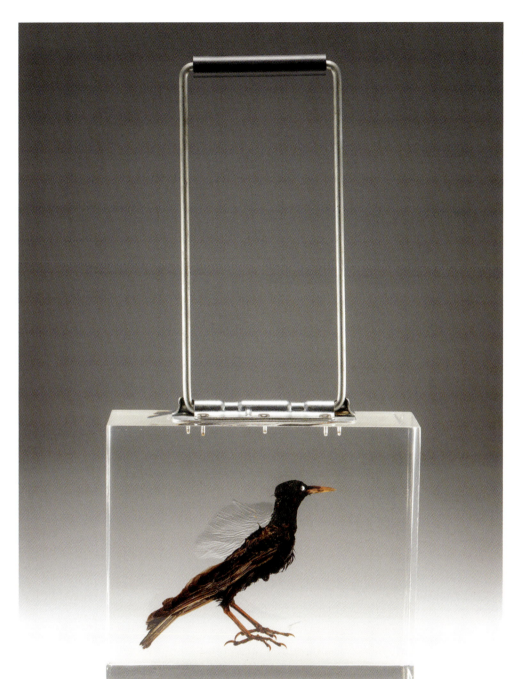

1.13
TED NOTEN
Darling Bag
2004
Starling cast in acrylic, steel, rubber
13.75 × 1.125 × 4 inches
Susan Beech Collection

to some degree, but Susan and our two friends never had and were frozen with fear. We protested politely, which Unger ignored. We did our best, but it was a disaster. I think she secretly enjoyed our discomfort.

We planned the trip so we would arrive in Munich during the week of Schmuck, which is a highly regarded juried show of contemporary jewelry held every March. Our first impression was surprise. We entered a large hall where we expected to see a beautiful exhibition of jewelry, and what we saw was a craft fair featuring lederhosen and other very Germanic handmade goods. Way in the back of the building was a gallery defined by walls covered with well-spaced cases for jewelry. This was a total treat, and we spent hours there. On other days we visited the studios of five or six jewelers in Munich, including David Bielander, Helen Britton, and Gerd Rothmann. We also took a train trip to Nuremburg to see a Karl Fritsch show curated by Ellen Maurer Zilioli, who came with us.

Fritsch was there and walked us through the show. This kind of VIP access and special insight was exactly what we had hoped to receive when we first came up with the idea of the trip, and it was extremely rewarding.

These were exciting times to see lots of jewelry that Susan could add to her collection. She was with other collectors who were also vying for the best jewelry on view. There is, it needs to be acknowledged, a bit of competitive spirit. The adrenaline was flowing, and Susan was on it. She has always been very fast about making up her mind to buy something, so she has the advantage over someone like me who is much slower to decide. However, we never came to blows over anything. In fact, we were very considerate of each other and let the contentious piece go to the best collection for it. The jewelry market is not like the very competitive art market with cutthroat collectors in attendance. The stakes are not as high nor are the pieces nearly as expensive.

I LIKE TWISTED NATURE. I LIKE DEAD BIRDS. I HAVE PIECES MADE FROM ANIMAL SKINS AND FUR, HUMAN HAIR, BURNED HOOVES. I'M INTERESTED IN SURREALISM, I DEFINITELY LIKE STRANGE ART, AND I LIKE STRANGE MOVIES. NOIR IS MY FAVORITE GENRE. I LIKE DRAMA AND I LIKE A TWIST IN MY DRAMA.
—SUSAN BEECH

What are the unique aspects of Susan's collection? Let me explain that by looking closely at what she has chosen. First, Susan likes jewelry that tells stories and carries meaning. But she also loves simply beautiful work and well-made pieces. She has a sense of humor and an irreverent side, which adds a bit of spark to her choices. But she is serious about what she is doing. She is fascinated by live animals but collects taxidermied rabbit heads, birds, and other dead animal forms. She is impressed by the beauty of nature but also the creepy and decaying parts. In other words, Susan is filled with contradictions while still intuitively choosing a coherent selection of jewelry for her collection. This is often the case with collectors who are not aiming at a grand statement with stringent discipline. This isn't an academic study but a passion of the heart.

Susan likes the materiality and sensuality of jewelry. As she wears certain pieces, she tends to stroke them and physically be aware of their presence. It adds to her appreciation of them. Susan is a sensual being and the tactile pleasures of jewelry suit her nature. More than anything else, Susan defines her relationship to her collection through the act of wearing. She admires the way contemporary jewelers grapple with wearability as much as any fan of the field, and she owns a number of pieces that put wearability into question, or take the idea as an invitation to experiment with making objects that will never be worn. But ultimately she is committed to wearing what she owns and collects.

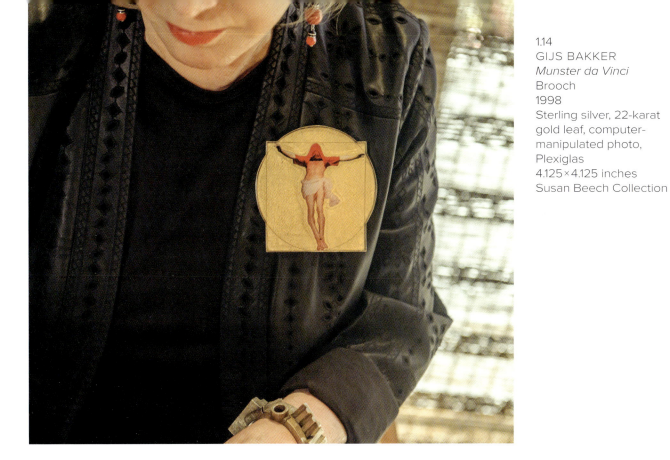

1.14
GIJS BAKKER
Munster da Vinci
Brooch
1998
Sterling silver, 22-karat gold leaf, computer-manipulated photo, Plexiglas
4.125 × 4.125 inches
Susan Beech Collection

Contemporary jewelry, she says, is part of the cabinet of curiosities that she has created in her Tiburon home, but it is the only art form that can be worn and taken outside the domestic sphere. Susan wears contemporary jewelry every day. What makes this collection unique is the claim she has made to every piece through the act of wearing. Everything is worn, at least once, in her home. Most things are worn, at least once, in public. And some special objects are worn repeatedly, becoming so much part of her sense of self that she jokingly suggests she will be buried with them, like a pharaoh or Viking king surrounded by their grave goods.

Susan says that she tends to shy away from wearing pieces that are too controversial, as they could create awkward situations and might be offensive. Her collection features several neckpieces and brooches that tackle provocative themes that she has worn in public. Gijs Bakker's *Munster da Vinci* (1998) is a brooch that she loves. The background is gold, like a medieval or early Renaissance altarpiece, with a figure imposed across the radiant surface. The legs and torso are the crucified Christ with a white loincloth and vivid red spear stab in his side, and puncture wounds from the nails in his feet. But the head and arms have been replaced with those of a jubilant football player, wearing a red shirt that has been pulled over his head to celebrate a goal, arms outstretched in celebration. Athletes are often regarded as gods and their heroic actions are praised by their devoted fans. Christ is also adored, and his actions are revered by devout Christians. The power and pleasure of Bakker's brooch comes from pointing out the similarities between two phenomena usually seen as entirely different. Susan loves this irreverent mixing, but she has never found anyone shocked by the brooch. Most often the response involves someone recognizing who made the brooch and complimenting her on her choice of jeweler.

One of the artists that Susan adores is Ruudt Peters. He is a charming, entertaining, and clever Dutch jeweler. She owns a total of 23 pieces by him, some of which are quite daring and controversial. Peters experiments with spiritual, metaphysical, and religious themes in his work, and he has been a seeker all his life, traveling around the world for knowledge. Each series is usually a result of his research into a particular cultural location and spiritual practice. Although Susan claims not to be a religious or a particularly spiritual person, she has a side to her that finds spiritual comfort in nature. She often goes for long walks in the hills near her house, or along the bay, feeling a sense of peace from the sounds of the waves, the sea breeze, and the wheeling birds. She has also practiced meditation for many years.

When Peters was in India, Thailand, and Cambodia, he saw penis shapes outside of homes and over doorways used as symbols of fertility, love, and strength. He was intrigued and produced a series of big necklaces consisting of phalluses made of various materials such as wood, glass, copper, silver, and foam. These necklaces are very provocative when worn, as they hang down in front of the wearer's groin. Susan purchased *Lingam I* (2007) from Ornamentum's

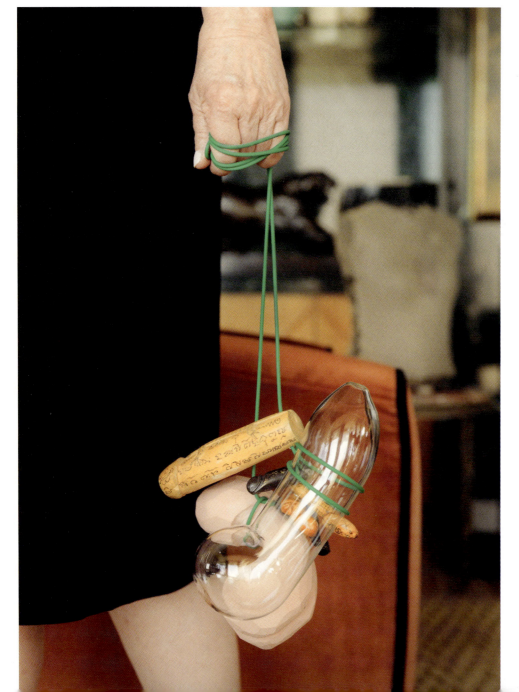

1.15
RUUDT PETERS
Lingam I
Pendants
2007
Wood, glass
8.6 × 7 × 6.3 inches
Gift to the Museum
of Arts and Design

1.16
TERHI TOLVANEN
Couronne Nacre
[Crown Nacre]
Necklace
2009
Mother-of-pearl, polyester,
mixed wood, paint, silver
9.25 × 8.25 × 2 inches
Susan Beech Collection

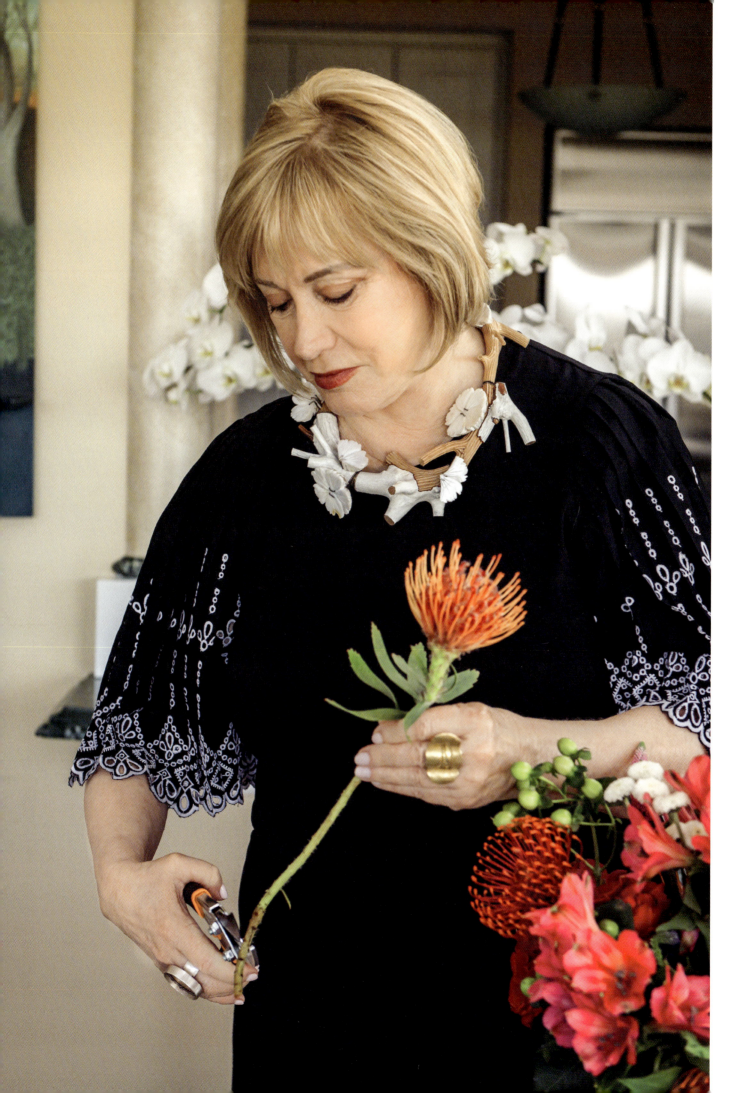

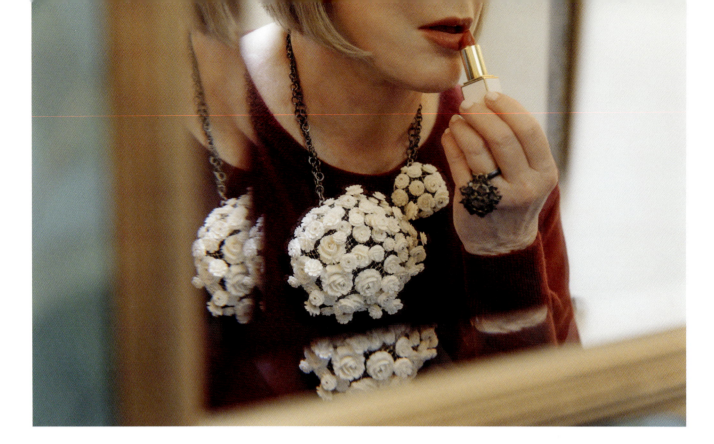

1.17
LOLA BROOKS
roses
Neckpiece
2008
Vintage ivory roses, stainless steel, 18-karat-gold solder, rose cut champagne diamonds, 18-karat gold
6 × 5 × 2.5 inches
Susan Beech Collection

booth at the SOFA craft fair, where she tried on different pieces from the series and wore them around the booth while looking for other things to buy. She received curious stares from passersby, especially men. As she recalls, no one looked at her face, just at the cluster of bobbing penises bouncing around her pubic area. It surprised her, given that this was a setting of art and craft collectors used to seeing strange and provocative objects, but apparently these necklaces were shocking enough to elicit a response from even a sophisticated and informed audience. She had fun wearing them that day, and bought two for her collection, but she has never worn them out of the house.

Besides provocative jewelry, Susan is also interested in nature, which is a common theme in jewelry. But she is especially interested in jewelry that presents nature in a twisted, subtly weird, or quirky way. That is the case with the Finnish artist Terhi Tolvanen, and Susan owns 25 pieces by her. Tolvanen's jewelry is not particularly shocking, but it is strange. It has a warm and comforting feeling, but it is also surreal. In the neckpiece *Couronne Nacre (Crown Nacre)* (2009) there is a transformation taking place, mimicking the processes of growth, blooming, and decay. Here the flowers have been cut from commercially produced mother-of-pearl in a way that undermines the material's original perfection and reveals the decay of the blossoms as they lose petals. The wood branches of different sizes are grooved in places and painted white in others. Nature has certain rules which Tolvanen quietly and thoroughly undermines in a way that takes more than one glance to fully comprehend. It is an unsettling strategy that Susan appreciates, aligned as it is with her appreciation for things that are subtly distorted, and not at all what they first appear to be.

The connection between jewelry and nature is also demonstrated in Lola Brooks's *roses* neckpiece (2008). When Susan first encountered Brooks's jewelry, she couldn't appreciate it. It seemed

much too sweet with its love of the sentimental and clichéd—all those bows, flowers, and hearts and vintage stones and carved elements that would have been old-fashioned in the late-nineteenth century, let alone a hundred years later. It was seeing and meeting Brooks herself that changed her mind. The jeweler is tall, slim, arms covered in tattoos, with a penchant for wearing vintage pant suits in plaid and polyester. She is a hipster, and this amusing and calculated self-presentation gave Susan permission to see her work in a new light, to look beyond the surface references to conventional jewelry and to understand the mix of irony and appreciation that powers her jewelry.

roses features dozens of ivory roses from the Victorian era that have been mounted on two stainless-steel cages or armatures of different sizes, soldered with 18-karat gold, and hung from a double stainless-steel chain. Some are set *en tremblant,* so they delicately quiver with the movements of the wearer's body. Diamonds are sprinkled among the roses, like dew drops. It's a sizeable neckpiece, but light and comfortable, easy to wear, beautiful too; it makes a big impact. Susan has worn it on some special occasions, aware that most viewers will just see it as a conventional piece of jewelry, but she knows the ironic attitude of the maker. It is a necklace that subtly changes the way Susan moves her upper body, encouraging her to sit up straight so that the piece is on display, making sure that there is maximum kinetic energy transferred to the trembling roses and diamonds, creating a shimmer that makes an attractive display for others, and in doing so generates a satisfying sense of special occasion for her as the wearer.

Susan has a fondness for animals, and this has become a theme in her jewelry collecting. She has two cats she adores and spends time with every day. She and her husband, Bill, have

1.18
DAVID BIELANDER
Scampi Raw
Bracelet
2007
Copper-plated sterling silver, elastic
2 × 3.5 × 3.5 inches
Susan Beech Collection

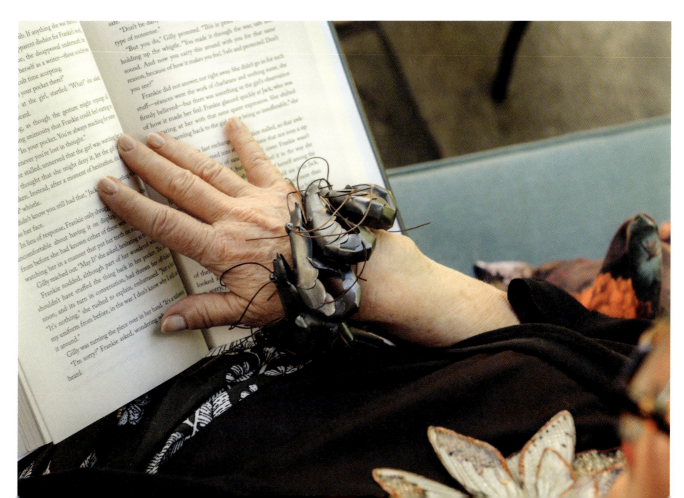

been involved with the San Francisco Zoo and with WildCare, a Marin County-based organization that provides medical care for injured wild animals. Susan and Bill have hosted events for both organizations in their home. These events are where her jewelry gets attention, and she always wears animal-oriented jewelry. People expect her to wear this jewelry and always comment on the pieces.

She has quite a few necklaces, brooches, and bracelets that reference animals and sea creatures, including *Scampi Raw* (2007), a humorous bracelet by David Bielander made to look like shrimp or langoustine. He is a jokester and often uses snakes, rats, fish, and other animals in his work—Susan owns examples of all of these. Susan says that the first time she met him, on the 2005 trip to Munich, she didn't understand his work or his sense of humor, but soon after she began to get it, and that resulted in the acquisition of fourteen pieces. It's possible to see how the completely ridiculous idea of making a bracelet out of prawns could charm and entertain Susan. The humor alone is wonderful and weird enough, but then to actually wear it, which she often does—every now and then while eating shrimp—is to have fun with those who see her. *Scampi Raw* is probably the piece by Bielander that Susan wears the most. It's easy to put on, comfortable to wear, and it adds a kind of surrealist delight to any outfit. It makes her smile and other people laugh. It's playfully different, without the complexity that comes with some of the other more challenging pieces in her collection.

Susan first saw an image of Sari Liimatta's *Hopeless* (2007) in Liesbeth den Besten's book *On Jewellery: A Compendium of International Contemporary Art Jewellery*, published by arnoldsche Art Publishers in 2011. She was so taken by it that she called all the

1.19
SARI LIIMATTA
Hopeless
Neckpiece
2007
Glass beads, pins, plastic
Bear: 6.5×3.5×2 inches,
entire neckpiece:
41.7×7.8×3.1 inches
Susan Beech Collection

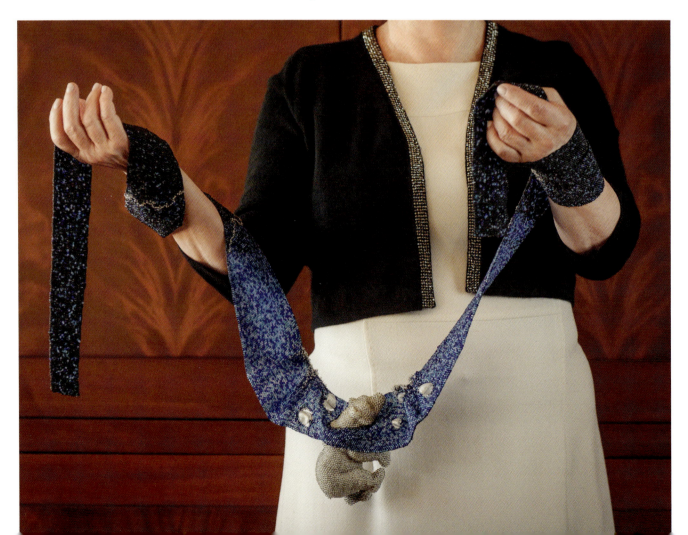

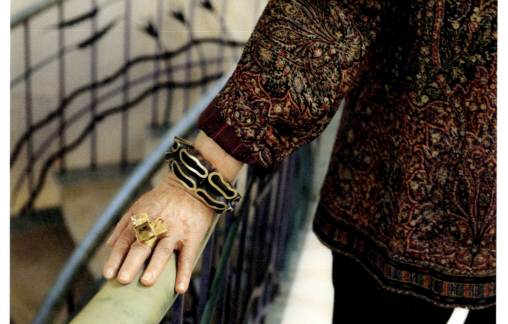

1.20
BARBARA PAGANIN
12 Valve
Bracelet
1999
18-karat-gold, oxidized sterling silver, freshwater pearls, Venetian glass seed beads
3.5 × 3.4 × 1.25 inches
Susan Beech Collection

galleries she thought might have it, and, once she tracked it down, purchased it immediately. A beaded white polar bear swims in a sea of blue and black beads, a few pieces of ice floating nearby, all that is left of its hunting grounds. The bear paddles arms and legs furiously, trying to keep its head above water. The story behind this sad scenario is that climate change is melting the polar ice, causing huge devastation to the animals and people who depend on the ice to live. The cause is hopeless, as the neckpiece's title suggests, leaving Liimatta with the task of memorializing the polar bear's struggle to survive in a display of exquisite skill and antique beads that draws on the power of jewelry and fashion to render something precious and eye-catching. Susan loves this necklace, although it is very hard to wear. That's because of the size and weight of the piece, which wraps around the neck and shoulders like a beaded shawl, so heavy that she can't tolerate it for more than a couple of hours at most. That physical burden embodies the psychological weight of the climate crisis facing humans and the natural world, and a bleak future as ecosystems change beyond recognition. Conceptually and physically, *Hopeless* is too weighty and uncomfortable a burden to carry.

 Some of the more purely decorative pieces in her collection are also the ones that Susan has worn the most. Barbara Paganin's bracelet *12 Valve* (1999) is a go-to piece, so much so that it has become a kind of personal symbol. She has worn it hundreds and hundreds of times since she acquired it in the late 1990s, after seeing it on the website of a gallery in Eastern Europe and tracking it down through Paganin's American dealer. She often wears it for extended periods of time, choosing to put it on day after day. For someone who loves wearing jewelry, this bracelet is perfect: robust and hard-wearing, extremely comfortable, and supremely attractive with its undulating folds of silver, perforated with tiny holes, banded in gold, and the interiors filled with shimmering pearls. It goes with anything. It is the ultimate "ready-to-wear" piece of jewelry: when she is not sure, or in a hurry, she'll put this bracelet on. Susan owns a number of brooches from the same series, and two of these have also been worn a couple of hundred times, placed side by side on the lapel of a jacket to show off the interplay between the circular forms.

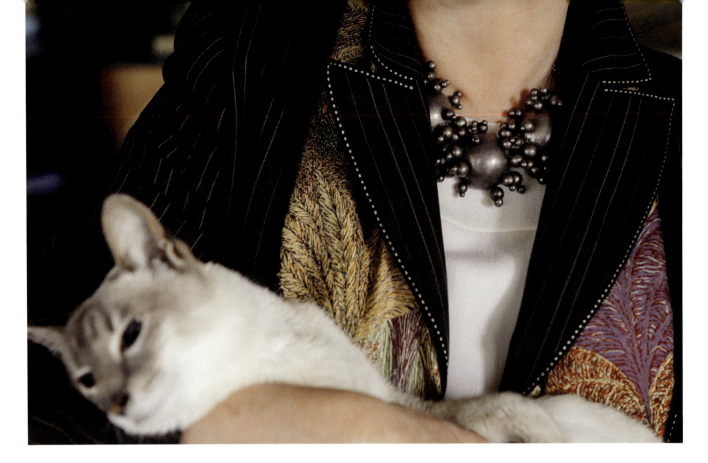

When you consider the pieces that Susan wears a lot, such as *Necklace* (1999), by Daniel Kruger, which she puts on at least once a month, it becomes clear that they share certain qualities. Some are obvious, like the requirement that the jewelry be comfortable to wear, easy to put on and take off, not too heavy so that it can be worn for a whole day or an evening without becoming burdensome, robust enough to stand up to normal wear and tear. All of those conditions are met by Kruger's necklace. It helps if the work can go with any outfit, and doesn't require specific clothing with all the forethought and planning that involves. That's true in this case, with the added benefit that the necklace has a really pleasing movement, the small silver balls glittering as they shift and catch the light when Susan sits, stands, or walks around. Kruger's necklace adorns, dressing up a plain outfit with its glitter, or providing a matching sparkle to fancier clothes. There is a definite sense of glamour, which is pleasingly matched by a sensual, tactile aspect; Susan's hand is drawn to touching the necklace, which creates a pleasing sound as the sterling silver balls clink and tinkle.

Perhaps less obvious is that this necklace, like most of the pieces Susan wears frequently, is an example of contemporary jewelry that doesn't have a subject matter other than the concerns of jewelry itself: the poetry of material choices, highly skilled methods of construction and fabrication, unexpected or uncommon paths to beauty and adornment. Kruger's necklace has plenty of meaning and much intelligence, but this lack of an external subject leaves space for a wearer like Susan to make the piece her own.

Then again, it is interesting that the bracelet that best represents, for Susan, what contemporary jewelry is and does is one that she never wears. *Whorls and Eddies Bracelet* (2007), by Sergey Jivetin, is made of jeweler's saw blades soldered together and then folded into a graceful, pointed arc. They are held in a teardrop shape with

1.21
DANIEL KRUGER
Necklace
1999
Sterling silver
8.5 × 6 × 1.75 inches
Susan Beech Collection

each of the pointed ends coming together to form the petals of a flower. This ingenious bracelet is forced open by the hand pushing through the petals, while the tension in the metal holds the bracelet in place on the wrist. It fits Susan's criteria as a perfect realization of contemporary jewelry because it is an utterly original idea, it looks entirely distinctive and unlike the work of any other jeweler, and it uses materials with a strong relationship to the wider field of jewelry in a novel and unexpected way. The bracelet is absolutely wearable, but for Susan it is just too precious to risk. It is one of the four or five pieces from her collection that she would save in a fire.

THE CRITERIA FOR WHAT I WILL WEAR DOESN'T CHANGE TOO MUCH. WHAT I MIGHT BUY CHANGES, AND WHAT I THINK ABOUT THINGS DEFINITELY CHANGES.
—SUSAN BEECH

Susan started out buying brooches. She wore them more often than necklaces. She lives in the San Francisco Bay Area, and it gets cool at night so you can always comfortably wear a jacket, which means you can always wear a brooch on the lapel. But at some point she realized that necklaces offer more possibility for large and showy displays, so they became the focus of her purchasing activities. She also started thinking more about the collection as a whole and planning what to add to it. While her intuition—that physical sensation in the pit of her stomach, the elevated pulse rate—is still her primary guide to what she buys, there is a greater awareness of the collection as an entity and how new acquisitions can develop and shape it. There is a sense of responsibility that comes with being a serious collector and part of the contemporary jewelry scene.

This is the story of collecting. Once a collector has committed to a particular passion it shapes their world, at least in part. As Susan's knowledge grew and she understood what she was doing, she became more adventurous with her choices. She went to studios and talked to artists. She went to dinner and talked to artists. She met people who knew more than she did about the jewelry she loved. She got to be friends with dealers and others who loved, sold, and collected jewelry. Her world was being shaped by them. Because of her travels she is recognized and respected as someone who knows about this field. Over the years, Susan's collecting has been noticed by the larger jewelry community.

Susan is one of several collectors in America who saw the skill and intelligence of craft artists growing throughout the 1970s and 80s. These collectors started organizing groups in the 1990s when they decided that the galleries and artists using craft materials should be better known and supported. The collectors took it upon themselves to put together groups defined by their interest in specific materials. These were sometimes associated with artists' organizations, like the Glass Art Society, and in other cases, as with the Friends of Fiber Art

International, were primarily for collectors, curators, and fans. I established Art Jewelry Forum with Susan and some other friends in 1997. It was intended to promote art jewelry as a legitimate art form. The process has been very slow, but it is accomplishing its aim. AJF organizes trips to places in the United States and abroad, encourages and advances all aspects of the community, and its website publishes original research with articles, interviews, and reviews. It has also given grants over the years, including an annual Young Artist Award, sponsored by Karen and Michael Rotenberg, that offers $7,500 for the winner and $1,000 each for the finalists. The Rotenbergs have been long-time supporters of AJF.

Susan added another award when she decided to support a grant for mid-career artists. This hugely important commitment demonstrates her appreciation for the artists whose work has been the focus of her activities as a collector. The grant was for $20,000 and was given to a jeweler who is in mid-career (35 to 55 years of age). The first award, in 2017, was given to Cristina Filipe, from Portugal, who used the grant to write and publish a history of Portuguese contemporary jewelry called *Contemporary Jewellery in Portugal: From the Avant-Garde of the 1960s to the Early 21st Century* (arnoldsche Art Publishers, 2019). In 2019 the award went to Detroit jeweler Tiff Massey for a proposal to produce *Get Big* (2021), a wildly immersive technological and hip-hop environment that uses adornment to shift the focus from the object to the participant. The 2021 winner was Iris Eichenberg, also from Detroit, where she is a professor at Cranbrook Academy of Art. The award supported a comprehensive exhibition and catalog of her jewelry organized by the Museum of Craft and Design, in San Francisco. *Iris Eichenberg: Where Words Fail,* was on view in 2022; the museum published the accompanying catalog that year. The most recent award was given to artist and educator Khanya Mthethwa, from South Africa, for a project that combines African jewelry with technology by using 3D printing. Susan, who has two children and three stepchildren in the mid-career age group, wanted to recognize jewelers who sometimes struggle in a career phase that can have none of the excitement of being new to the scene, and none of the gravitas that comes from having decades of work successfully achieved. The Susan Beech Mid-Career Grant, which ended in 2024, was very generous in a field that has hardly any grants, and certainly none this substantial. This has been no small commitment.

What kind of a collector is Susan? She is theatrical. She is concerned with wearability and presentation. More than anything, Susan has created a beautiful persona complete with a very consistent look. She doesn't draw attention to herself through her clothing, but then she layers on top of it pieces of jewelry that are in many cases outrageous, or certainly not traditional. The quietly elegant attire is overshadowed by the performance of the jewelry. Her collecting is social, and it is important to her to see reactions to what she wears. She likes being noticed, like a character in a movie. She comes by this desire from her love of film noir, which she has watched over many years. She is an expert on the characters and the plots. Witty, catchy dialog, cynical heroes, femme fatales, disguise, and paranoia are all there. These film noir stories taught her that women could be tough and beautiful, to which she adds a sense of humor and delight in the absurd.

1.22
SERGEY JIVETIN
Whorls and Eddies Bracelet
2007
Jeweler's saw blades, stainless steel
6 × 6 × 0.5 inches
Susan Beech Collection

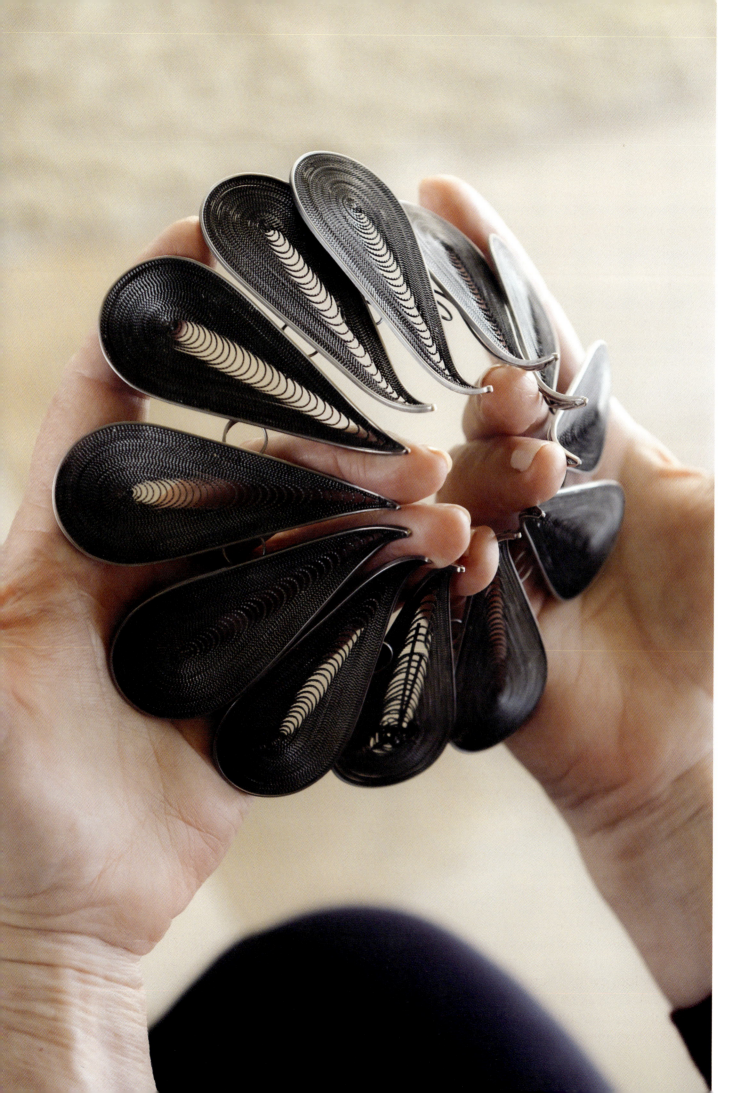

Susan is one of a small number of American collectors who have amassed significant collections of contemporary jewelry, some of which have been donated to museums and published in accompanying catalogs. Perhaps the best known is Helen Williams Drutt, whose comprehensive collection of international contemporary jewelry (with particular depth in American and European jewelers) was accepted into the Museum of Fine Arts, Houston, in 2007. Published in a magisterial book called *Ornament as Art*, with an abundance of overview essays recounting the history of contemporary jewelry (and Drutt's important role in this story as a dealer, collector, and promoter of the field) as well as biographical and thematic essays about individual jewelers, Drutt's collection is really about history, with the 792 works acting as a record of how contemporary jewelry developed in many countries around the world during the period from the late 1960s to the early 2000s. The similarly large collection put together by Daphne Farago and accepted into the Museum of Fine Arts, Boston, in 2006, is also historical in its orientation. With a stronger emphasis on American jewelers, and a larger historical span to include the modernist jewelry movement from the 1940s and 1950s, the collection was presented in the publication *Jewelry by Artists: In the Studio, 1940–2000* as a record of contemporary jewelry within the broader studio crafts movement.

Other collections haven't been positioned as documents of contemporary jewelry's history and development, but rather as opportunities to explore the unique possibilities of contemporary jewelry. This is the approach taken with *Zero Karat*, an exhibition and accompanying publication that took place at the American Craft Museum (as the Museum of Arts and Design was then called) in 2002, drawing on the donation by Donna Schneier of 80 pieces from her collection. Almost exclusively featuring jewelry made in the 1980s, the focus was on contemporary jewelry's rejection of precious materials in favor of materials and techniques that would emphasize the rupture between artistic and monetary value that is one of the great achievements of the contemporary jewelry movement starting in the 1960s. *Beyond Bling*, a book published in 2016 to celebrate Lois Boardman's donation of her more than 300-piece contemporary jewelry collection to the Los Angeles County Museum of Art, took a similarly thematic approach, offering a little bit of history (this time the development of contemporary jewelry on the West Coast of the United States) and reflections on what makes this type of jewelry distinctive and interesting.

Now that the grand narratives of contemporary jewelry in the United States, Europe, and many other countries around the world have been told in books, exhibitions, and on the internet, it leaves contemporary jewelry collections with other work to do. You can see this in the approach taken by the exhibition, and accompanying book, *Jewelry of Ideas,* from 2017–2018, to celebrate the collection of Susan Grant Lewin going to the Cooper Hewitt, Smithsonian Design Museum, in New York. These 150 pieces, mainly by American and European jewelers, can be used to tell old stories in new ways (it was exhibited in sections, which were called American Pioneers, European Pioneers, Scandinavian Jewelry, and Emerging Global Interactions) but most importantly provide an opportunity to discuss themes and issues (politics, nature, the body, and so on) that contemporary jewelry has returned to repeatedly over the past 60 years.

Where does Susan's jewelry collection fit into this lineage? Susan, like many collectors, would like her collection to find a permanent museum home, but she hasn't built her acquisitions on a premeditated idea of what a museum might want, or identified a particular approach or framework that structures her collecting activities and gives her collection meaning. For example, she hasn't developed her collection as a record of history, seeking to fill in gaps that would represent key countries, artists, periods, or concerns. Apart from unexpected opportunities to buy older pieces by jewelers she particularly likes, or encounters with jewelry made long before she began seriously collecting in the late 1990s—the kind that that give her the particular tingle that is a sign she is in the presence of an object that really matters—her collection is a record of what she saw and could buy starting from the time she committed to the field of contemporary jewelry.

More than any other, Susan's collection most resembles the one put together by West Coast collector Lois Boardman. Like Lois, Susan has chosen what she likes and what she will wear, and almost nothing else. This is a collection devoted to a particular person's vision and taste, whose knowledge has grown over time and become more sophisticated and adventuresome. There are many museum-worthy pieces in this collection, and some of them are going to the Renwick Gallery (part of the Smithsonian American Art Museum, in Washington, DC) and to the Museum of Arts and Design, but many pieces will stay with Susan so she can continue to wear them.

When asked a few years ago what her collecting motto might be, Susan replied, "It's quite simple, really. I want to get that tingle. I want to get excited about something original, well-thought-out, and beautifully made. The process of collecting all starts with that moment when you come face to face with something that is surprising and wonderful." Everything in Susan's collection has been filtered through this desire, and made her own by wearing. ■

AN ARGUMENT FOR THE NARRATIVE

TONI GREENBAUM

Much of the jewelry in Susan Beech's collection, whether American or European, can be described as "narrative," although the designation has been typically regarded as an American anomaly. That having been said, there is a slight difference of opinion among jewelry makers and scholars as to what constitutes "narrative" when the term is applied to jewelry.

Early experts in the field, such as the British authors Ralph Turner and Peter Dormer, had been hard-pressed to establish a definition. In their seminal book from 1985, *The New Jewelry: Trends and Traditions*, Dormer and Turner described narrative jewelry rather moderately, as "figurative … occasionally [used] to make … social or political commentary."[1] In the Netherlands, narrative jewelry wasn't a consideration until the Museum Het Kruithuis mounted *American Dreams, American Extremes* and then *Beauty Is a Story*, in 1990 and 1991, respectively, which included Dutch, Belgian, Austrian, British, and German makers, along with American.[2] In his 2007 PhD thesis, "Contemporary European Narrative Jewellery," Scottish jeweler Jack Cunningham admits that "narrative jewelry" has thus far been hard to define, offering a general, rather broad-based, explication: "A wearable object that contains a commentary or message which the maker, by means of visual representation, has the overt intention to communicate to an audience through the intervention of the wearer."[3]

For me, a piece of jewelry is narrative if it possesses a specificity of imagery or juxtaposition of materials that aim—whether directly or discreetly—to tell a story, indulge in a fantasy, relate an experience, refer to an event or locale, or make a topical statement. American jeweler Bruce Metcalf, who regards his own output as "narrative symbolism," states that for jewelry to be considered narrative "there must be context, character(s), arc, and (ideally) consequence."[4] New Zealand art historian Damian Skinner views narrative jewelry as "jewelry that explores the challenges of representing a time-based story or scenario charged with meaning within the object itself, using figurative images."[5]

Regrettably, narrative jewelry has had to endure an uphill battle to win the universal favor it enjoys today. Perhaps the story-telling position was deemed too obvious, the oftentimes impertinent images too provocative. Maybe the rejection of elegant design and abstract ideas was offensive to the European sensibility. As the director of Museum Het Kruithuis Yvònne G.J.M. Joris wrote in the catalog accompanying *Beauty Is a Story*, in the 1960s and 1970s the design and choice of materials for jewelry "were purely conceptual. Anything personal or emotional was taboo: what counted was cool logic, calm calculation, straight lines and geometric shapes."[6] In the

1 Peter Dormer and Ralph Turner, *The New Jewelry: Trends and Traditions* (London: Thames and Hudson, 1985), 119, 116.
2 Liesbeth den Besten, email to Toni Greenbaum, July 19, 2024. The author wishes to thank den Besten for her invaluable help in sourcing pertinent literature.
3 Jack Cunningham, "Contemporary European Narrative Jewellery" (practice-based PhD, The Glasgow School of Art, Department of Silversmithing and Jewellery, July 2007), 25. This thesis includes a comprehensive bibliography on various theories of narratology.
4 Bruce Metcalf, email to Toni Greenbaum, June 18, 2024.
5 Damian Skinner, email to Toni Greenbaum, June 10, 2024.
6 Yvònne G.J.M. Joris, "Apology," in *Beauty Is a Story* ('s-Hertogenbosch, Netherlands: Museum Het Kruithuis, 1991), 8.

same catalog, design critic Gert Staal stated, "A few years ago [jewelry with a story] would have been unthinkable in connection with an exhibition of modern west European jewellery. The story —then preferably described by the term 'anecdote'—was an arch-enemy of jewellery. It was part of the jewellers' guilty conscience that they ever functioned as illustrators."[7] Although typically regarded as an American phenomenon, I'm not sure it was the profusion of American narrative jewelry alone that accounts for this newfound international recognition. European jewelers came to their own conclusions by experimenting with the narrative format independently, thereby realizing its expressive potential.

———

To better understand narrative jewelry's trajectory, I'd like to briefly touch upon the field's nascent years, on both sides of the Atlantic, before concentrating on the American narrative works in Susan Beech's collection. European studio jewelry—at least during the period immediately following World War II—has been habitually regarded as abstract, displaying a nonobjective formalism, compositional harmony, and/or experimental surface treatment while maintaining traditional jewelry-making materials and methods. European studio jewelers saw themselves bound by the tenets of modernism, which shed light on their pursuit of a purist aesthetic, whereas American makers relied, instead, on a mélange of styles. As Joris boldly states, "America lacks a coherent cultural history vis-à-vis European art. … American art was cradled in an anthropological melting pot, rooted in its own continent but with deep traditions in Africa, South and Central America, Europe, and Asia."[8]

 Additionally, most European studio jewelers were trained by fine jewelers under the apprenticeship system, which explains their reliance on metal, gemstones, and enamel. Unlike their European counterparts, those wishing to study jewelry-making in the United States were dependent upon occupational-therapy classes for returning war veterans, some of which included metalsmithing, or general adult-education craft courses offered in select high schools and colleges; many were self-taught. American studio jewelry, at the time, ran the stylistic gamut, with makers who wished to forge a new expression turning to ethnography, along with the tropes of modern art—primarily Cubism, Constructivism, and Surrealism, the last epitomized by the phantasmagorical creatures of Sam Kramer such as *Cyclops* (1946). Here, a single figure speaks volumes, even though its story doesn't include supporting characters or sites. Such an evocative work allows for individual interpretation, conjuring a different tale for each person who engages with it. The figure's bizarre form may suggest a fetus to some, or a grotesque monster to others and, considering the year of its making, just after the end of World War II, perhaps a body mutilated by the detonation of an atom bomb.

———

7 Gert Staal, "Beauty Is a Story," in *Beauty Is a Story*, 21.
8 Yvònne G.J.M. Joris, "Foreword," in *American Dreams, American Extremes* ('s-Hertogenbosch, Netherlands: Museum Het Kruithuis, 1990), n.p.

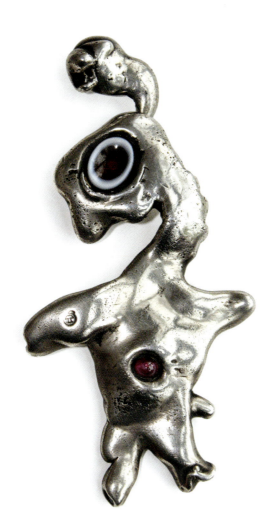

2.1
SAM KRAMER
Cyclops
Pendant
1946
Silver, banded agate, semiprecious stone
4.5 × 2.1 × 0.12 inches
Deedie Rose Collection, promised gift to the Dallas Museum of Art

Despite reluctance on the part of stalwart formalists, by the late 1960s European narrative jewelry had begun to evolve, and it did not emerge from a vacuum. There were historical precedents, along with fledgling examples, being made in Europe during the mid-twentieth century. In fact, narrative jewelry has existed in Europe since ancient times. For example, Roman and Byzantine betrothal/wedding rings featured chased profiles of couples gazing lovingly at one another. Medieval guild members wore identifying badges with narrative references to their associations, and didactic enamel images of Christ and his disciples were common in the Christian world during the Middle Ages, Renaissance, and Baroque eras, when most parishioners were illiterate. In the eighteenth and nineteenth centuries secretive lovers wore brooches with tiny paintings of one another's eyes, and rings and brooches were mounted with memorial scenes drawn with hair. In the early twentieth century, continental Art Nouveau and British Arts and Crafts jewelry featured enamelwork depicting myths and legends. And in 1941 Salvador Dalí began to design jewels, appropriating motifs from his surreal paintings, which were fabricated by jeweler Carlos Alemany. Other fine artists, such as Pablo Picasso, Georges Braque, and Max Ernst, followed suit, designing narrative jewelry that was also made by professional goldsmiths.

The trend continued and, in fact, expanded. German sculptor and jeweler Herbert Zeitner rebelled against the geometric abstraction of the Bauhaus as early as the 1920s and, in the late 1940s and

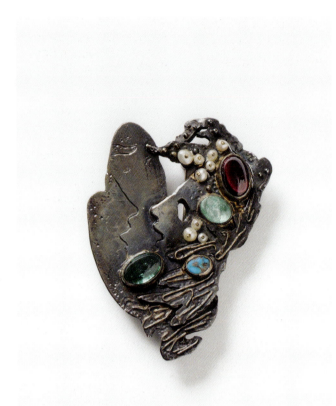
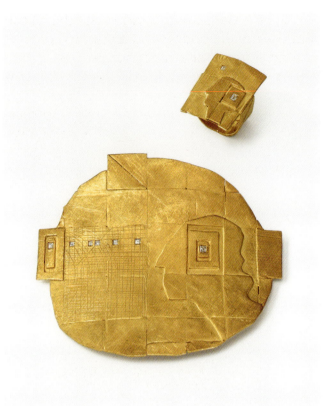

early 1950s, created silver brooches depicting enigmatic women's faces. Beginning in 1966 German jeweler Eberhard Burgel fabricated brooches from thin sheets of gold and carved ivory illustrating historical and mythical themes, as well as celebrated personalities. At about the same time another German, Reinhold Reiling, who possessed a sculptural preoccupation with the human form, added jewelry designs featuring photoetched images of individuals, as well as linear profiles engraved on gold, to his otherwise nonrepresentational output.

Czech-born German Hubertus von Skal, who perceived jewelry as totems that attract the eye through signs and symbols, concocted a brooch featuring a cast gold fly poised on a window screen, followed by others portraying tiny, realistically rendered male figures in business suits situated within surreal tableaux; bracelets and rings with moon-like faces; stick pins topped by human heads; and even penises fitted with tiny legs that appear to be scampering after potential partners. In 1973 Marion Herbst and Karel Niehorster, along with other experimental Dutch jewelers, founded the B.O.E. group—Union of Rebellious Goldsmiths—poised to revolutionize jewelry by challenging the reductivist aesthetic imposed by De Stijl in favor of creative freedom.[9] They also investigated new materials, such as steel, aluminum, and plastic. Herbst created a brooch from silver and acrylic that depicted a place mat with an oversized fork in the process of lifting one corner to reveal hidden "gems," while Niehorster made two surreal, pillow-like brooches from silver, one bisected with a zippered resin eye, the other by a zippered plastic mouth.

2.2
HERBERT ZEITNER
Narcissus
Brooch
1950
Silver, gilding, emerald, turquoise, tourmaline, pearls
1.96 × 2.7 × 1.5 inches
Die Neue Sammlung – The Design Museum

2.3
REINHOLD REILING
Ring and *Brooch*
1969–1970
Gold, diamonds
Ring: 1.18 × 0.9 × 0.74 inches, brooch: 3 × 3.3 × 0.23 inches
Permanent Loan of the Danner Foundation, Munich, Courtesy Die Neue Sammlung – The Design Museum

9 De Stijl was a Dutch art movement, founded in 1917, that advocated pure abstraction, reducing objects to the essentials of form and using only black, white, and primary colors.

In 1971 Barbara Cartlidge, founder of the groundbreaking Electrum Gallery in London and a staunch proponent of narrative jewelry, created a "toys for adults" series, exemplified by a silver bracelet replete with a miniature gold train that moves around a track, surrounded by golden houses and pine trees. As the 1970s progressed, narrative jewelry was embraced by an increasing number of European studio jewelers. Exemplified by the watershed exhibition *Beauty Is a Story*, in 1991, narrative jewelry was well on its way to becoming an integral part of the contemporary jewelry canon.

2.4
HUBERTUS VON SKAL
Fliege auf Fliegengitter
[Fly on Flyscreen]
Brooch
1967
Steel, iron, gold, rock crystal
2.4 × 2.4 inches
Permanent Loan of the Danner Foundation, Munich, Courtesy Die Neue Sammlung – The Design Museum

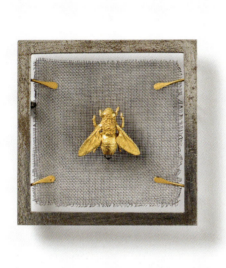

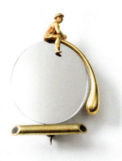

2.5
HUBERTUS VON SKAL
Spiegelminiaturs
[Miniature Mirrors]
Brooches
1972
Cobalt chrome, polished
1.1 × 0.9 inches
Permanent Loan of the Danner Foundation, Munich, Courtesy Die Neue Sammlung – The Design Museum

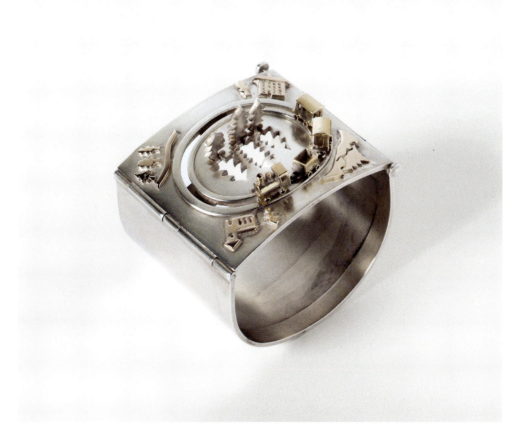

2.6
BARBARA CARTLIDGE
Bracelet
1971
Silver, gold
1.77 × 2.55 inches
Permanent Loan of the Danner Foundation, Munich, Courtesy Die Neue Sammlung – The Design Museum

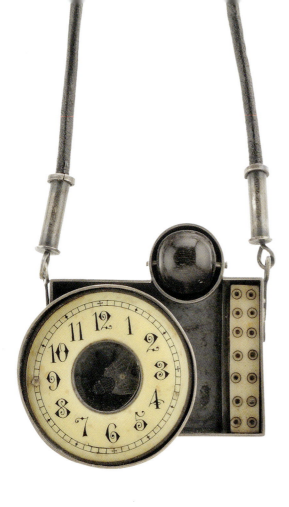
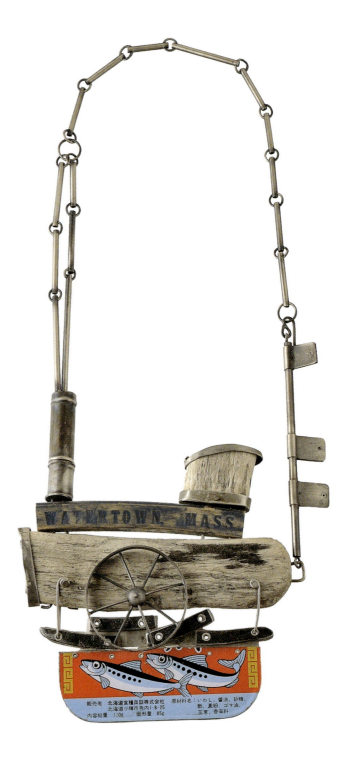
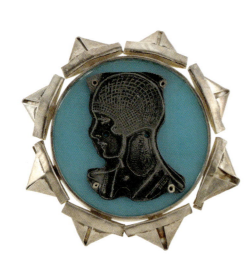

2.7
RAMONA SOLBERG
Time Flies
Necklace
1995
Silver, clock face, plastic fly,
bone ornament, rubber cord
Pendant: 3×3.25 inches,
entire necklace:
25.25×3×3.12 inches
Die Neue Sammlung –
The Design Museum

As Joris writes, "No country in the world appeals so strongly to the imagination as America … [where] the muses are … unfettered. 'Freedom' is probably the sole identifying feature of American art."[10] The pioneer spirit of America's Pacific Northwest exemplified such freedom. In the 1950s the city of Seattle was on the cusp of becoming a major center for studio jewelry due to metalsmith and educator Ruth Penington, who introduced metalsmithing into the art program at the University of Washington, in Seattle. This course of study would prove to be one of the most influential programs of its kind in the United States. Penington taught Ramona Solberg, who in turn mentored Laurie Hall, Kiff Slemmons, and Ron Ho, all of whom are included in Susan Beech's collection. Solberg, the acknowledged master of the "Seattle School," specialized in jewelry assembled from ethnic, folk, and vintage found objects collected during her extensive travels around the world. The necklace *Time Flies* (1995), previously owned by Beech and now in the collection of Die Neue Sammlung – The Design Museum in Munich, consists of an antique watch face, what appears to be a walrus ivory object of Inuit origin, and a fly preserved under crystal. Catchy titles, as well as her enchantment with assembled found objects, were likewise adopted by her acolytes.

Like Solberg, Laurie Hall incorporates found objects by indigenous people, folk art, and organic materials, as well as scrap metal and items from popular culture, which she augments with hand-fabricated replicas of everyday things. Where Solberg's jewelry is an elegant medley of compatible elements, Hall's displays a clever wit that is sometimes truly funny and often refers directly to her own life. Citing the perennial female quest for male companionship, Hall pays tribute to a teenager she knew as a child, while growing up in Portland, Oregon, in the brooch *Available* (2003). Hall recalls the girl going downtown to the waterfront to pick up sailors during the Annual Rose Festival, in June, when the naval fleets were in.[11] The round blue Plexiglas mounting, upon which a vintage tintype portrait of a young woman wearing Jantzen swimwear—a Portland-based brand—is affixed, is framed by a circle of fabricated silver sailor hats, or perhaps a flotilla of silver sailboats, reminiscent of the toy boats children make from folded paper. These vessels and/or the seamen represented by their caps appear to rotate endlessly around the swimmer's hopeful visage but never drop anchor, signifying the young woman's failure to snag a sailor.

Hall's necklace *Watertown* (2006) was suggested by the eastern Massachusetts city of the same name, located on the Charles River just west of Boston. Settled in 1630, its name was probably derived from the abundance of water and fish in the area. Hall utilized driftwood to fashion a tugboat in the shape of one that would likely have navigated the Charles, and placed an actual sardine can—decorated with lush images of fish—beneath it. Hall adds emotional impact to her narrative by anthropomorphizing this diminutive castoff, musing that "the sardine can would wish to be along for the ride."[12] Hall placed

10 Joris, "Foreword," n.p.
11 Laurie Hall, email to Toni Greenbaum, April 3, 2024.
12 Ibid.

2.8
LAURIE HALL
Available
Brooch
2003
Sterling silver, Plexiglas, found print plate
3.5 inches in diameter
Gift to the Renwick Gallery, Smithsonian American Art Museum

2.9
LAURIE HALL
Watertown
Necklace
2006
Sterling silver, driftwood, found wooden hanger embossed with the word "Watertown," sardine can, scrap iron
5.5 × 5.25 × 0.875 inches
Gift to the Renwick Gallery, Smithsonian American Art Museum

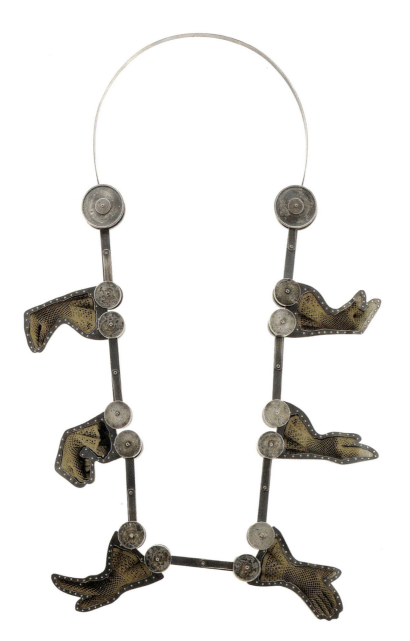

2.10
KIFF SLEMMONS
Manual Locomotion
Necklace
1999
Silver, mica, photographs
15 × 9 inches
Gift to the Renwick Gallery, Smithsonian American Art Museum

steel fragments above the sardine can to depict the river's current; likewise, silver elements on the portion of the piece that encircles the neck suggest the steam-fueled movement of the tugboat as it chugs down the river. Through the purposeful choice of found, selected, and fabricated materials that reference specific locales, both *Available* and *Watertown* convey a powerful sense of place.

Beech is a great fan of the jewelry of Kiff Slemmons, who is represented by ten works in the collection. Although residing in Chicago for many years, Slemmons is still considered a Pacific Northwest jeweler due to her time spent in Seattle as an integral member of the metalsmithing community there. Although she was great friends with Ramona Solberg and considers her a mentor, Slemmons is self-taught in jewelry-making, having originally pursued art and literature at the Sorbonne, and then art and French at the University of Iowa. While Hall's jewelry is a tongue-in-cheek commentary on popular culture and quotidian life, Slemmons's tends toward the intellectual, integrating philosophical exposition with lived experience. As a child growing up in rural Iowa, Slemmons spent time in her father's printing plant, where she came to love words and letters, perceiving in both a poetic as well as physical presence; she frequently incorporates typeset letters into her assemblages. In addition to these, Slemmons has often

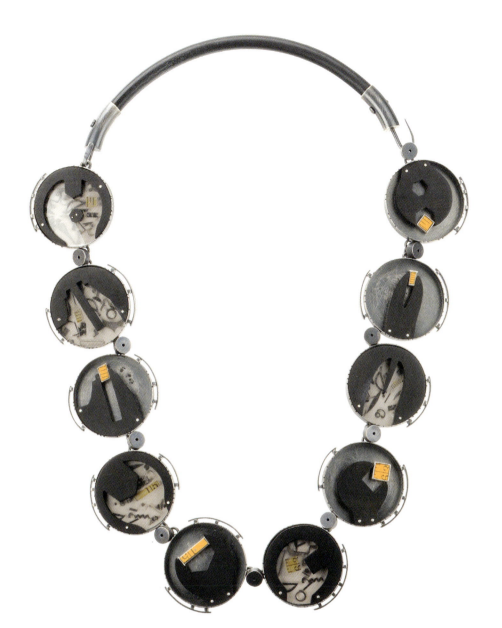

2.11
KIFF SLEMMONS
Coming to Grips
Necklace
2001
Silver, wooden ruler, photo fragments
25 inches long
Gift to the Renwick Gallery, Smithsonian American Art Museum

chosen photographs to tell a story. The multiple images in motion by avant-garde English photographer Eadweard Muybridge hold a particular fascination for her. The necklace *Manual Locomotion* (1999) is comprised of six contiguous mounted photos of a gloved hand, each manifesting a different gesture, which, when turned upside-down and separated into individual components, function as pull toys. Titles play a significant role in Slemmons's work.

As with *Manual Locomotion*, the necklace *Coming to Grips* (2001) illustrates Slemmons's love of language, facility with puns, and, in this instance, enchantment with tools. Wrenches, depicted in positive and negative space, are both the subject and object of the necklace, which is made up of ten circular elements, each containing a photograph of a wrench head, with some appearing to grasp a tiny piece of wooden ruler.

Ron Ho, a student of Solberg's at the University of Washington, was also a seminal figure in the Pacific Northwest jewelry movement. Chinese heritage and a Hawaiian upbringing are the main themes of his autobiographical necklaces. *Soil Toil* (1998) is a poignant tale about Ho's paternal grandfather, who immigrated from China in 1878 to work as a tenant farmer in Kula, Hawaii, and subsequently became rich by selling his lima bean crop to the United States government

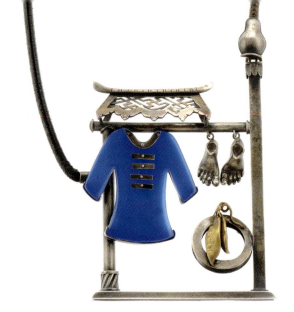

2.12
RON HO
Soil Toil
Necklace
1998
Plexiglas, fabricated and pierced silver, gilded silver peas, Guatemalan silver foot charms, leather
4.25 × 4 × 0.875 inches
Gift to the Renwick Gallery, Smithsonian American Art Museum

during World War I. The necklace represents Ho's grandfather's retirement, as a Chinese-style lattice roof shelters a now purposeless blue field worker's jacket, and a pair of charms in the guise of two naked feet hover over a bucket of golden lima beans, symbolic of his financial success.

A more politically charged narrative emanated from Central Washington University, in Ellensburg, an epicenter for the counterculture movement of the 1970s and which, like the University of Washington in Seattle, offered a fine metalsmithing program that still operates to this day. Nancy Worden was a young protégé of Funk artist Ken Cory when he was chairman of the metals department there. Her raw, feminist works, several of which, like Cory's, reference Indigenous American formats as well as social commentary, are exemplified by the necklace *Casting Pearls before Swine* (see page 15). Fashioned from Barbie doll arms cast in brass, it is configured like a Sioux bear claw necklace, with each hand holding a pearl—a precious offering to boors, who are unappreciative of human value. The brooch *Hidden Agenda* (1994), meanwhile, is an example of Worden's practice of hiding the most telling element of a work from the viewer. In this case, it's a tiny toy gun, which signifies her anger at right-wing religious groups, animal hunting, and the proliferation of firearms for personal use.

———

Based in Richmond, Virginia, Robin Kranitzky and Kim Overstreet also use assembled found objects in their highly detailed mixed-media brooches. Kranitzky and Overstreet's collaborations, however, are far more dreamlike than those emerging from the Pacific Northwest. *Imago* (1999), *Chasm* (2000), and *Fontanelle* (2001)—each a pristine tableau set within a stage-like enclosure—delve into the world of magic realism and fantasy, as opposed to cultural references, politics, and/or actual experience. The focus of *Fontanelle* is a baby's head, which appears to float within a fishbowl-like womb. The title refers to a space between the bones of an infant's skull, where ossification is not yet complete—the so-called "soft spot." Although much of Kranitzky and Overstreet's jewelry is upbeat, *Fontanelle* has an eerie, nightmarish quality to it, reminiscent of memento mori.

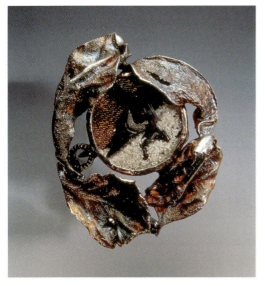
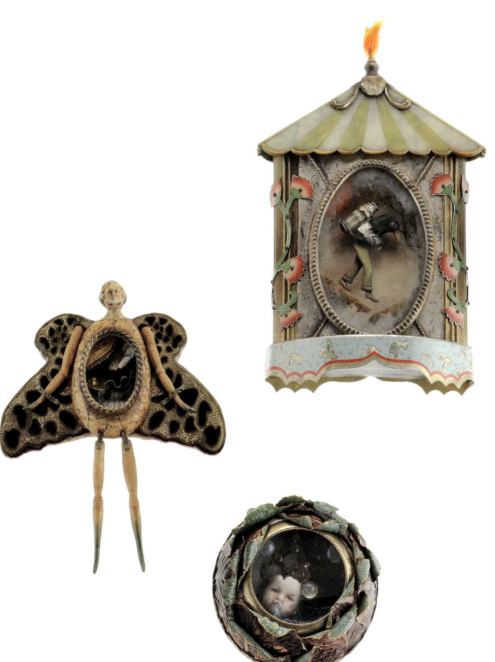

2.13
NANCY WORDEN
Hidden Agenda
Brooch
1994
Silver, hematite, pearl, shark teeth, watch crystal, silk, sand, mixed media
2.5 × 3 × 0.75 inches
Gift to the Renwick Gallery, Smithsonian American Art Museum

2.14
ROBIN KRANITZKY AND KIM OVERSTREET
Imago (left)
Brooch
1999
Wood, velvet, acrylic, found objects
5 × 4 × 0.75 inches
Gift to the Renwick Gallery, Smithsonian American Art Museum

Chasm (top)
Brooch
2000
Mixed media
6.375 × 4 × 1.25 inches
Gift to the Renwick Gallery, Smithsonian American Art Museum

Fontanelle (bottom)
Brooch
2001
Mixed media
3 × 3.5 inches
Gift to the Renwick Gallery, Smithsonian American Art Museum

Bruce Metcalf, Keith Lewis, and Joyce J. Scott explore darker narratives than either the Pacific Northwest jewelers or Kranitzky and Overstreet. Metcalf's heady, often autobiographical jewelry chronicles both the joyful and angst-ridden challenges common to humans. Always contemplative, and sometimes sad, his multi-faceted, densely packed object/brooches nonetheless offer hope. *Visionary* (1995), an homage to American artist Jess Collins, consists of a brooch configured as a fetus-like male (a frequent motif of Metcalf's) in the guise of an artist sitting before an easel upon which a painting of a solitary eye, almost as large as his entire head, is balanced. The detachable figure and easel inhabit a room-like structure. There are two drawings on the room's inner surface, one of a pine cone, the other of a monk, which are both seen hanging on the wall of Collins's studio in a 1983 picture. The figure represents Collins, with the eye image taken from his painting *Looking Past Seeing Through: Translation #19*, from 1975. Enclosed in this prison-like cell —a cenobite secreted within the cloister of his own imagination—

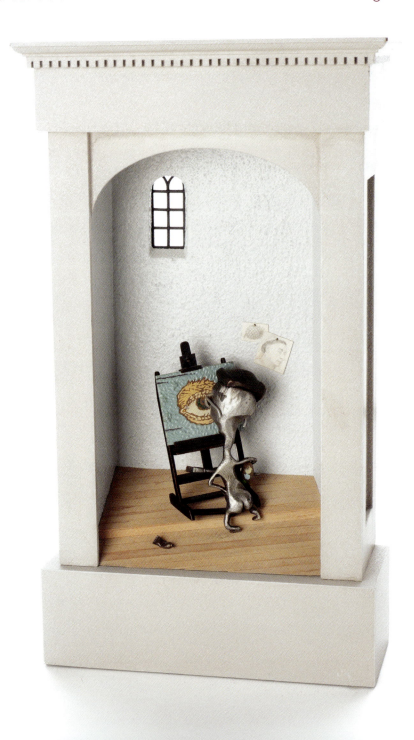

2.15
BRUCE METCALF
Visionary
Brooch and stand
1995
Brooch: silver, copper, brass, wood, painting in enamel, Plexiglas, stand: painted wood, brass, silver, drawing on paper
Brooch: 3.5 × 2 × 1 inches, stand: 10.75 × 6.25 × 2.75 inches
Gift to the Renwick Gallery, Smithsonian American Art Museum

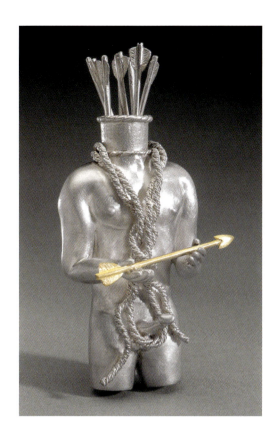
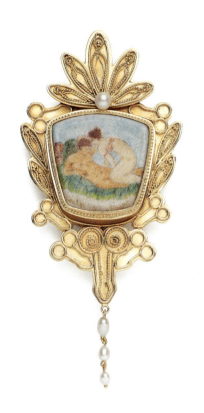

2.16
KEITH LEWIS
Sebastien (Imaginary Self-Portrait)
Brooch
1999
Sterling silver, 18-karat gold
3.25 × 1.25 × 1.25 inches
Gift to the Renwick Gallery, Smithsonian American Art Museum

2.17
KEITH LEWIS
Cuculla's Brooch
2001
Sterling silver, fine silver, 18-karat gold plate, enamel on copper, pearls
3.3 × 1.5 × 0.4 inches
Gift to the Renwick Gallery, Smithsonian American Art Museum

he gazes at the eye as it stares back at him.[13] Although the "studio" space in Metcalf's tableau is somewhat claustrophobic, a tiny barred window at the top of its far wall admits some light, indicating his perpetual trust in positive outcomes.

Metcalf's narrative symbolism, along with his world view, drew aspiring jeweler and AIDS activist Keith Lewis to Kent State University, Ohio, in 1990, where Metcalf was teaching at the time. In fact, Lewis's formative work shows Metcalf's influence in the cartoon-like way he depicted the shape of the male body. Lewis ultimately turned to the naturalism of classical Greek and Roman statues for models, of which the brooch *Sebastien (Imaginary Self-Portrait)* (1999) is a prime example. In keeping with Metcalf's struggle between unease and optimism, Lewis's *Sebastien* is a double-edged celebration of gay sexuality, as here the martyred saint seems sanguine rather than suffering, as he holds a golden arrow (symbolizing penetration) as if it were a royal offering. Satirically celebrating his love of history, as well as his love of men, Lewis puckishly explains, "All fags have to do a St. Sebastien, given his sexy persistence in Christian art."[14]

Lewis also attacks the hypocrisy surrounding modern sexual mores. *Cuculla's Brooch* (2001) is based upon an erotic fresco found at Pompeii. The fun, as well as the irony, of this pin is that, at first glance, it resembles an anodyne example of late-Victorian archeological revival jewelry. However, upon closer inspection you realize that an imminent act of coitus is portrayed in the enamelwork, while the gold frame surrounding it is composed of alternating penises and vulvae that terminate in a phallus from which a stream of semen, fashioned as a pearl chain, flows.

13 Bruce Metcalf, email to Toni Greenbaum, March 31, 2024.
14 Keith Lewis in Damian Skinner and Keith Lewis, *Dead Souls: Desire and Memory in the Jewelry of Keith Lewis* (Stuttgart: arnoldsche Art Publishers, 2023), 31.

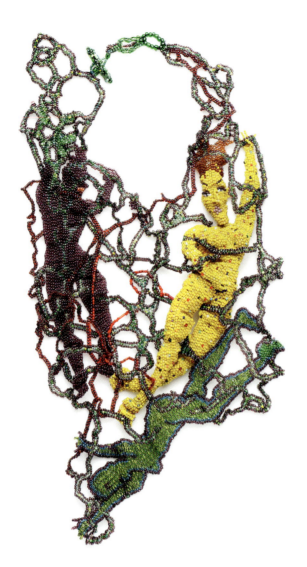

2.18
JOYCE J. SCOTT
Branches like Water
Necklace
2004
Glass beads, thread
16 × 7 inches
Gift to the Renwick Gallery, Smithsonian American Art Museum

2.19
LAUREN KALMAN
But if the Crime Is Beautiful … Hood 6
Necklace
2014
Plastic pearls, elastic
12 × 12 × 12 inches
Gift to the Renwick Gallery, Smithsonian American Art Museum

2.20
LAUREN KALMAN
But if the Crime Is Beautiful … Hood 6
2014
Inkjet print
20 × 16 inches
Gift to the Renwick Gallery, Smithsonian American Art Museum

Like Lewis, Joyce J. Scott aims to raise social awareness through art. In her powerful jewelry, sculpture, installations, and performance, she, too, has addressed the AIDS crisis, along with domestic violence, police brutality, racial prejudice and stereotyping, gender bias, and body image. Scott's necklaces are constructed with the peyote stitch, an Indigenous American beading technique that she learned in the mid-1980s from Muscogee (Creek) artist Sandy Fife Wilson at Haystack Mountain School of Crafts. Although consistently addressing horrific incidents, such as lynching and rape, and political issues, like South African apartheid, much of her imagery centers on ancestry, family, and romance. *Branches like Water* (2004) not only is an excellent example of "lovers entwined," a theme Scott returns to frequently, but, like the majority of her practice—whether freestanding sculpture or jewelry—it also indicates her commitment to elevating the status of women's work, of which beading is an integral part. Scott is descended from a long line of quilters, and, in fact, it was her mother, Elizabeth Talford Scott, who taught her to sew. The beaded and sewn male and female figures in *Branches like Water* are fashioned in the round, giving the necklace a three-dimensional quality related to her sculpture.

15 Lauren Kalman, *But if the Crime Is Beautiful … Hoods (2014–2016)*, accessed July 30, 2024, www.laurenkalman.com/portfolio/hoods.
16 Ibid.

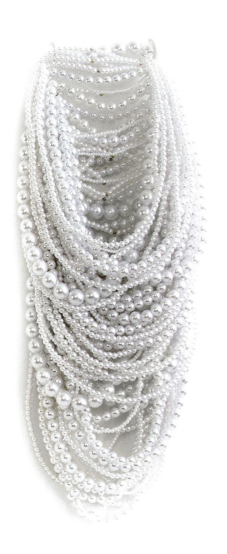
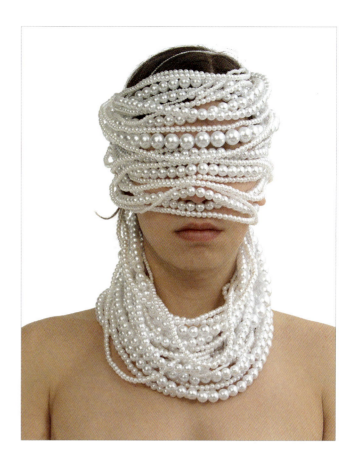

Although she does not work in peyote stitch, Lauren Kalman, like Scott, uses beads in some of her multimedia works, which, along with those by Jennifer Trask, Sondra Sherman, and Lisa Gralnick, represent a hybrid of narrative and conceptual strategies. Employing herself as the model, Kalman's photograph *But if the Crime Is Beautiful … Hood 6* (2014) rails against Austrian architect Adolf Loos's 1908 treatise, "Ornament and Crime," in which he denigrates decorative embellishment, demanding, instead, unadorned simplicity for modern design. The photograph is part of Kalman's series *But if the Crime Is Beautiful*, a multimedia project consisting of approximately 70 photographs, wearable objects, sculptures, and installations which questions the traditional art historical chronicle that grants privilege to a "utopic and myopic masculinist Eurocentric narrative."[15] The beaded hoods accompany those made from fabric, as well as fold-forming and cold-connected brass halos, and 3,000 photo-chemically etched brass leaves pressed manually on a hydraulic press over a 3D-printed die. Kalman's hoods can also be read as masks, with the series evoking multiple references from executioners' hoods to gimp masks.[16] Although both hoods and masks connote power, and sometimes oppression, *But if the Crime Is Beautiful* is comprised of 11,000 alluring Swarovski pearls, an ironic choice for an object of containment, but then again, if ornament is a crime, Kalman's punishment is sublime!

Both Jennifer Trask and Sondra Sherman have told stories through the language of flowers, but in divergent ways and with

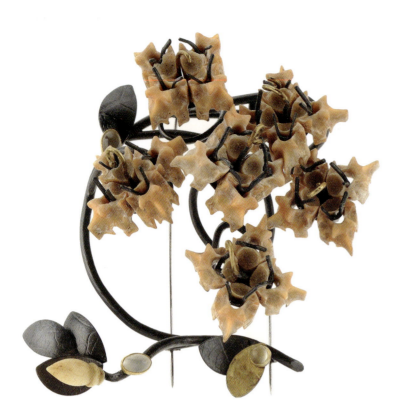

2.21
JENNIFER TRASK
Asteracea: Posey Brooch
2007
Silver, 18-karat gold, 22-karat gold, bone, moonstone
3.5 × 3 × 2 inches
Susan Beech Collection

dissimilar intent. Trask engages nature to elevate the cycle of existence, ameliorating death and decay "by transforming … detritus … into 'living' art."[17] She typically uses a combination of organic and inorganic matter, metal, and minerals to create jewels that channel the plants for which they're named. *Asteracea: Posey Brooch* (2007) is part of her series *Unnatural Histories*, in which she "delved into our precarious, at times contentious, relationship with nature," inverting flora and fauna by fabricating the petals of the aster-like flower from snake vertebrae, which have been mounted in silver and punctuated with moonstones.[18] In this, her first series to use animal bones, Trask—ever sensitive to ecological concerns—was thinking about hybrids and our human habit of tinkering with the genome without regard for the consequence.[19] Bone is the core of her practice. "Used literally to express definitive physical sensation and emotional sentiment, bone is considered the absolute reductive essence of our physical senses."[20] *Germinate* (2010, see page 104), from the *Embodiment Series*, is made almost entirely of deer antlers, cow and ox bones, rodent teeth, and pigeon skulls, carved naturalistically to replicate flowers which appear to grow around the wearer's neck like a burgeoning vine. Wanting the necklace to feel like an extension of the wearer's own bones, Trask manipulated the antlers to rest ergonomically against the human clavicle.

17 David McFadden, quoted in Toni Greenbaum, "The Transformative Art of Jennifer Trask," *Metalsmith* 34, no. 5 (2014): 31.
18 Jennifer Trask, "Unnatural Histories: Flourish" (undated and unpublished manuscript, collection of the artist, n.p.).
19 Jennifer Trask, email to Toni Greenbaum, April 30, 2024.
20 Ibid.
21 Sondra Sherman, email to Toni Greenbaum, April 10, 2024.
22 Ibid.

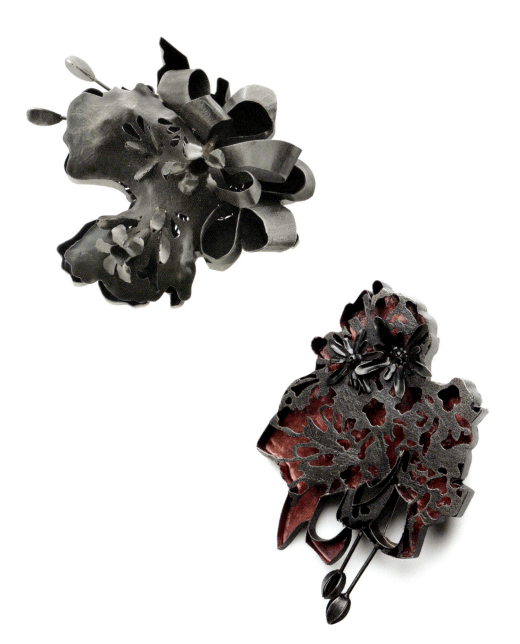

2.22
SONDRA SHERMAN
Corsage: Lavandula Lavender
Brooch
2007
Steel, nail polish
3.25 × 3.25 × 1 inches
Gift to the Renwick Gallery, Smithsonian American Art Museum

2.23
SONDRA SHERMAN
Study: Rhodiola Rosea
Brooch
2007
Steel, nail polish
3.5 × 2.25 × 0.5 inches
Gift to the Renwick Gallery, Smithsonian American Art Museum

Sherman regards botanicals as a metaphor for society's ills and pills, her jewelry a story of malady and manipulation. Her brooches *Corsage: Lavandula Lavender* (2007, named after an herb used in teas and aromatherapy as a calming agent) and *Study: Rhodiola Rosea* (2007, a plant available in capsule form to treat anxiety, fatigue, and depression) are from the series *Anthophobia: Fear of Flowers* (named after a real psychological condition). The latter brooch is a preliminary study piece. Although reminiscent of traditional corsages, these brooches allude to botanical psycho-pharmaceuticals, that is, plants used to treat social anxiety and depression. Although innocent looking, the corsages contain contradictory meanings that reference socially induced psychopathy, along with the disquieting advertisements for medicinal interventions touted by drug companies. "I hate pharmaceutical commercials," states Sherman. "They make me nervous and then sell me something to ease my nerves."[21] Nonetheless confident in the power of flowers to heal, she posits, "Fear of flowers? Who is afraid of a flower? I like the idea of a medicinal corsage … jewelry that soothes."[22]

In a project titled *The Gold Standard*, Lisa Gralnick attached golden appendages, such as bits of a sink faucet, sections of footwear, portions of wireless telephones, and body parts, onto plaster casts to conduct "an inquiry into the value systems through which contemporary society negotiates progress, accumulates knowledge, and promotes physical comfort through consumerism."[23] Exploring the history and lore behind gold and its function as a commodity in the marketplace, Gralnick calculated the ratio of gold to plaster based upon the market price of the object that the plaster replicated, and the value of the gold needed to represent that object on a given day.

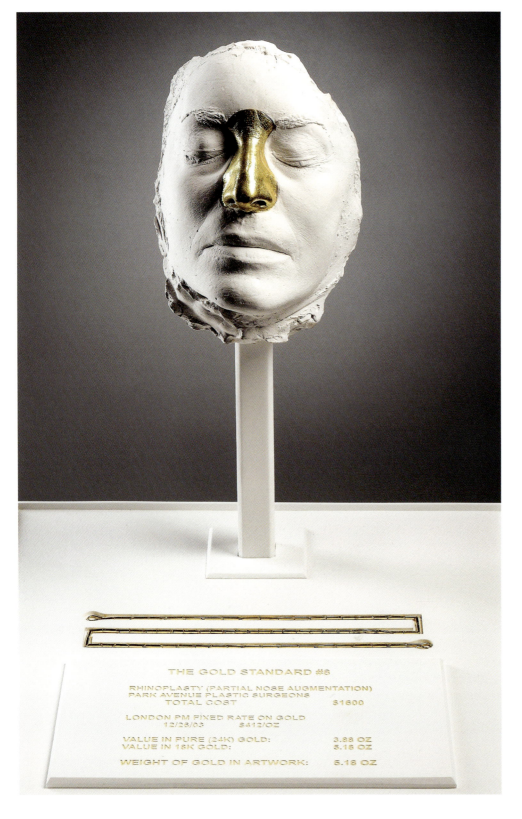

2.24
LISA GRALNICK
The Gold Standard Part 1: #8 Rhinoplasty
Nose jewel
2005
Gold, plaster, acrylic
15.5 × 15.5 × 17 inches
Gift to the Renwick Gallery, Smithsonian American Art Museum

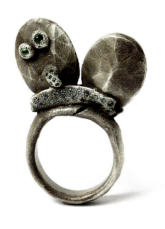
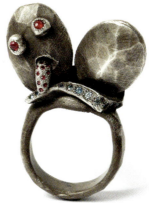

2.25
KARL FRITSCH
Double Pukana
(front and back)
Ring
2024
Silver, rubies, synthetic sapphires, cubic zirconia
0.98 × 1.5 × 0.39 inches
Private collection

Gralnick made a plaster cast of her neighbor's face—from which a golden nose protrudes—to create *The Gold Standard Part 1: #8 Rhinoplasty* (2005). Because Beech wanted to wear the nose as a piece of jewelry, she altered the work's narrative in ways both she and Gralnick may not have anticipated, propelling the proboscis into the functional realm by requesting that it be fitted with a detachable gold chain for use as a pendant. Disengaging the gold portion from the plaster cast raises several questions: How does the narrative change when the nose is removed from its support? Does the plaster object lose its narrative affiliation without the gold appendage? Is it now an autonomous sculpture? A naked armature? Only a prop? And, most significantly, what role does the wearer play in donning a replica of another person's body part? When Beech actually met the model for *The Gold Standard Part 1: #8 Rhinoplasty* at a SOFA fair some years later, Gralnick asked Beech if she recognized her; indeed she did.[24] The nose knows!

───

There is a sensitivity, irony, and, sometimes, even humor to narrative jewelry that isn't found in work systematizing form, structure, materials, and process alone. Karl Fritsch, best known for satirizing jewelry's tradition-bound standards by subverting them using their own formats and techniques, adopts a narrative approach for his *Double Pukana* (2024) ring. The wide-open eyes and protruding tongue of the *pukana* facial gesture performed by Māori men as part of *kapa haka* (performing arts) in New Zealand is a mark of the performer's excitement as well as providing emphasis to the meaning of the song or chant. Is Fritsch using the *pukana* to offer another challenge to jewelry?

───

23 Lisa Gralnick, quoted in Kiff Slemmons, "More Than One to Make One," Art Jewelry Forum (website), March 23, 2014, accessed July 30, 2024, www.artjewelryforum.org/articles/more-than-one-to-make-one/.
24 Susan Beech, email to Toni Greenbaum, May 22, 2024.

Narrative jewelry has the power to instruct and ignite, to touch our emotions along with our intellect. Narrative jewelry provides a platform for conversation, connection, and empathy. Its messages can be combative, but they can also calm. Narrative jewelry entails interaction between the maker, object, wearer, and viewer, uniting humans more closely than any other type of jewelry by nature of its communicative purpose. Among the salient features of narrative jewelry is an ability to be both autobiographical and biographical, reflecting the maker's experience, the wearer's affinity with that experience, and the viewer's complicity. Narrative jewelry can also tap into the collective unconscious, sparking common memories and universal sentiments.

The fact that Susan Beech's collection is dense with narrative works may indicate nothing more than personal preference, but then again, they present a compelling argument for its relevance to the field in both the United States and abroad during the last quarter of the twentieth century up to the present. Narrative jewelry is challenging to wear, because attention is focused not only on the object but also on the individual bringing its story into a public arena. The characteristics that make narrative jewelry engrossing can also lead to misunderstanding and a consequent need for explanation. This is true of conceptual jewelry also, but narrative jewelry commands a more intimate interaction. Some collectors don't welcome such attention and are reluctant to engage in the discourse that may ensue. Not Susan Beech! The sheer number of such works in her collection demonstrates both the richness of narrative jewelry and, considering its current proliferation, the foresight of Beech herself.

Today narrative jewelry is a benchmark of the discipline. Inspired by classic fables and modern comics, German maker Alexander Blank invents protagonists to relate narratives that channel his personal thoughts. To speak of the female archetype and women's conflicting roles in contemporary society, Hungarian jeweler Veronika Fabian employs tattoo imagery to decorate necklaces comprised of multiple nested chains. Dutch maker Felieke van der Leest uses textile techniques, such as knitting and crochet, to fashion necklaces and brooches featuring hilarious fantasy animals that often find themselves in weird situations—much like humans. And the list goes on. It took time, but narrative jewelry is in the ascendant. It's ironic that some of the American jewelers I interviewed for this essay denied being "narrative." Maybe this is due to an amorphous definition and/or the pejoratives formerly associated with the term, or perhaps there remains a lingering notion that literal is somehow less than equivocal. Putting semantics aside, let us value jewelry that not only makes us think but also makes us feel. ∎

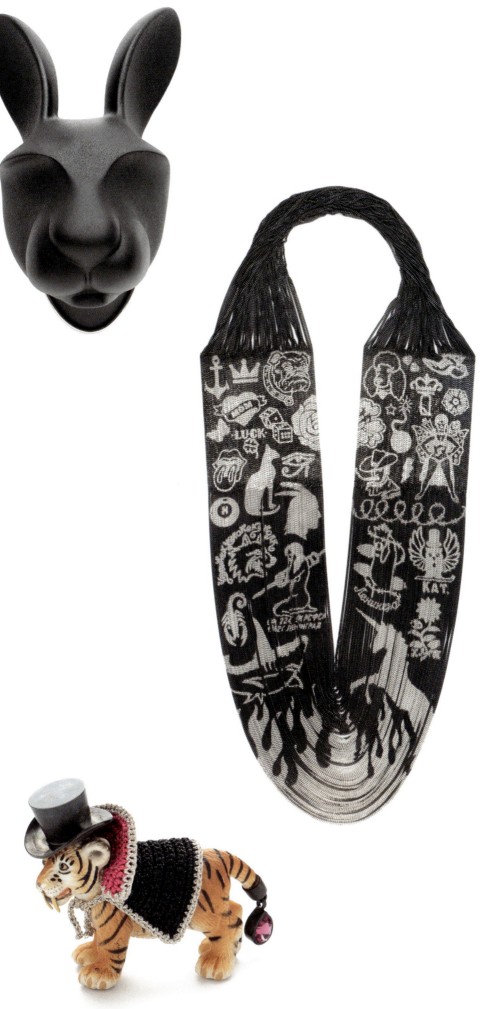

2.26
ALEXANDER BLANK
Evil Ed & Friends (Rabbit)
Brooch
2009–2010
Rigid foam, silver,
Perspex, lacquer
5.5 × 3.5 × 4.5 inches
Gift to the Museum
of Arts and Design

2.27
VERONIKA FABIAN
*Burn/Chains for an
Average Woman*
Necklace
2018
Silver-plated, partly
oxidized brass chains
17.7 × 11.8 × 0.2 inches
Gift to the Museum
of Arts and Design

2.28
FELIEKE VAN DER LEEST
Dracula Tiger Cub
Brooch
2004
Textile, plastic animal, gold,
silver, synthetic ruby
2.75 × 2 inches
Gift to the Museum
of Arts and Design

REDEEMING BEAUTY

BARBARA PARIS GIFFORD

Beauty is a vexed subject in contemporary art jewelry, a field rooted in avant-garde values of disruption, experimentation, and concept-driven explorations of form. Beauty is positioned as the opposite of intellectual and aesthetic rigor because of its relationship to visual pleasure, conventionality, and elite culture. By contrast, in the worlds of costume and luxury jewelry, beauty remains the aesthetic gold standard, embellishing its wearer, who is almost always female, with associations of feminine good taste, wealth, and social power. It is a statement about one's elevated sense of style through exquisite design, use of precious metals, and a profusion of gems. So, for the uninitiated, the idea of art jewelry as purposefully unconventional in form, difficult to wear, or at times downright ugly is a stumbling block. Jewelry should be beautiful, and that absence is hard to comprehend.

Much of Susan Beech's collection of contemporary art jewelry resides comfortably within the avant-garde discourse that prioritizes an edgy, unconventional approach to materials and form. Yet what strikes me about the collection and makes it stand apart is that there is also a quiet embrace of beauty—a stealth thread, if you will—of work by contemporary art jewelers pushing back against beauty's marginalization.

Perhaps this shouldn't come as a complete surprise. Beech is a seeker of beauty and her desire for it is great. Her home features a sublime view of the San Francisco Bay Area as a backdrop to a visual feast of neckpieces, bracelets, brooches, and rings she sometimes displays in her living and dining rooms. With this jewelry, the

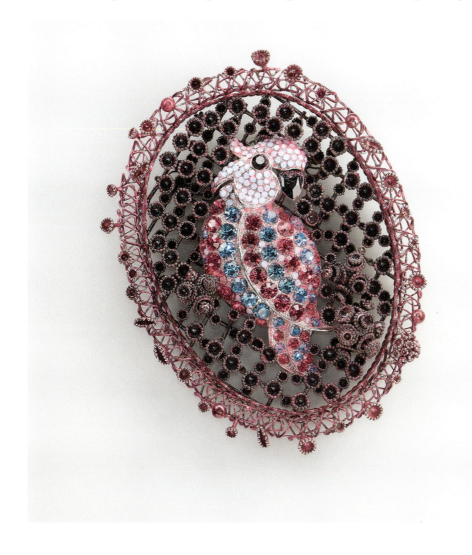

3.1
ROBERT BAINES
Endangered Pink Fallalery, Parrot
Pendant
2012
Costume jewelry, silver, powder coat, paint
5.75 × 4.375 × 1.125 inches
Gift to the Museum of Arts and Design

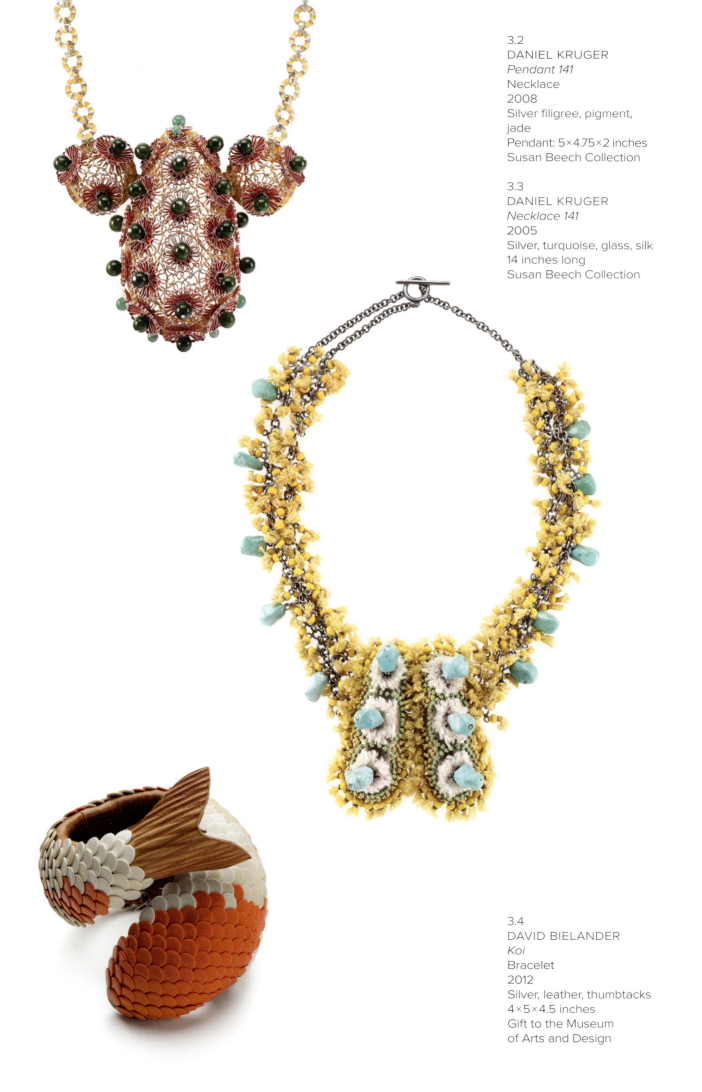

3.2
DANIEL KRUGER
Pendant 141
Necklace
2008
Silver filigree, pigment, jade
Pendant: 5 × 4.75 × 2 inches
Susan Beech Collection

3.3
DANIEL KRUGER
Necklace 141
2005
Silver, turquoise, glass, silk
14 inches long
Susan Beech Collection

3.4
DAVID BIELANDER
Koi
Bracelet
2012
Silver, leather, thumbtacks
4 × 5 × 4.5 inches
Gift to the Museum of Arts and Design

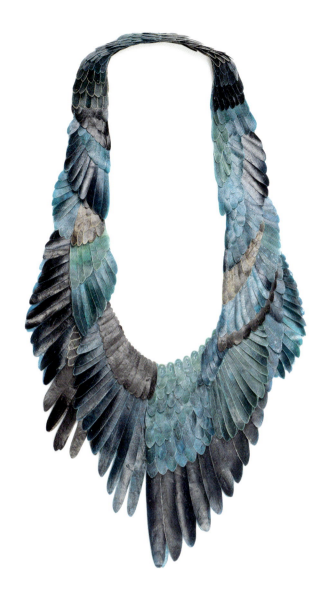

3.5
EUNMI CHUN
Wings of the Blue Bird
Necklace
2019
Cow's small intestine, thread, ink
24×12.5×1.5 inches
Gift to the Museum of Arts and Design

glimmering lights, shimmering water, enchanted forests, and colorful architectural wonders of San Francisco seem to have burst through her windowpanes and scattered throughout her home.

Robert Baines's brooch *Endangered Pink Fallalery, Parrot* (2012) sparkles along with the landscape, its rhythmically set rhinestones trembling in dramatic pinks, aqua blues, and ruby reds. Radiating a similar vibe are Daniel Kruger's necklaces with their pleasing beaded shapes in bright yellow, turquoise blue, and deep orange. Attractive not only to the eye but also to the senses, his spellbinding jewelry encourages you to reach out and touch it.

David Bielander's *Koi* (2012) appears to have the ability to swim up the wearer's arm and astonishes with its delicate curvature, scalation, and animating affects. This spilling over of nature continues with, among others, Eunmi Chun's necklaces, seemingly made of the most perfectly articulated and dramatic bird feathers ever encountered. Beech's collection contains so many splendid birds; in fact, you can easily imagine them flying around the room, adding to the enchanted aura that encapsulates her world. The reconstructed coral in Tanel Veenre's *The Garden III* (2018, see page 105) echoes the soaring Golden Gate Bridge in the distant background. The bridge feels as if it could be removed and worn around the neck, a second harmonizing ornament to Veenre's work.

With her collection, it is evident Beech has managed to amass contemporary art jewelry that is beautiful.

The art critic and poet Peter Schjeldahl, in his "Notes on Beauty," described beauty as "a conversion experience" that always has "a touch of strangeness and novelty about it" that "halts the flow."[1] This echoes Beech's physical reaction when she sees a piece of jewelry she must have—the excitement in the pit of her stomach and elevated pulse when she sees something new. Schjeldahl continues:

> Beauty teaches me that my brain is a physical organ and that "intelligence" is not limited to thought, but entails feeling and sensation, the whole organism in concert. Centrally involved is a subtle activity of hormonal excitation in or about the heart—the muscular organ, not a metaphor. Beauty is a willing loss of mental control, surrendered to organic process that is momentarily under the direction of an exterior object.[2]

Beech's fluttering heart, thus, is an affirmation of being in the presence of beauty.

Beauty is essentially impossible to define, however, although many have tried. It's been debated for centuries in Western philosophy, along with the nature of art. Beauty was a predominant topic among ancient Greek, Hellenistic, and medieval philosophers, as well as synonymous with art until the twentieth century. Its status began to decline in the Age of Enlightenment, especially in the eighteenth and nineteenth centuries. The central argument of beauty during these periods was whether it is objective, that is, a feature of beautiful things (as Schjeldahl believes), or subjective, located in the eye of the beholder.

Aristotle and Plato believed beauty to be objective, involving the arranging of integral parts into a coherent whole, based on principles of proportion, harmony, and symmetry known as the "Mathematical Style."[3] This concept is exemplified in classical and neoclassical architecture, painting, and sculpture—and, in Beech's collection, by Ruudt

3.6
RUUDT PETERS
Capital
Brooch
1982
Formica, silver
10 × 1.25 × 0.125 inches
Gift to the Museum of Arts and Design

3.7
GIJS BAKKER
Adam
Necklace, numbered edition
1988
18-karat gold-plated brass, color photo, PVC
11 inches in diameter
Susan Beech Collection

3.8
HELEN BRITTON
Collection
Brooch
2007
Silver, paint, rhodonite, vintage glass
3.5 × 2.5 × 0.75 inches
Gift to the Museum of Arts and Design

3.9
NORMAN WEBER
Portrait #1
Brooch
2006
Silver, glass, lacquer, digital print
4.5 × 5.4 × 2 inches
Gift to the Museum of Arts and Design

Peters's brooch *Capital* (1982), made of a photo of a Corinthian column, and Gijs Bakker's necklace *Adam* (1988), with its use of imagery from Michelangelo's *The Creation of Adam*, in the Sistine Chapel.

Further elaborating on the idea of pattern and unity in relation to beauty and form, Plotinus claimed ugly things as those that had not been mastered by pattern. "Where the Ideal-Form has entered… it has rallied confusion into co-operation: it has made the sum one harmonious coherence."[4] This recalls Helen Britton's *Collection* brooch (2007), in which she organized a discordant grouping of mixed media materials by color and shape to create one pleasing, lyrical piece.

In Giorgio Vasari's time, beauty was entwined with art and the principles of "formal beauty."[5] Masterpieces exuded qualities like "beauty, harmony, and generosity," terms that were associated not only with classicism but also with women.[6] Specifically, traditional beauty was represented by the female nude from ancient Greek times through the Renaissance and into the nineteenth century. Women in these artworks typically wore minimal clothing, if any, and were adorned with luxurious jewelry made of gold, pearls, colored gems, and diamonds. The observable traits of women in paintings and sculptures—passivity, tranquility, animated expressions, a composed demeanor, sweetness, pathos, youthfulness, sincerity, sentimentality, and romanticism—were equated with beauty and sensuality.[7] The tale of Lucretia serves as the epitome of feminine beauty, as she tragically takes her own life to protect her virtue, adorned with elaborate jewelry and an encrusted sword piercing her bare chest. Norman Weber's *Portrait #1* brooch (2006)

1 Peter Schjeldahl, "Notes on Beauty," in Bill Beckley and David Shapiro, eds., *Uncontrollable Beauty: Toward a New Aesthetics* (New York: Allworth Press and School of Visual Arts, 1998), 54.
2 Ibid., 53.
3 Crispin Sartwell, "Beauty," *The Stanford Encyclopedia of Philosophy (Fall 2024 Edition)*, ed. Edward N. Zalta and Uri Nodelman, accessed August 16, 2024, https://plato.stanford.edu/entries/beauty.
4 Quoted in ibid.
5 Wolfgang Herrmann, *Gottfried Semper: In Search of Architecture* (Cambridge, MA: MIT Press, 1984), accessed August 16, 2024, https://doi.org/10.7551/mitpress/3331.003.0022.
6 Dave Hickey, *The Invisible Dragon: Four Essays on Beauty* (Los Angeles: Art Issues Press, 1993), 47.
7 Kenneth Clark, *Feminine Beauty* (New York: Rizzoli, 1980), 7–33.

is a modern example of this idealized feminine beauty. It depicts Barbie contained within a bejeweled cage, her serene expression defying the restrictions imposed upon her, her cheerfulness unflappable.

Plotinus and Plato had linked beauty with virtue and divinity, and in the eighteenth century philosopher Anthony Ashley Cooper, 3rd Earl of Shaftesbury, took this a step further, relating it to God. He laid out three levels of beauty: natural beauty created by God; beauty created by humans through art or intelligence; and the intelligence that ultimately created these artists (meaning God).[8] Beauty from natural things, such as metal, stones, flora, and fauna, are fertile territories for art jewelers. As an example of Shaftesbury's first and second levels, Terhi Tolvanen cleverly transforms the gnarly tree branches she finds on her walks into wearable art, her *Winter Flowers* necklace (2017) incorporating pearls, silver, and oyster shells along with man-made cement and paint.

By examining nature and proportion, the eighteenth-century philosopher Edmund Burke presented a contrasting viewpoint to the classical understanding of beauty in his book *A Philosophical Enquiry into the Origin of Our Ideas of the Sublime and Beautiful*, calling into question the Mathematical Style:

> Turning our eyes to the vegetable kingdom, we find nothing there so beautiful as flowers; but flowers are of every sort of shape, and every sort of disposition; they are turned and fashioned into an infinite variety of forms. … The rose is a large flower, yet it grows upon a small shrub; the flower of the apple is very small, and it grows upon a large tree; yet the rose and the apple blossom are both beautiful. … The swan, confessedly a beautiful bird, has a neck longer than the rest of its body, and but a very short tail; is this a beautiful proportion? we must allow that it is.[9]

Karin Wagner's *Felt Necklace* (2008) follows this logic by presenting red blooms at all stages, burgeoning small buds to glorious mature flowers, resting on green vines so attenuated it's a wonder they can hold them. She uncannily captures the beauty nature creates.

Burke and other Enlightenment thinkers were less inclined to support beauty as contained within a thing (objective), preferring the idea of beauty as individual or subjective. Hume wrote in "Of the Different Species of Philosophy":

> Beauty is no quality in things themselves: It exists merely in the mind which contemplates them; and each mind perceives a different beauty. One person may even perceive deformity, where another is sensible of beauty; and every individual ought to acquiesce in his own sentiment, without pretending to regulate those of others.[10]

8 Quoted in Sartwell.
9 Ibid.
10 Ibid.

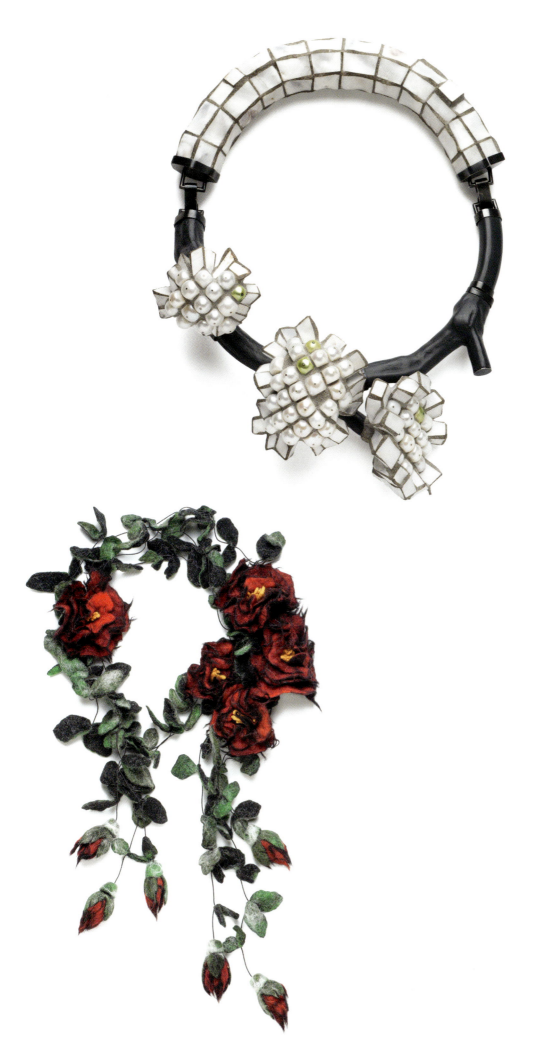

3.10
TERHI TOLVANEN
Winter Flowers
Necklace
2017
Pearls, oyster shell, heather wood, cement, paint, silver
9.375 × 7.5 × 2.625 inches
Susan Beech Collection

3.11
KARIN WAGNER
Felt Necklace
2008
Felted wool and alpaca fleece, elastic cord
9.25 × 6.25 × 1.5 inches
Gift to the Museum of Arts and Design

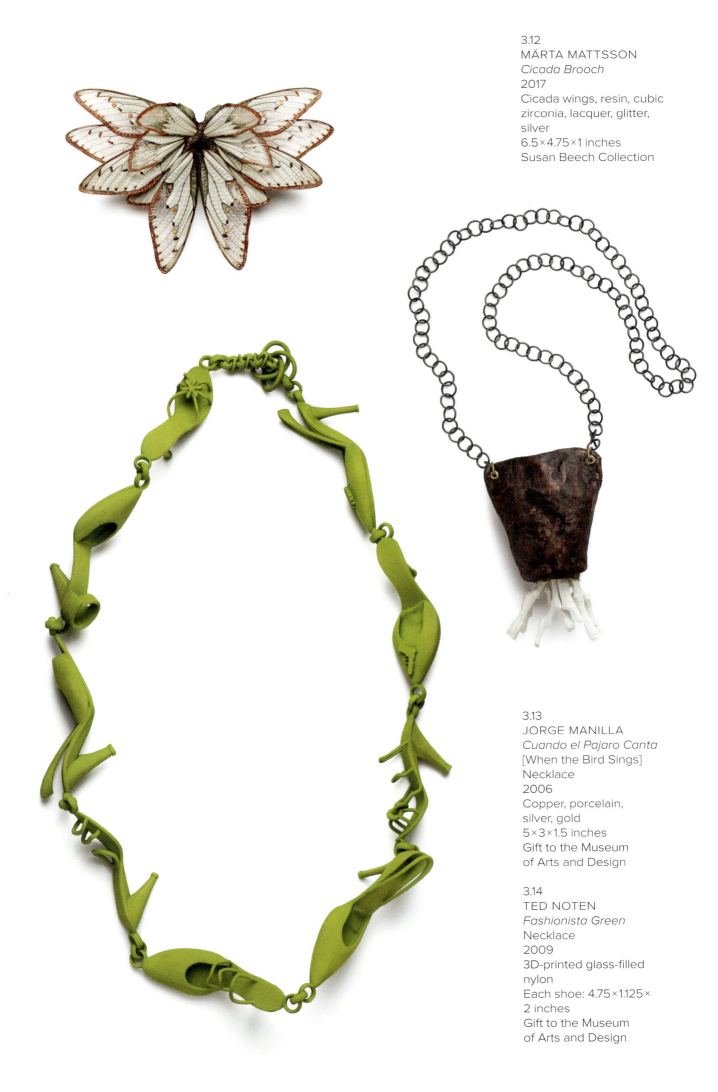

3.12
MÄRTA MATTSSON
Cicada Brooch
2017
Cicada wings, resin, cubic zirconia, lacquer, glitter, silver
6.5 × 4.75 × 1 inches
Susan Beech Collection

3.13
JORGE MANILLA
Cuando el Pajaro Canta
[When the Bird Sings]
Necklace
2006
Copper, porcelain, silver, gold
5 × 3 × 1.5 inches
Gift to the Museum of Arts and Design

3.14
TED NOTEN
Fashionista Green
Necklace
2009
3D-printed glass-filled nylon
Each shoe: 4.75 × 1.125 × 2 inches
Gift to the Museum of Arts and Design

Märta Mattsson, for instance, finds dead cicadas captivating enough to wear on the body, lacquering them, adding glitter, and adorning them with cubic zirconia, while others find these bugs repulsive. Additionally, Jorge Manilla's necklace *Cuando el Pajaro Canta* (2006) possesses an unconventional attractiveness that Beech appreciates, perhaps related to her love of birds.

John Locke conjured beauty as pleasure, a viewpoint later supported by Spanish-American philosopher George Santayana, which ultimately led to beauty's demise as a subject of substance in philosophy and art. Reason and logic reigned supreme in the Enlightenment, emotion relegated to frivolity. Since a definitive, rational definition of beauty eluded thinkers, it was perceived as having little significance beyond providing entertainment, amusement, or distraction.[11] As an illustration, Ted Noten's necklace *Fashionista Green* (2009), an infinite loop of fabulous green stiletto heels that summons joy, sets up the notion of beauty/pleasure without serious consideration (even though Noten's necklace could be an ironic statement worthy of contemplation).

In the twentieth century, beauty became a marketing tool, its effectiveness recognized for selling things. Worshipped for hundreds of years with its power universally understood, critics dismissed its potency, banishing it to the marketplace until the end of the century.[12]

Politics infiltrated beauty, and it was put on trial and dissected from every direction. The Enlightenment built the framework for democratic, Western societies, modernizing culture by discovering the "higher masculine plane" of rational thought and pure abstraction, transcending the "earthly domain" occupied by women and nature (beauty).[13] It hastened the French Revolution, arguing for the rights of common men as opposed to the exclusive rights of elites. Specifically, revolutionaries linked beauty to the French aristocracy and the rococo style, with its opulent jewelry and dress, lavish interiors filled with decorative flourishes, gilded furniture, decadent paintings, and sumptuous textiles. Beauty's association with wealth and indulgence implicated it, opening it up to moral and political critique, and even intentional destruction, driven by political motives. In reaction, numerous anti-capitalists, including many Marxists, rejected beauty altogether as a corrupting social force.[14]

Simultaneously, egalitarian ideals made for odd bedfellows with the capitalist-driven Industrial Age. The ability to cheaply mass-produce the very aristocratic objects that had been damned turned them into opioids for the masses. Broadcast around the world through new media, commerce ensured "beauty" was accessible and available for every household. Burgeoning consumer culture with its byproduct, conspicuous consumption, created an environment

11 James Hillman, "The Practice of Beauty," in *Uncontrollable Beauty: Toward a New Aesthetics*, 266.
12 Hickey, 13.
13 Lynda Nead, *The Female Nude: Art, Obscenity and Sexuality* (London and New York: Routledge, 1992), 45.
14 Sartwell.

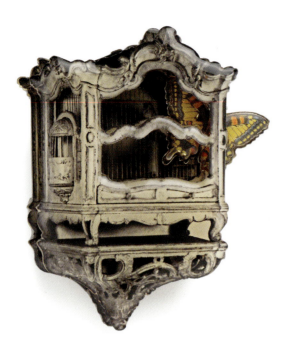

3.15
IRIS NIEUWENBURG
Royal Butterfly
Brooch
2009
Sterling silver, veneer, lacquer, photo, sticker, Swarovski crystal
3.25 × 3 × 0.75 inches
Gift to the Museum of Arts and Design

where people "no longer wanted what [they] needed [but rather] only wanted what [they] did not need."[15] Awash with affordable luxuries, the Western mind was forever altered.

The avant-garde anti-art movement Dada believed societal change brought on by industrialism led to the horrors of nationalism and World War I. They could not understand how the Enlightenment, which birthed civilized and high-minded societies, could ignite the most brutal wars in history.[16] To disassociate from the mainstream they morally questioned, Dada set out to dismantle beauty, aligning art with the ugliness they saw around them. As Dadaist Max Ernst recounted:

> A horrible futile war had robbed us of five years of our existence. We had experienced the collapse into ridicule and shame of everything represented to us as just, true, and beautiful. My works of that period were not meant to attract, but to make people scream.[17]

In 1917 Dadaist Marcel Duchamp submitted as art the infamous *Fountain*, a urinal signed R. Mutt, to the Society of Independent Artists exhibition in New York, which rejected it. Although at first an object of scorn, it called into question the nature of art and aesthetics, successfully disrupting the art world to consider severing art from beauty.

Without beauty, though, how could art be recognized? While opening the doors to new art movements and making space for the birth of contemporary art, Dada's deposing of beauty enforced yet

15 Stephen Bury, *Artists' Multiples 1935–2000* (Burlington, VA: Ashgate Press, 2001), 24.
16 Arthur C. Danto, "The Abuse of Beauty," *Daedalus* 131, no. 4 (Fall 2002): 46.
17 Ibid.
18 Hickey, 45.
19 Adolf Loos, "Ornament and Crime," originally published in *Les Cahiers d'Aujourd'hui* in 1913, accessed August 17, 2024, https://www2.gwu.edu/~art/Temporary_SL/177/pdfs/Loos.pdf.
20 Rosalind Galt, *Pretty: Film and the Decorative Image* (New York: Columbia University Press, 2011), 113.
21 Ibid., 42–46.

3.16
DAVID BIELANDER
Corn Cob
Pendant
2008
Sterling silver, split pins (brass-plated steel)
9 × 3 × 2.25 inches
Gift to the Museum of Arts and Design

another hierarchy in favor of patriarchy. Along with modernity's prioritization of abstraction over nature, rational over emotional thought, and men over women, the authority to determine what art is transferred from the common beholder to the author/artist and the art critic, those considered to have "prophetic singularity"[18] and the cultivated taste to recognize it (that is, white men).

Modern architecture and design theory incorporated similar differentiations, with Adolf Loos's manifesto "Ornament and Crime" standing out as one of the most audacious articulations of this shift. Using an evolutionary argument to support the moral and cultural superiority of the color white, clean lines, and unadorned surfaces (and white men), Loos maligned ornament (and beauty) as criminal for all those who upheld it:

> The Papuan tattoos his skin, his boat, his paddles, in short everything he can lay his hands on. He is not a criminal. The modern man who tattoos himself is either a criminal or a degenerate. ... We have outgrown ornament. ... Soon the streets of the city will glisten like white walls.[19]

Loos perceived the pursuit of beauty through ornamentation, personal adornment, and a vibrant aesthetic as aligned with what he deemed inferior forms of humanity, such as Papuan people. He also went on to assail Persian weavers, peasant and elderly women, cobblers, and laborers: people he considered morally beneath him for their preference for ornament and therefore dangers to society. The connection between ornamentation, femininity, and otherness is not coincidental. Much of the history of misogyny and xenophobia can be linked to the historic dismissal of ornament, beauty, and decoration.[20]

In this context, it is predictable that color, associated with beauty, women, and otherness, diminished in status, with drawing, or the line, elevated in design. Seeded in ancient times, this line/color hierarchy became omnipresent in modern Western aesthetics. It assigned masculine qualities of reason to the former and feminine traits such as emotion and pleasure (beauty) to the latter. Moreover, the consumption of vivid imagery became a sign to racialize and marginalize subjects tied to colonialism, primitivism, race, sexuality, and ethnicity.[21]

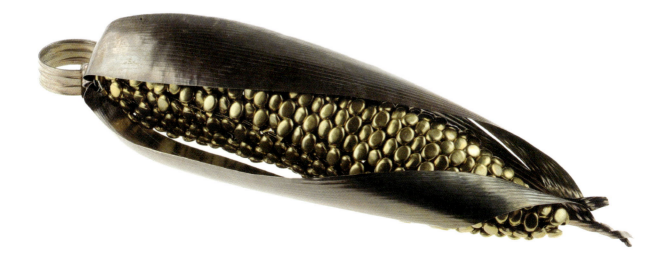

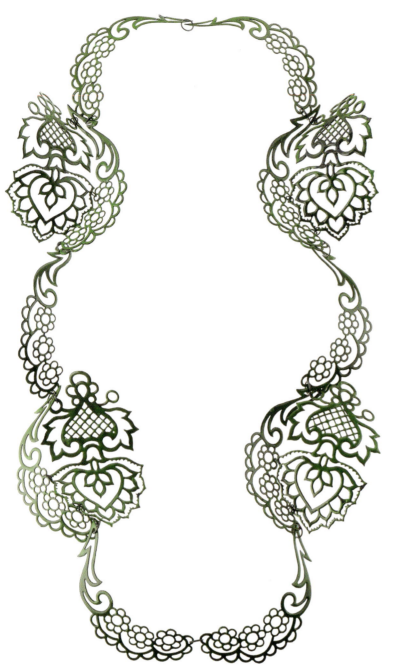

3.17
VERA SIEMUND
Untitled
Necklace
2006
Hand-sawn steel, enamel
16 inches long
Gift to the Museum
of Arts and Design

3.18
SVENJA JOHN
Rokkasho
Bracelet
2017
Macrofol polycarbonate,
nylon, acrylic paint
4 inches in diameter ×
2.625 inches
Gift to the Museum
of Arts and Design

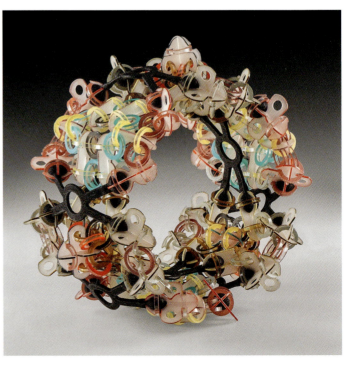

In the 1960s beauty disappeared from the artistic agenda altogether. It was part of the definition of art through the first quarter of the twentieth century, yet 40 years later institutions such as the National Endowment for the Arts omitted it from the language used to describe art.[22] Jerome Stolnitz wrote in 1961:

> We have to catch ourselves up in order to recognize that "beauty" has receded or even disappeared from contemporary aesthetic theory. For, like other once influential ideas, it has simply faded away.[23]

As the poet Bill Berkson wrote to Arthur C. Danto, author of *The Abuse of Beauty*, in the early 2000s, the idea of beauty is a "mangled sodden thing."[24]

In the face of the denigration of beauty and its association with feminine terms such as pleasure, frivolity, decoration, color, and ornamentation, it's unsurprising that makers working in craft and design at midcentury wanted to align with fine art (masculine) rather than decorative art (feminine).[25] No form of art would be taken seriously unless it challenged existing ideas, processes, and forms, these being the tenets of the avant-garde. Jewelry, with so many feminine associations baked in, would need to work particularly hard to be taken seriously as art. By definition, it is in regressive opposition to the clean lines and functional qualities of modernism advocated by the European architecture and design worlds.[26]

Thus, contemporary art jewelry emerged as a critique of precious jewelry, such as the traditional jewels worn by the aristocracy and by women in classical art throughout history.[27] As recounted by a number of jewelry historians, the emergence of the field in Europe (and the United States) was rooted in the Bauhaus principles and carried out by makers such as those on the Dutch jewelry scene. Emphasis was placed on function over decoration, a preference for clean lines, the use of democratic materials, and economic viability for everyone.[28] Employing quotidian materials as opposed to expensive ones transformed the value of jewelry from metals and gems to ideas. Like Dadaism in unlinking beauty and art to emphasize meaning and the singularity of the artist, separating precious materials from jewelry freed the medium to become a vehicle for artistic expression and experimentation. This radical positioning against

22 Danto, 37.
23 Jerome Stolnitz, "'Beauty': Some Stages in the History of an Idea," *Journal of the History of Ideas* 22, no. 2 (April–June 1961): 185.
24 Danto, 39.
25 Galt, 103, and Liesbeth den Besten, *On Jewellery: A Compendium of International Contemporary Art Jewellery* (Stuttgart: arnoldsche Art Publishers, 2011), 143, in which she states, "The history of twentieth-century art jewellery is imbued with a need to reveal jewellery's raison d'être, along with a strong inclination towards fine art. ... The form cannon was Modernist."
26 Galt, 109.
27 Damian Skinner, "The History of Contemporary Jewelry," in Damian Skinner, ed., *Contemporary Jewelry in Perspective* (Asheville, NC: Lark Books, 2013), 83.
28 Peter Dormer and Ralph Turner, *The New Jewelry: Trends and Traditions* (London: Thames and Hudson, 1994), 14; Skinner, 79; den Besten, 143.

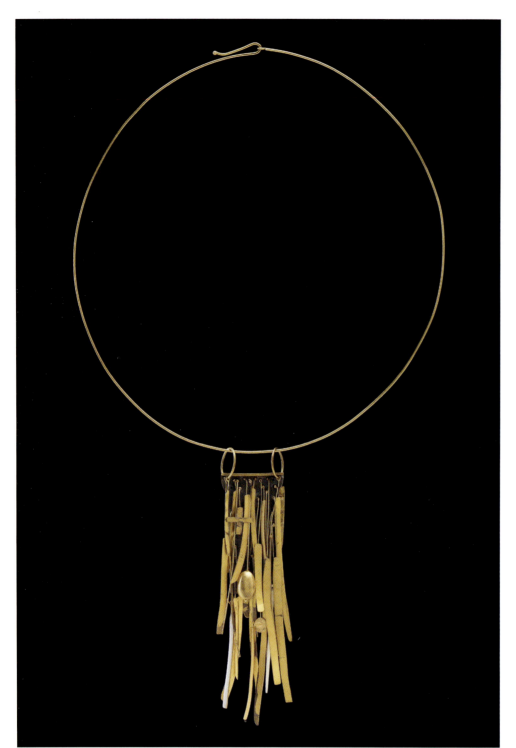

3.19
HERMANN JÜNGER
Halsschmuck
Necklace
Circa 1980
Gold, enamel
10.5 × 6.25 × 0.5 inches
Museum of Arts and Design, purchase with funds provided by the Horace W. Goldsmith Foundation, 2004, 2004.38

traditional jewelry and for avant-garde principles drew a line in the sand with beauty and fashion, considered taboos in the field.[29]

Art jewelry prospered in Europe, developing in West Germany first under the direction of three men: Hermann Jünger, at the Academy of Fine Arts, Munich; Friedrich Becker, in Düsseldorf; and Reinhold Reiling, professor of jewelry in Pforzheim.[30] Peter Dormer and Ralph Turner confirmed the credentials of Jünger's jewelry, relating it to modernism and fine art in their book *The New Jewelry*: "Expressiveness in Jünger's work derives from two aspects of Bauhaus design—an inclination to keep designs to essentials, whilst at the same time incorporating a freer and sometimes more playful ingredient, such as we see in a Paul Klee painting."[31]

They praised the variety of materials used early on in the Netherlands and proclaimed its influence significant, describing the

3.20
GIJS BAKKER
Splash
Brooch
1992/2014
Palladium white gold, diamonds, tourmaline, aquamarine, color print, PVC
2.75 × 5 × 0.25 inches
Gift to the Museum of Arts and Design

work of Emmy van Leersum and Gijs Bakker as "radical" and "rational."[32] The expansiveness alternative materials provided, as well as the subjects the new medium could accommodate, such as politics and conceptual ideas related to the body, eventually led to a departure from some of the core features of modernism. Bakker, for example, used laminated images as a key material, as in *Splash* (1992/2014) and *Adam* (1988), maintaining egalitarianism but setting aside function and clean lines. Importantly, the critique of preciousness remained intact.[33]

Art jewelry affords wearers (mostly women) freedom from some of the most troubling aspects of precious jewelry. Without high-value materials such as faceted stones, platinum, and gold, women are not treated as objects to display their family's wealth. Devoid of the rituals of traditional jewelry, they have agency to buy and select their own jewelry and wear it as a form of self-expression. However, as Liesbeth den Besten points out in *On Jewellery*:

> Since the days of the New Jewelry, it is almost as if thinking about the wearer is a taboo. After all, the emancipation of contemporary jewellery proclaimed a new artistic self-awareness and a new positioning in the market, irrespective of clients, conventions, fashion or economics. The jeweller became an artist, acting with the assumed freedom of an artist.[34]

Contemporary jewelry at its inception demanded the wearer forsake her own beauty expectations in favor of the artist, the jeweler. It required her to provide her body as a site, jewelry as art in need of a host. (As an anecdote, I once overheard a contemporary jeweler demand his collectors wear only black, to better display his pieces. He even suggested they wear special bras to flatten their breasts!) While mitigating troubling traditions in precious jewelry and expanding the grammar of ornament in wearable art, abandoning beauty set up a new set of issues with the potential to marginalize women all over again. As part of the ground rules of the field, art jewelers were given permission to treat their ideas as primary, with the beautification of their wearers second, if at all.

29 den Besten, 24.
30 Dormer and Turner, 8.
31 Ibid., 23–24.
32 Ibid., 9.
33 Skinner, 83.
34 den Besten, 60.

3.21
Model wearing piece by Gijs Bakker and Emmy van Leersum, circa 1967.

We can slip into the Beautiful with the same ease as we slip into the seamless embrace of water; something ancient within us already trusts that this embrace will hold us.[35]
—John O'Donohue

A public break with modernism occurred in the contemporary art jewelry world in 1985, with the work of Dutch artist and jeweler Robert Smit. He deliberately poked the field when he exhibited what den Besten describes as "pure, gold ornaments" in his exhibition *Ornamentum Humanum*, at Galerie Ra, in Amsterdam. She continues: "Everything atrocious was there: the word 'ornament' for jewellery, the gold, the spontaneous painterly treatment of the gold and the absence of a concept."[36] In 1986 a public debate took place within the pages of the Dutch art magazine *Museumjournaal* between Bakker, who saw the work as a threat to the *raison d'etre* of contemporary jewelry, and Smit, who embraced beauty and restoring aspects of the "old" jewelry.[37] Bakker considered traditional or "bad" jewelry as sentimental, expressive, and lacking in meaning (without concept) and worried that embracing pieces like Smit's would relegate contemporary jewelry to the "merely decorative," feminine realm.[38] European jewelers such as Bakker were motivated by a desire to create pieces that held the same significance as fine art (masculine), even though they were meant to be worn on the body. But unbeknownst to Bakker, the art world and its perception of beauty was about to change.

Beauty resurfaced at the end of the 1980s, not as a sign of wealth but rather as an agent for change. Dave Hickey, in *The Invisible Dragon*, recounts the example of Robert Mapplethorpe's *X Portfolio*, banned along with his *Perfect Moment* exhibition at the Corcoran Gallery of Art, in 1989. At the core of the matter were his powerful S&M photographs, presented within the context of formal beauty. The religious right in the US feared they could normalize queerness, which of course they did. When an idea is presented wrapped in beauty, the strategy goes, the idea and the beauty become indistinguishable, the beauty making the idea palatable. As Hickey explains:

> To state the case historically: we have, for nearly a hundred years, hypostasized the rhetorical strategies of image-making and worshipped their mysteries under the pseudonym of "formal beauty." … As a consequence, when these rhetorical strategies are actually employed by artists like Caravaggio or Mapplethorpe to propose spiritual or sexual submission, we are so conditioned to humbling ourselves before the cosmetic aspects of the image that we simply cannot distinguish the package from the prize, the vehicle from the payload, the "form" from the content.[39]

As Hickey argued about beauty in Western culture, it has the potency to change perspectives about controversial subjects on a mass scale.[40] Artists on the periphery due to their gender, race, and/or sexuality, such as Mapplethorpe, appreciated its strength and

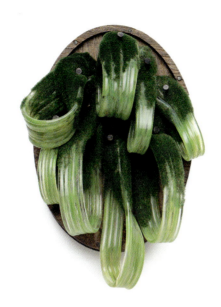

3.22
EVERT NIJLAND
Ribbons
Brooch
2012
Wood, glass, flock, silver, steel
4.5 × 3 × 1.5 inches
Gift to the Museum of Arts and Design

started reintegrating it into their work. In the context of art, beauty plays a significant role in its interpretation.[41] Once seen as devoid of meaning, as Bakker believed, beauty was again acknowledged as a fundamental concept in art.

Along with this, feminist scholars of the female nude in the history of art, such as Lynda Nead, challenged the traditional art historical narratives regarding women, beauty, and art put forth by writers such as Kenneth Clark in his book *Feminine Beauty*. By focusing on women's self-representation and self-definition and bringing attention to female perspectives that were often overlooked or excluded in the Western artistic tradition, new frameworks for understanding were established. Beginning in the 1970s, the shift in the portrayal of women from passive objects to active subjects in art shed light on their experiences and undermined the dominance of the male gaze. Writing and representing one's own narrative is an act of empowerment: It is about shaping your own story rather than conforming to the narratives and ideals imposed by others. In taking control, terms associated with women, such as beauty, ornament, decoration, color, and so on, were reconsidered and politicized as tools of the critique of patriarchal culture.

As claimed by den Besten, "today, ornament is back" in contemporary jewelry, in the form of filigree, flowers, arabesques, loops, stones, and so on, as expressed by artists in Beech's collection, such as Robert Baines, Vera Siemund, Evert Nijland, and Iris Nieuwenburg, among many others.[42] This revival connects to the reevaluation of beauty and women in art, including postmodern design's empowerment of decorative elements, the ability to add depth of meaning through familiar ornamentation, and the placating effects of beauty in making difficult subjects acceptable.

35 John O'Donohue, *Beauty: The Invisible Embrace* (New York: HarperCollins, 2004), 2.
36 den Besten, 144.
37 Ibid. I have relied on den Besten's description of the discussion between Bakker and Smit as it was originally recorded in Dutch.
38 Ibid.
39 Hickey, 35.
40 Ibid., 24.
41 Danto, 56.
42 den Besten, 141–142.

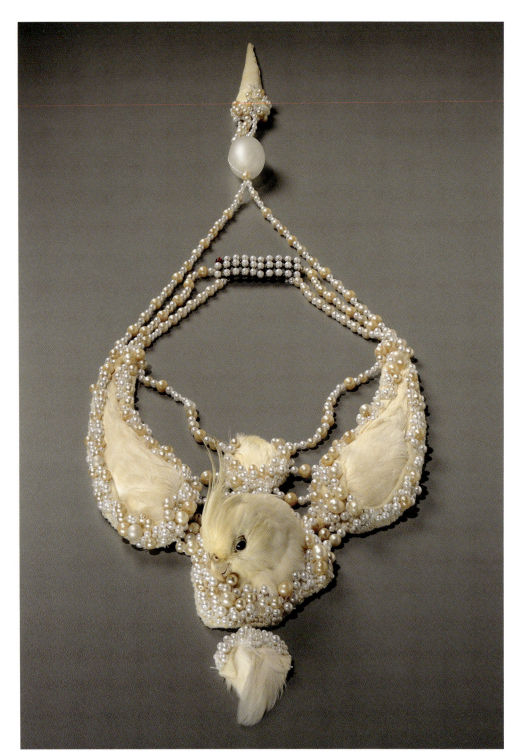

3.23
IDIOTS
Virgin
Necklace
2012
Taxidermy parakeet, plastic, glass beads, felt
6 × 2.75 × 20 inches
Gift to the Museum of Arts and Design

Swathed in beauty, death is pacified. Idiots presents three necklaces in Beech's collection that demonstrate the symmetry of beauty and bereavement. Swarovski beads and crystals, and pearls—traditional jewelry materials—envelop dead birds, taxidermized to maintain their natural shapes and bright colors. The pleasing hues and shiny textures of these neckpieces seduce the eye, until you realize you are gazing upon maiming and dismemberment, which catches you by surprise. Beauty, here, leads to a kind of faint pleasure.[43] The birds are appreciated in a different light, seen not as deceased family pets but rather as delicate wonders of nature, worthy of our gaze, even when life has left their bodies.

43 Arthur C. Danto, "Beauty and Morality," in *Uncontrollable Beauty: Toward a New Aesthetic*, 26.

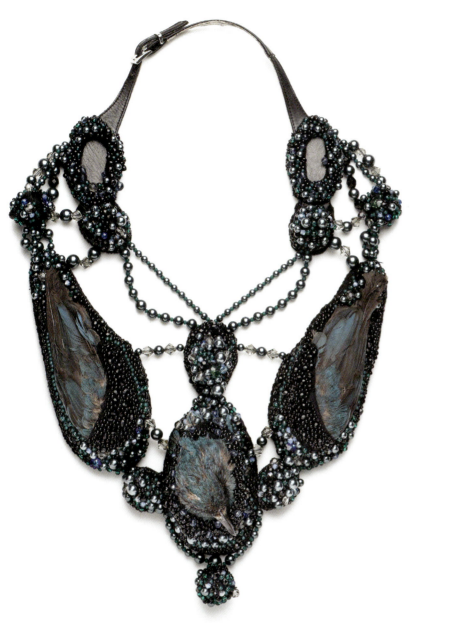

3.24
IDIOTS
Black Bird
Necklace
2008
Taxidermy bird, Swarovski beads and crystals, leather, felt
15 × 10 × 1.75 inches
Gift to the Museum of Arts and Design

3.25
IDIOTS
Untitled
Necklace
2009
Taxidermy bird, glass beads, felt, leather, metal
11 × 10.125 × 2.375 inches
Gift to the Museum of Arts and Design

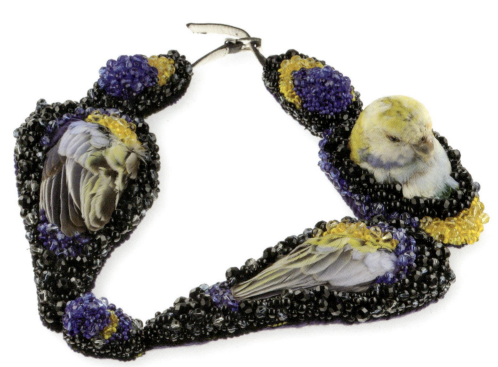

Jiro Kamata's *Arboresque* brooch (2010) uses the depth of ravishing color to pull you into a narrative of used camera lenses. Enthralled by the craftsmanship and stories these lenses once photographed, Kamata paints them in beautiful cosmic hues, making these otherwise pedestrian objects fascinating to contemplate. The viewer ponders the voyeuristic nature of the camera lens, the infinite life experiences and rituals to which it has borne witness.

And beauty allows Eunmi Chun the opportunity to courageously dress her wearers in pig skin, human hair, and cow intestine. In her hands, these ugly materials are transformed into stunning jewelry through her allegiance to the principles of formal beauty. Without these classic and well-understood concepts of beauty, the lexicon for contemporary jewelry would remain limited.

In a field where jewelers are generally made to believe that making beautiful work is not enough or is even downright vapid, Beech's collection demonstrates that beauty poses no threat to conceptual ideals. Further, the field's purpose is not at risk by integrating beauty. The artists who represent this strain of making in the collection assembled by Susan Beech understand that beauty is part of the meaning in their work, not a frivolous pursuit that compromises it. While the discourse has yet to fully consider beauty's place in the field, it is deserving of redemption. Additionally, a full embrace of beauty could offer a way forward for contemporary jewelry by broadening its acceptance. This is one important reason why the Museum of Arts and Design acquired Beech's collection and looks forward to presenting it—her eye corrects the beauty problem. ■

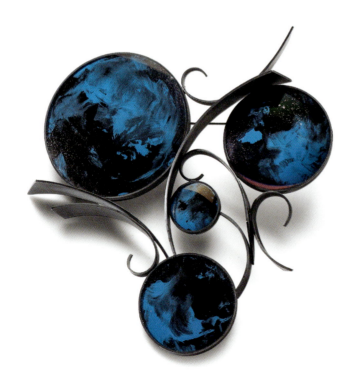

3.26
JIRO KAMATA
Arboresque
Brooch
2010
Sterling silver, camera lens, acrylic paint
4 × 4 × 0.625 inches
Gift to the Museum of Arts and Design

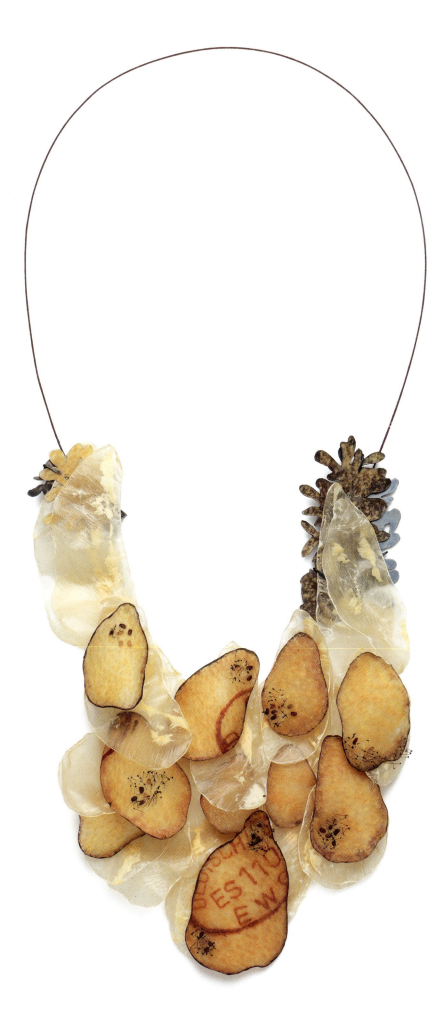

3.27
EUNMI CHUN
Untitled
Necklace
2007
Pig skin, human hair, cow intestine, seeds, silver, wire
8 × 5.3 × 1 inches
Gift to the Museum of Arts and Design

AT HOME WITH SUSAN BEECH

DAMIAN SKINNER

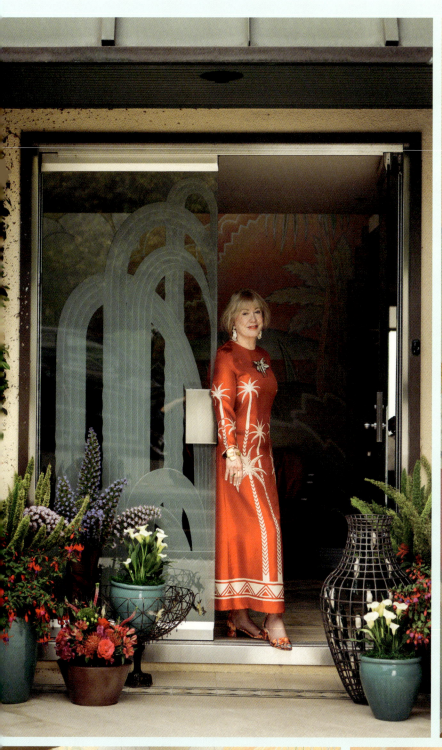
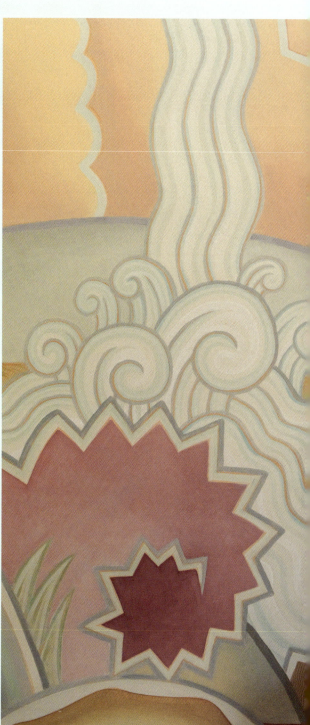
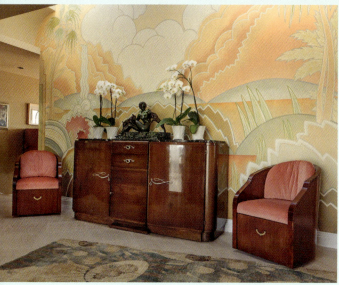
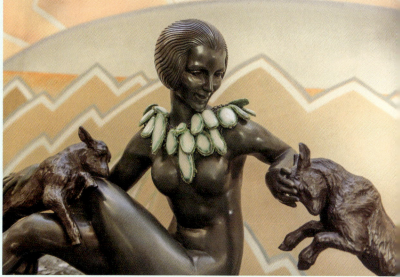

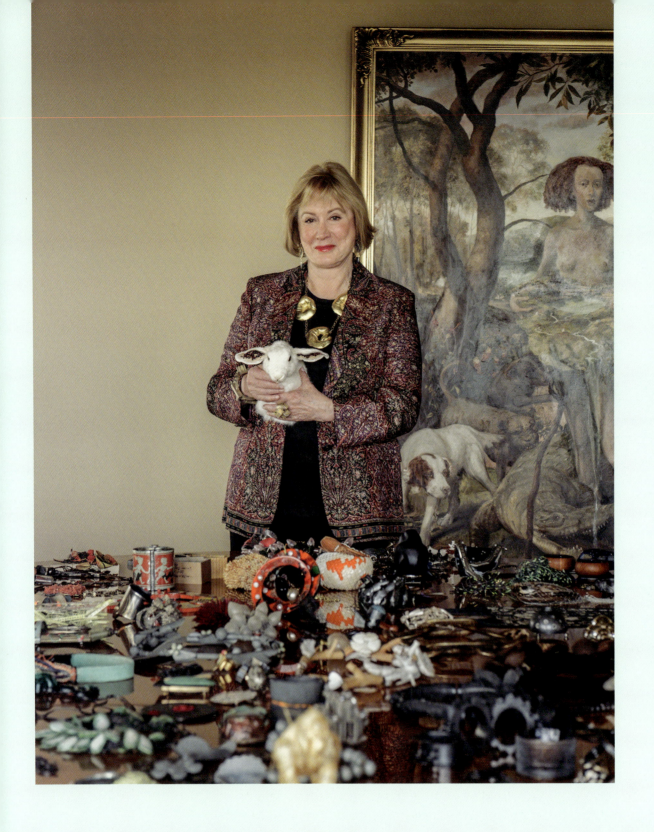

4.1
Susan Beech in the dining room, holding one of the taxidermy rabbits from Idiots's *Dermatologically Tested* series (2003–2009)

Imagine you have been invited to Susan Beech's house to view her collection of contemporary jewelry. While the entire house is in many ways a carefully planned stage for displaying jewelry, she most often presents her guests with a selection of her favorite pieces, laid out on the large dining room table. It is a visual feast, the neckpieces, bracelets, brooches, and rings carefully heaped on the polished wooden surface. Beech presides over it all in her conservative, elegantly tailored clothes, her fingers sporting at least one, usually two, large rings, a watch on one wrist, a bracelet on the other—and maybe a large neckpiece or brooch, depending on what kind of outfit she is wearing.

Take a moment to look at what is laid out in front of you. The jewelry is primarily European, with some American makers, and most of it comes from the past two decades. Beech will tell you, with her light Californian drawl, that she really started collecting seriously first American jewelry in the later 1990s, then European jewelry after she attended the first Collect art fair, in London, in 2004. What might you see? Some jewelers will be represented by a lot of pieces, including Ruudt Peters, Terhi Tolvanen, Daniel Kruger, and Evert Nijland, who are particular favorites that Beech has been collecting for many years. Others, like Sergey Jivetin and Keith Lewis, only have a few works, but Beech has finely honed observations about why they are in her collection.

Even with so much jewelry laid out on display, Beech will be able to describe her attachment to each piece. As you listen to her talk, you'll realize her approach is more intuitive than intellectual. First encounters are best described by the pitter-patter her heart makes, the elevated pulse, and sense of excitement when she sees something new. Much of her investment in the collection is built up through the act of wearing it. Almost all the jewelry on the table has been worn by her, and some of it has been worn by her a great deal. Whatever she knows about the individual jewelers and their artistic intentions will also be informed by the tacit knowledge that comes from being an owner and wearer.

After a while, having touched and viewed all the jewelry that particularly attracts you, your attention might wander to the room in which you stand. The table, chairs, and sideboard all have a vaguely Art Deco style, as does the painted cove ceiling, with its rim of inlaid wood diamonds. The vases displayed on top of the sideboard are definitely Deco. The pendant light, also Deco in style and strangely jewelry-like with its inset stones, reveals itself to be a nest for three or four David Bielander snakes that lie submerged in the glass bowl and poke their heads and tails over the edges. In fact, there is contemporary jewelry in various surprising places, hanging around the neck of the almost life-size sculpture by Cristina Córdova of a woman holding black balloons, or woven through the wire armature of the large vessels by Kim Cridler. Three taxidermy rabbit heads with embroidered ears by Idiots, mounted on one wall, make you realize just how many dead birds and animals appear in the jewelry lying on the table. It's funny, and just a little creepy.

To visitors who have come to see the jewelry, Beech doesn't usually talk about the art and other objects in her home. There is too much jewelry on the table to allow time for anything else.

4.2
Pendant light with David Bielander snakes

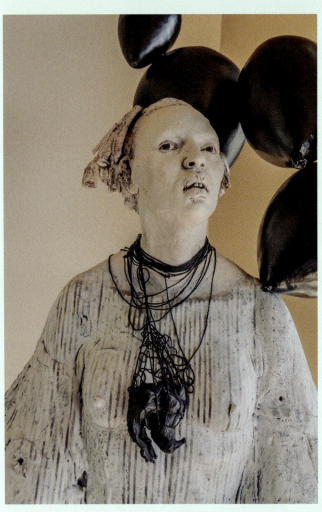

4.3
CRISTINA CÓRDOVA
El Aire Huele a Humo
[The Air Smells Like Smoke]
2008
Ceramic, resin, steel, pigments
67 × 26 × 23 inches
Susan Beech Collection

4.4
IDIOTS
Dermatologically Tested
(detail)
Object
2003–2009
Taxidermy rabbits, thread
9.5 × 8 × 7 inches
Susan Beech Collection

4.5
(Painting in background)
SCOTT GREENE
We Can't Keep Meeting Like This
2000
Oil on canvas
69.25 × 45.25 inches
Susan Beech Collection

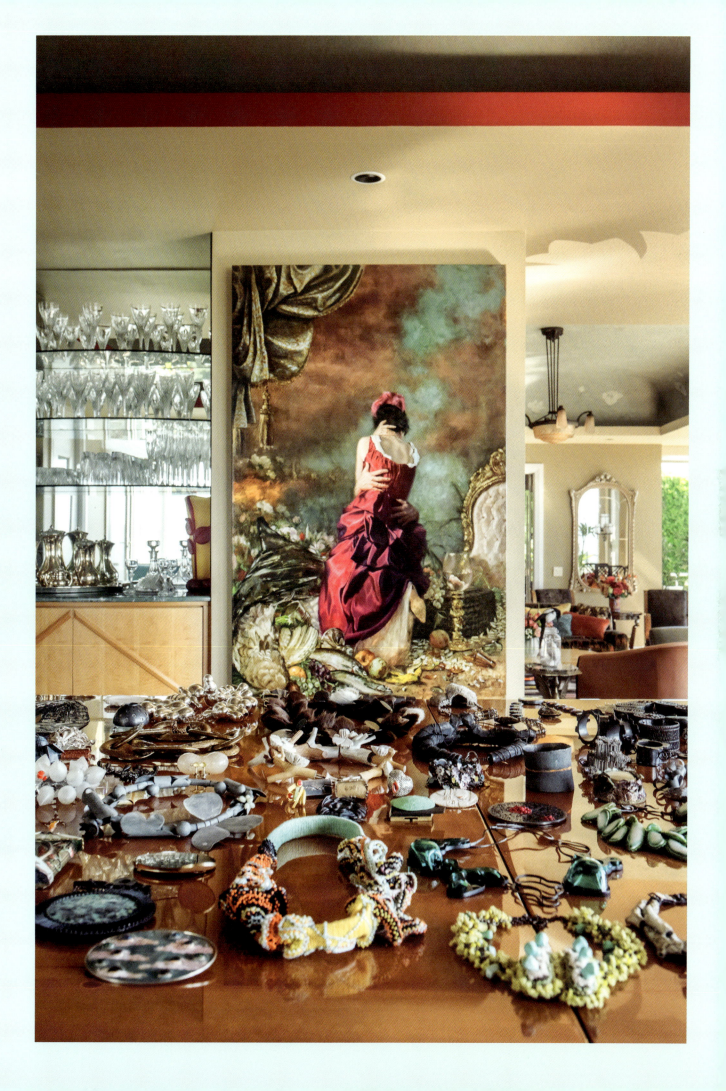

But what isn't spoken about can still have its effect. On one wall of the dining room hangs Scott Greene's painting *We Can't Keep Meeting Like This* (2000). The narrative is uncertain. We see the back of a woman wearing a red dress, perched on a chair, two large male hands holding her around the waist. A smaller, female, hand caresses her neck. The man is invisible apart from his disembodied hands. A pair of false teeth sits in a vase or goblet. Are they his? The woman's dress and the tasseled curtain are luxurious and expensive; we can see the luster of the velvet, the golden threads of the drapes. The chair is elaborately carved and gilded, and the stem of the vase or goblet is richly ornamented. A silver candlestick and goblet lie discarded among the piles of food on the ground. A black sack spills out its contents of birds, fruit, fish, like a cornucopia displaying the kind of expensive foodstuffs lavishly captured in Dutch still-life paintings. But what of the cigarette butts, banana peels, and broken bottles that also litter the ground?

There is a lot of striking art in Beech's house, but the combination of this painting and the jewelry collection displayed on the dining room table is worth paying attention to. This rotting cornucopia, with its unsettling, sexualized narrative, has many parallels with the contemporary jewelry laid out near it. Much of the jewelry deals in a kind of twisted or disturbed nature, a vocabulary of plants and flowers that are subtly warped and transformed. Natural materials such as skin, bone, and wood—and even the literal corpses of dead things—are made precious by the attentions and tricks of the jeweler's trade. But the line between ripe and rotten is frequently put under stress, and some of this jewelry plays with the disruptions created when something abject or disturbing is made into a jewel and placed on the skin or body.

There is also a pulse of eroticism and sexual playfulness in this jewelry collection. Sometimes it is conjured by forms and materials that evoke genitals and erogenous zones, or it appears in the image of the human body aroused or having sex. Contemporary jewelry can seem a bit sanitized by the automatic elevation that comes from its proximity to the world of fine jewelry, with its precious materials and high monetary value. The same thing happens because of the obvious skill and technique that is on display in so much of the jewelry in Beech's collection. Seeing these objects next to Greene's painting is a refreshing reminder of just how strange and curdled a lot of this jewelry is.

It's enough to make you look again and wonder about this elegantly dressed woman at the head of the table, presiding over what is obviously a theatrical display several layers deep. She is an inscrutable presence, someone who dresses in a more traditional manner but clearly has a taste for the unusual, the sexually explicit, the surreal and strange—in both her jewelry and her domestic environment. Who is this woman who welcomes you into her home and seems strangely indifferent to whatever reaction you might have to what you see?

From the dining room windows of Beech's house, there is a spectacular view of the Golden Gate Bridge and the San Francisco Bay, the city laid out behind it. San Francisco is an almost mythological place, a city of misfits, outcasts, creatives, and criminals. This reputation stretches back to the California gold rush of 1848, when the population of what had been a small town exploded, bringing untold wealth and prosperity for some and false hopes and dashed dreams for most. Even now it is a somewhat uncanny city, renowned for its spectacular fogs, built over a topography of hills connected by two iconic bridges, with streets that drop vertiginously and tangled narrow alleys. In summer, Beech is in a prime spot to watch the majestic fog that flows over the mountains along the coast and through the Art Deco towers and graceful suspension cables of the Golden Gate Bridge, like a turbulent river in flood that has been filmed in slow motion.

The cinematic view of this city and its mysterious fogs is the perfect setting for Beech, who loves film noir more than any other kind of cinema. In San Francisco, the location of many of the best-known film noirs, such as the *The Maltese Falcon* (1941), you can never tell who or what might be lurking just over the crest of the next hill or around the corner of a menacing dark alley lit by a spectral streetlight. Film noir is the name given to a group of American movies made in the 1940s and 1950s which owe a debt to hard-boiled detective fiction for their characters and stories, and German Expressionist cinema for their distinctive aesthetic of dramatic lighting and distorted camera angles. Characters in these films are often trying to escape a burden or trauma from their past. No one emerges unscathed.

Beech's favorite film noir is *Double Indemnity*, which was released in 1944. When asked why, she jokingly replies, "They're all bad. They all die. That's my favorite theme. But the dialogue, oh, my God, it has the best dialogue." In case you've never had the pleasure of watching it, *Double Indemnity* is the story of murder as a crime of passion and money, told as a series of flashbacks and narrated by the lead character, insurance salesman Walter Neff, played by Fred MacMurray. "There was no way I could have known that murder sometimes can smell like honeysuckle," he begins, weaving a tale of greed and duplicity and careful planning undone by chance. His partner in the perfect crime gone wrong is bored, beautiful, and bad housewife Phyllis Dietrichson, played by Barbara Stanwyck, who wants to take out an accidental death insurance policy for her husband without him knowing about it. "Yes, I killed him," says Neff. "I killed him for money and for a woman. I didn't get the money and I didn't get the woman. Pretty, isn't it?"

The film has everything: flawed and venal characters who are duplicitous and, in one case, definitely evil, a crackling script filled with double entendres and eminently quotable dialogue ("I loved her like a rabbit loves a rattlesnake"), a menacing musical score, and dramatic camera work and iconic lighting. Even Stanwyck's ridiculously fake-looking blonde wig, chosen by director Billy Wilder to emphasize her character's instinct for deception, is bad.

4.6
Susan Beech watching film noir in the TV room

She wears an enormous ring on her wedding finger, so large it leaves doubts in the viewer's mind about how real it might be. Another piece of jewelry, a gold anklet by Joseff of Hollywood, inscribed with Phyllis's name, helps weave a spell of passion that convinces Neff to go along with her diabolical plan to murder her boorish husband and get away with it by using his insider knowledge as an insurance salesman. Large geometric brooches accessorize two of the outfits that Phyllis wears in key scenes of seduction. There is a lot here for a collector of jewelry to admire.

Indeed, movies help explain something of the way Beech dresses and the domestic environment she has created for herself and her collection. Perhaps not film noir, which is a bit too over-the-top, but Hollywood in general is the source of an essentially old-fashioned notion of glamour that inspires how she dresses and how she lives. As a kid living in a California ranch house in Van Nuys, part of Greater Los Angeles, she and her younger brother would watch television in the den. After school or on the weekends, local channels were always guaranteed to be showing old movies from the 1930s and 1940s. Her favorite actor was Errol Flynn, known for his swashbuckling roles in *Captain Blood* (1935) and *The Adventures of Robin Hood* (1938). (Because Beech loved Errol Flynn movies so much, when she heard he'd written an autobiography called *My Wicked, Wicked Ways* [1959], she walked down to the local bookstore and bought a copy. Her mother saw it in her room and confiscated it as totally unsuitable reading for a young girl. Not to be deterred, Beech walked down to the bookstore the next week and bought another copy, this time carefully hiding it from adult eyes.) Anything with action was preferred, but they also saw plenty of dramas with characters who inhabited stunning Art Deco houses, the women with beautiful suits, a big brooch pinned to the lapel, a stylish hat and gloves, their heels and their handbags matching. It is an ideal that Beech adopted when it came time for her to create her own adult look—elegance and style, a commitment to glamour.

Then again, perhaps we can trace a small part of Beech's persona—the one created by how she dresses and the way she

decorates her home—to the film noir genre with its emphasis on disguise. Clothes are essential in creating identities and shaping how others see you. Phyllis Dietrichson, in *Double Indemnity*, always knows the perfect ensemble to get what she wants, from the glamorous gowns and jumpsuits she wears at home to the short-sleeved, fringed black dress she wears when tricking her husband into buying accident insurance, to the pale cardigan, black trousers, and belted camel hair coat she wears when visiting Neff's apartment to convince him of her sincerity. It hints at innocence, but the sweater, worn backward, reveals her bra, ensuring that Neff won't forget the sexual desire at the heart of their liaison. Clothes declare her to be shrewd and dangerous, capable of outwitting and sexually manipulating or even killing the men she encounters.

 Beech's essentially tasteful and traditional clothing is a kind of misdirection, a camouflage for the kinds of art and objects she chooses to live with at home. The jewelry she wears is often quite outrageous in some way, which sets up a delicious contradiction between the evidence provided by her clothes and the evidence provided by the jewelry. It is a strategic and conscious decision. Ever since she was a teenager, she has dressed a certain way, what she describes as "under the radar," realizing what could be gained by not drawing too much attention with outrageous choices in clothes or hair or makeup. As a teenager, dressing traditionally allowed her activities to escape detection simply because she looked just like everyone else. Wild thoughts and wild behavior could be camouflaged successfully by this simple disguise. Maybe it is a strategy she still uses as an adult. Like a film noir femme fatale, Beech uses costume and her contemporary jewelry collection to shape and play with perceptions.

4.7
ROBERT BAINES
Bloodier than Black #1
Brooch
2004
Silver, powder coat, paint
8.5 × 4.5 × 1.5 inches
Gift to the Museum of Arts and Design

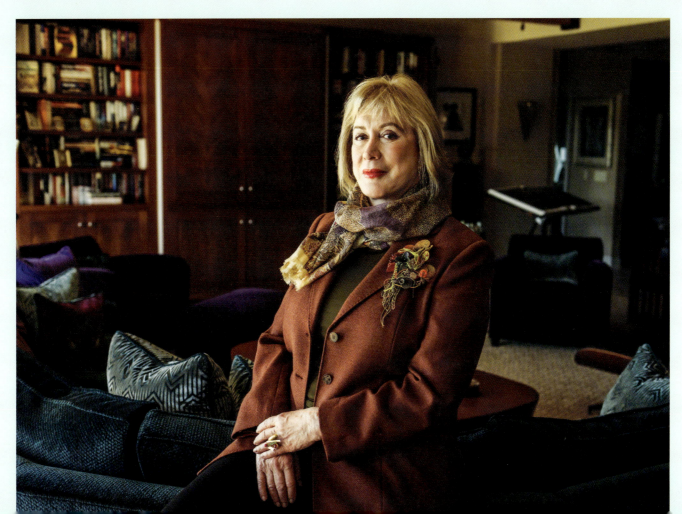

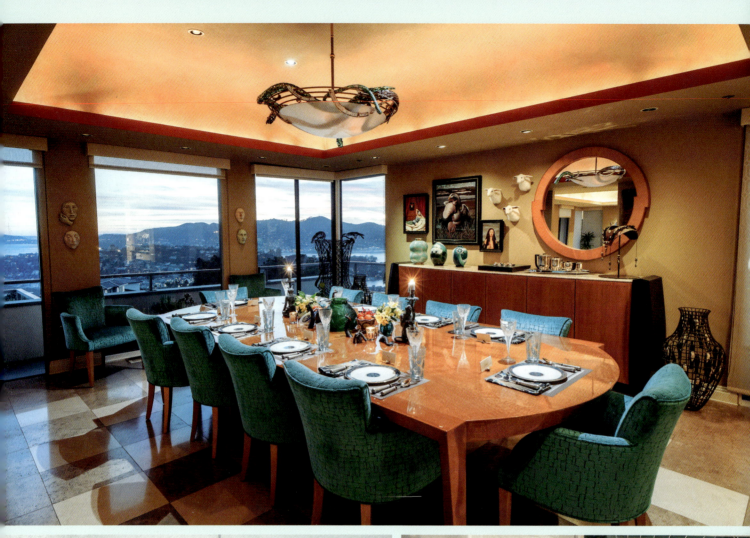

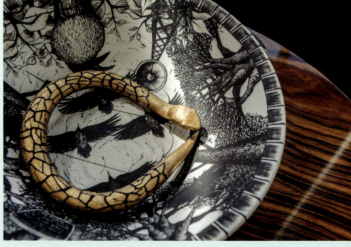

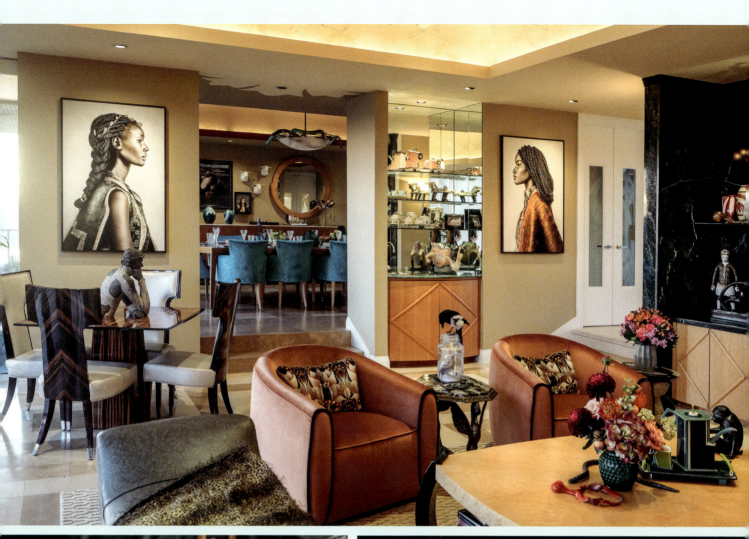
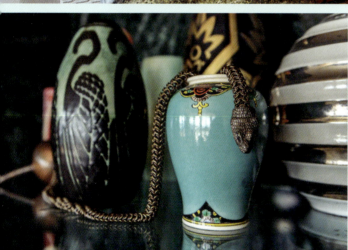
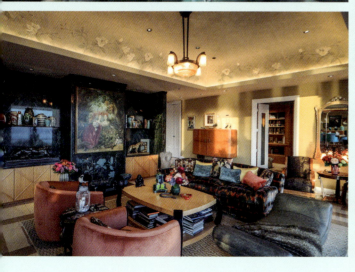
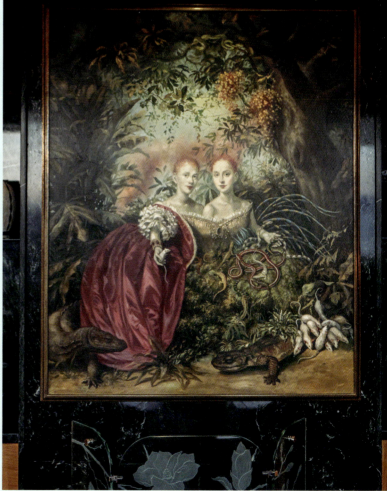

Beech and her second husband, Bill, purchased their house, in Tiburon, in 1990. She was in her 40s, her children had left home, she had traveled the world, staying in great hotels and visiting lots of museums, and she had a very strong idea of her ideal aesthetic. The house was notable for its great view and good location (a quiet cul-de-sac with lots of parking), but not much else. It was a reasonably plain, contemporary structure. The decision was made to gut the house and reimagine the building within the existing footprint. The only thing she added was the conservatory, bringing light and views of Mount Tamalpais, to the west. Beech found a contractor she liked, and she commissioned interior designer Sharon Campbell to work on the layout and finishes.

Beech's brief was both specific and open-ended. The house needed to embody a version of the glamour she remembered from the old movies she had watched as a kid. Those beautifully dressed women inhabited theatrical versions of Art Deco, brought to life by studio art directors such as Cedric Gibbons, at MGM, who created film sets that became a kind of radical testing ground for modern interior design concepts. Movies in the late 1920s and early 1930s adopted the ideas of Le Corbusier and the Bauhaus, Frank Lloyd Wright, and the 1925 Exposition Internationale des Arts Décoratifs et Industriels Modernes, in Paris, which eventually gave Art Deco its name. They promoted interior decor that transformed not just movie sets but the tastes and homes of many Americans. In the film *The Easiest Way* (1931), working woman Laura's wealthy lover's penthouse is an Art Deco dream. Of the apartment, Laura says, "Oh, every time I come here, I feel like someone else, like a girl in a storybook or a play. It's a wonderful feeling." This is a sentiment that Beech shared. When it came time to create her own stage set for living and collecting, the pleasures and glamour of Art Deco were exactly what she wanted.

Beech knew Art Deco firsthand from her many overseas trips. She had even begun to collect some Deco furniture, sculpture, and vases, and her plan was to rapidly acquire more. At a time when most people remodeling their houses were getting rid of built-in bars as an undesirable throwback to the party decades of the 1970s and 1980s, Beech explicitly requested a spectacular bar as a focus for parties that would fill the downstairs and spill outside, the northern California night ringing with laughter and the clinking of cocktail glasses.

There were frequent conversations, lots of looking through the collection of Art Deco books that Beech already owned, and a steady stream of drawings and cabinetry models prepared by Campbell and her contractors and presented to Beech for approval. The end result has many of the elements that make Deco interiors so distinctive. There is the plentiful use of glass, in the form of carved frosted door panels and the mirrored backsplash in the downstairs bar. The designs of gracefully arcing jets of water, etched onto glass and painted to look like marquetry on the vanity doors in the powder room, are a classic Art Deco motif. There is the richly detailed cabinetry and furniture—the anigre timber paneling with ebony inlay in the library, and the book-matched crotch mahogany with its delicate feather-like grain inset with aluminum rods in the bar—and the eclectic borrowing of historical architectural styles, such as faceted pilasters and palm column capitals. The spectacular water feature

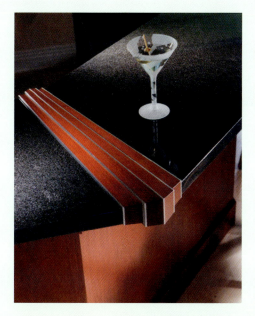
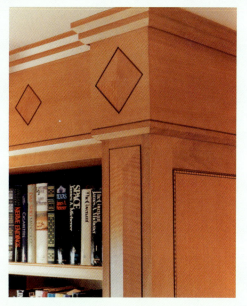
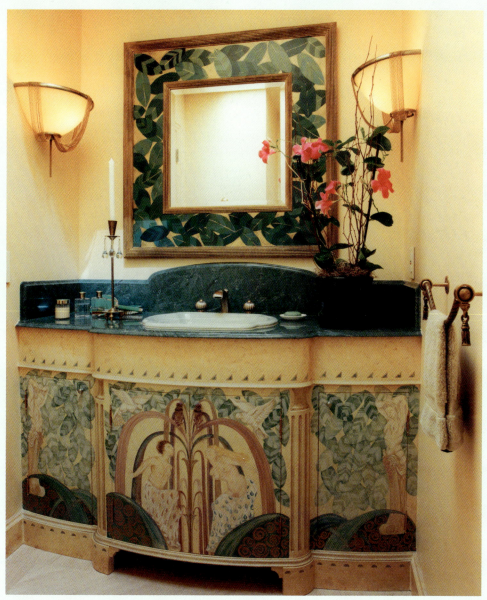

seen through the window by the bar is made of glass bricks lit from behind and surrounded by the lush growth of striking plants such as papyrus, ferns, and grasses. There are murals, highly patterned fabrics, every surface offering some kind of design, texture, patina, or color to create a riot of visual delight that is both opulent and elegant.

4.8, 4.9, 4.10
Art Deco details from Susan Beech's house, photographed in 1991 when the renovations were completed

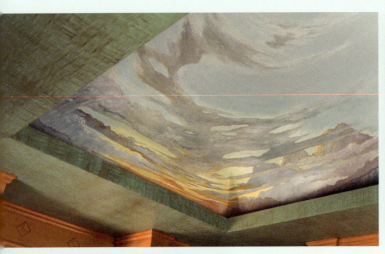
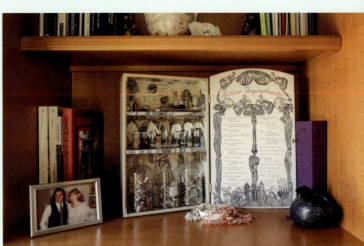
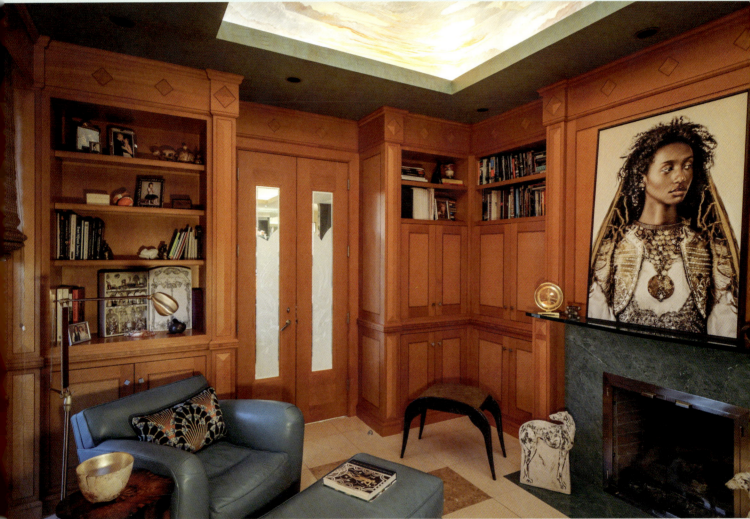
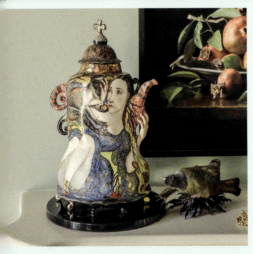
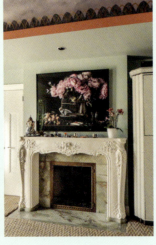
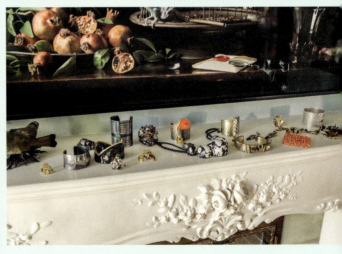

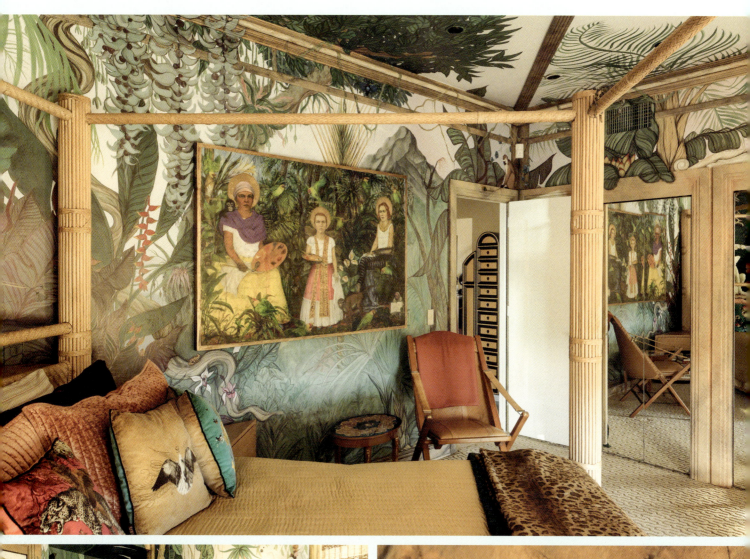
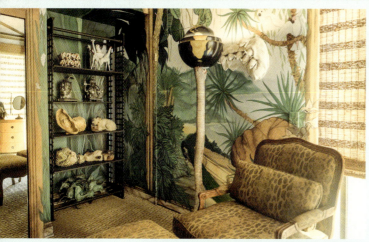
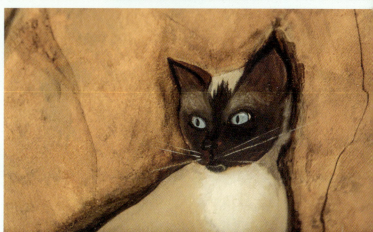
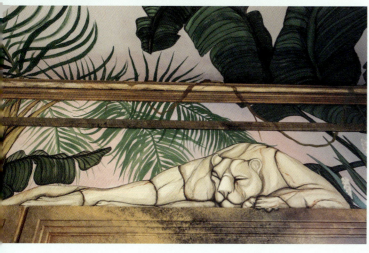
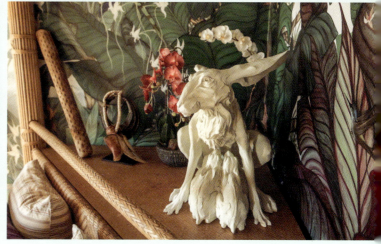

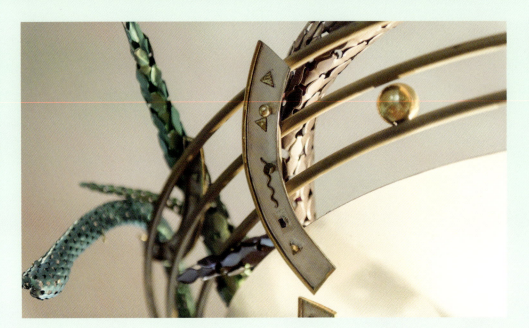

4.11
Close-up of pendant light in dining room

Even while the house was being built, Beech was focused on finding objects that would help her realize the perfect environment. She and her husband already had some furniture and a few sculptures, and they would attend the annual Art Deco fair held at the Concourse in the San Francisco Design Center. One of the vendors, Reiner, a real character, told Beech that he could help them acquire great quality Art Deco objects if she and Bill would take a trip with him to Belgium, his home country. Always up for an adventure, they got on a plane to Brussels, having booked a week to travel, not really knowing where they would stay or who they would visit. High above the Atlantic, they speculated, half joking, about whether the dealer would even meet them when they got off the plane. He did, and he was well-organized. Bill ate some bad seafood the first night and became very ill, too unwell to do any of the activities that Reiner had planned. So it was Beech on her own, packed with Reiner into a small car, his cigarette smoke fogging up the interior (windows closed to keep out the winter chill), the two of them driving to small towns all over Belgium, picking out bronze sculptures, chairs and tables, vases, and other objects.

In the early 1990s Art Deco was cheaper in Belgium than in neighboring France. Sometimes they would stop at galleries and shops, sometimes what seemed to be private homes. Reiner would tag the chosen items and Beech would pay, still half wondering if they would turn up in San Francisco. At the end of the week there was enough to fill a container. Bill recovered, and he and Beech left to travel around Europe. A few months later all her purchases arrived, ready to provide some authenticity and period detail to the interiors that were slowly taking shape in Tiburon. It was, Beech later thought, one of the stranger episodes of her life, but it worked out just fine.

Beech's interior captures the spirit of her memories of those 1930s movies, seen in black-and-white in the den of her childhood home, in California. The film sets were a version of the Streamline Moderne form of Art Deco that Americans favored during this period. More restrained, more serious, it felt like the right aesthetic for a society experiencing economic turmoil and social hardship in the wake of the Great Depression alongside rapid technological advances in the Machine Age.

4.12
JUDITH KAUFMAN
Brooch
1989
22-karat gold, 18-karat gold, green gold, garnet, sapphire
3 × 2.25 × 0.625 inches
Susan Beech Collection

But what she ended up creating with the assistance of her interior designer and team of highly skilled artisans was something much more akin to the early years of Art Deco in France, which promoted furniture, objects, and interiors made of expensive materials and with high-quality craftsmanship. Exacting techniques were applied to the most exotic materials to create refined items of furniture featuring curves, contrasting timbers, carved details, lacquered surfaces, and exotic materials such as shagreen, tortoiseshell, mother-of-pearl, and ivory, as well as glass, copper, and aluminum. There was little or no symbolism, and no imperfections of surface. Deco interiors that borrowed from ballet and performance delighted in the theatrical. Rooms became like stage sets: a multitude of patterns covering surfaces, billowing drapery, walls with arches and built-in paintings. No wonder Beech turned to Art Deco to inspire the stage that she made for herself in 1991.

===

At the time Beech finished her house, she wasn't a serious jewelry collector. What pieces Beech did own—jewelry from her mother, costume and fine jewelry she had purchased for herself or been given as gifts, and a small but growing collection of American contemporary jewelry—were kept in drawers in the bathroom and in her bedroom, where she could find them easily and decide what to wear. But contemporary jewelry did—and still does—make its presence felt in the dining room pendant light, which was custom-made for the house. Using emeralds, sapphires, and garnets set in precious metals, the design is based on a brooch by American jeweler Judith Kaufman that Beech had purchased from the Susan Cummins Gallery in 1989. The piece is not Art Deco, but its curves, scrolls, and zigzags and the quasi-industrial feel of the metal set with rectangular and round stones certainly feels in sympathy with the overarching style of the interior. What it becomes in the light shade is swooshes of sparkling metal and stones that adorn the wire rings and sweep down across the shallow concave bowl of frosted glass.

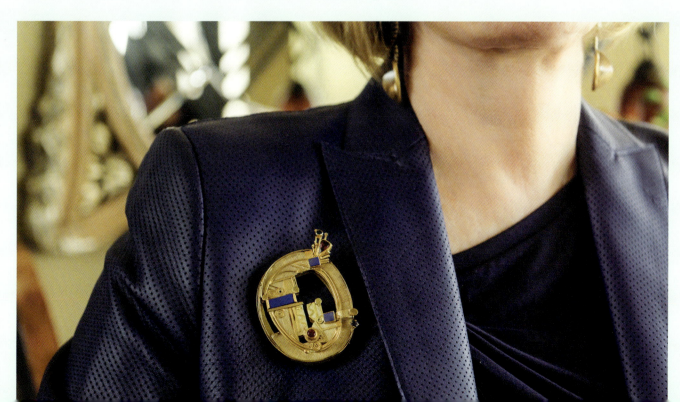

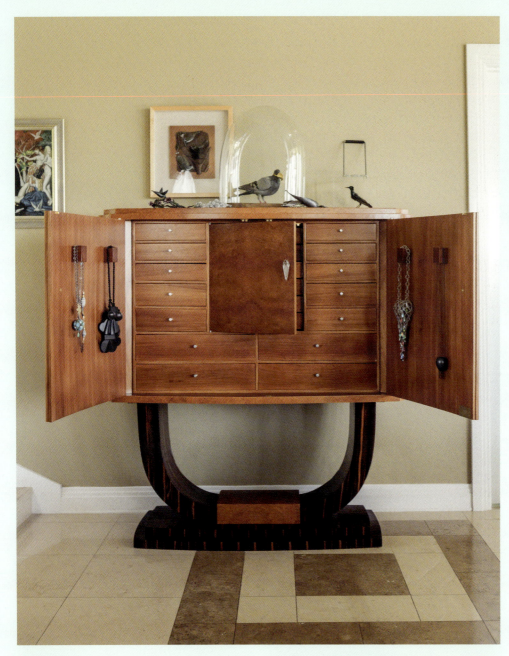

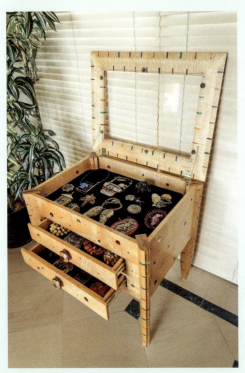

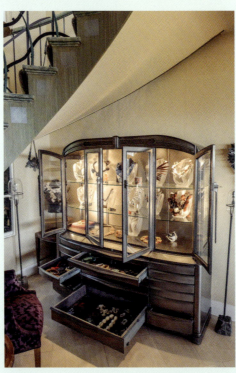

4.13
KENT TOWNSEND
Jewelry Cabinet
2008
Amboyna wood, ebony,
narra wood, maple
61 × 60 × 24.5 inches
Susan Beech Collection

4.14
DANIEL PETERS
Jewelry Cabinet
1999
Curly maple, Lucite
31 × 32.5 × 24.25 inches
Susan Beech Collection

4.15
JONATHAN MAXWELL
Jewelry Cabinet
2009
Steel, glass
74 × 70.5 × 21.5 inches
Susan Beech Collection

One of the best ways to track the scope of Beech's activities as a collector is through the dedicated jewelry cabinets that she commissioned to store and display her collection. These are evidence that by the end of the 1990s Beech had become a serious collector, and her jewelry collection started taking on a more prominent role in her home, far beyond what was imagined when the Kaufman brooch inspired the pendant light in the dining room.

The first and smallest cabinet, acquired in 1999, is by Daniel Peters, made from curly maple with colored Lucite forms set into the richly grained timber. The rounded edges and geometric patterns are probably more postmodern in style, but with strong affinities to Art Deco. The second, a commission made by Kent Townsend in 2008, is a large cabinet with elegantly curved edges that stands dramatically poised on an inverted U-shaped base. As if flagrantly declaring its aesthetic allegiance to Style Moderne, the cabinet doors are made from amboyna and the base is ebony, both timbers prized by Art Deco furniture makers. Inside, the cabinet features twenty drawers that showcase the beautiful grains and colors of narra and maple woods. The third jewelry cabinet, by Jonathan Maxwell, was commissioned in 2009. Made of steel and glass, it is entirely Art Deco in style, perfectly at home under the stairs, where it holds court with the elegant bar on the other side of the stairs, and the glass-bricked waterfall outside.

It wasn't just contemporary jewelry that Beech was buying in the years after her home was completed in 1991. Having even more of an effect on her domestic environment were the paintings, photography, and craft that she slowly introduced, layering them into the Art Deco stage—and in the process changing and transforming it. Rooms became an extraordinary mix of Deco-inspired cabinetry, painted ceilings and etched glass panels, vintage furniture and objects from the 1920s and 1930s, all sitting alongside contemporary art and craft. This is the environment which Beech's contemporary jewelry both inhabits and helps to create.

Let me create three comparisons between the contemporary jewelry and the fine art to illustrate the kinds of themes and visual relationships found in the interior that Beech has created over the past three decades. From the jewelry collection, take Jennifer Trask's *Germinate* neckpiece (2010), with its elaborate parade of flora and fauna ranging from the sweet (flowers, lace-like frills) to the sinister (the delicate cavities of a bird skull), each element delicately carved from bone, a material choice that corrupts any celebratory or life-affirming meanings suggested by the title. From the dining room, consider Julie Heffernan's painting *Self-Portrait as Infanta Holding a Landscape* (1999), with its inscrutable central figure, naked and looking directly at the viewer, one landscape held in her hands like an offering while she stands in a second landscape filled with a menagerie of ferocious animals and lush plants that sprout exotic flowers and strange fungi.

Lola Brooks's *quiescentheart* neckpiece (2015) consists of stainless-steel chains that have been stiffened with 18-karat gold solder to create a heart-shaped open cage pendant. Dozens of oval pendants that display iridescent butterfly wings are suspended inside the heart, cascading in a shimmering, shifting tangle through the base of the pendant. The effect is somehow dreamy and languid,

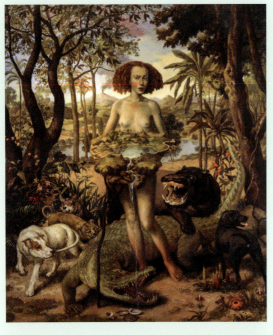

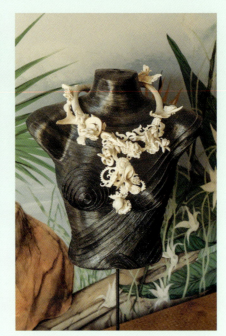

4.16
JULIE HEFFERNAN
Self-Portrait as Infanta Holding a Landscape
1999
Oil on canvas
66 × 58 inches
Susan Beech Collection

4.17
JENNIFER TRASK
Germinate
Necklace
2010
Steel, brass, diamonds, mule deer antler, cow and ox bone, antler, nutria teeth, pigeon skull
22 inches long, 14 inches across collar
Susan Beech Collection

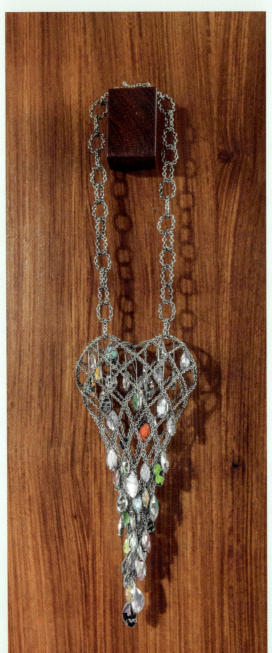

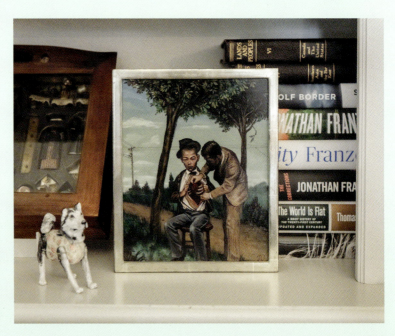

4.18
LOLA BROOKS
quiescentheart
Necklace
2015
Stainless steel, quartz, butterfly wings, 18-karat gold solder
19.25 × 2 × 4.25 inches
Susan Beech Collection

4.19
(Painting at center)
TIMOTHY CUMMINGS
Goodbye Sadness
1998
Acrylic on wood
10.25 × 8.875 inches
Susan Beech Collection

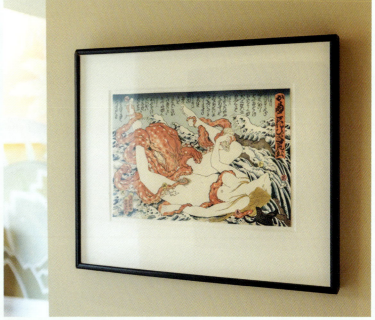

not the gush of arterial blood but a more poetic and perhaps sentimental release. Compare the neckpiece to *Goodbye Sadness*, a painting by Timothy Cummings from 1998. Two boys or young men, both wearing suits that seem to come from an earlier era, perhaps the 1930s or 1940s, are enacting a mysterious and gruesome ritual in which the seated boy holds open his shirt while the other, standing, figure spreads skin and muscle with his left hand and grasps the top of the red, beating heart with two fingers of his right hand. It is a peculiarly delicate gesture, as are the tears that run down the seated boy's cheeks.

Finally, consider Tanel Veenre's *The Garden III* neckpiece (2018), made from reconstructed coral that is vividly red and perfectly smooth and shiny. The plump form that is suspended at the front of the necklace, bisected by a thin vertical strip that protrudes slightly above the surface, is an elegantly abstracted vulva, a sleek representation of female sex organs. Imagine *The Garden III* on display next to Masami Teraoka's woodblock print *Sarah and Octopus/ Seventh Heaven* (2001), in which a woman lies on a rocky shoreline, black diving goggles discarded by her head and what could be a used or unwrapped condom in her right hand. She is being pleasured by an octopus, whose tentacles wind around her body and whose head rises between her legs. The print is an artistic homage to the famous shunga by Hokusai called *The Dream of the Fisherman's Wife*, first published in 1814.

The scale of Beech's collecting activities and the many levels of thematic and visual relationships means that the interior of her home is filled with this kind of interaction between art, craft, and jewelry. And these connections are staged against the background of the house, itself an opulent and theatrical homage to Art Deco. The guiding philosophy of Art Deco interiors was to stimulate the eye through combinations of pattern, texture, color, and objects. This is exactly what Beech's house provides. There is glamour here, but also carefully considered visual and intellectual delights that have been constructed through decades of collecting.

But what truly makes Beech's interiors special and carries them far beyond the Art Deco interiors of the early twentieth century that

104
105

4.20
TANEL VEENRE
The Garden III
Necklace
2018
Stabilized wood, reconstructed coral, silver
4.75 × 2.75 × 1.75 inches
Susan Beech Collection

4.21
MASAMI TERAOKA
Sarah and Octopus/ Seventh Heaven
2001
29-color woodblock print on Hosho paper, edition 24/200
19 × 23 inches
Susan Beech Collection

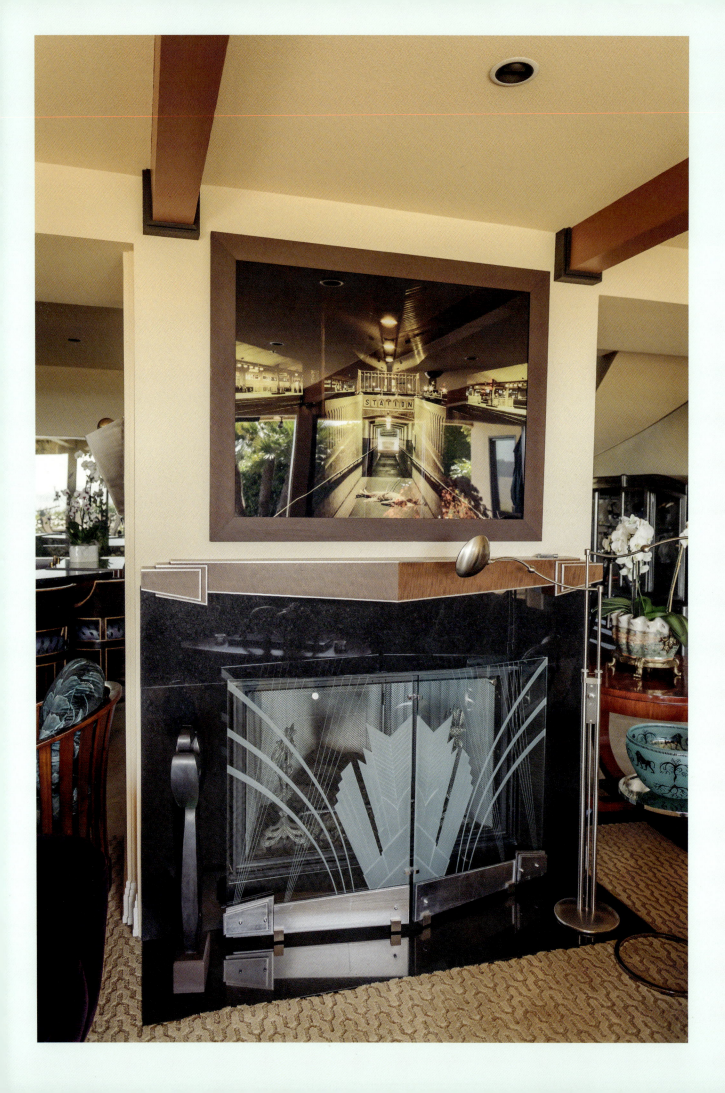

inspired her is the disruptive and transformative power of the themes introduced by fine art, craft, and jewelry. What Art Deco tames and orders with harmony and balance—fountains gush in symmetrical streams, animals and plants arrange themselves in rhythmic friezes—the contemporary art and craft displayed next to it unleashes and distorts. Nature is red in tooth and claw, and beauty is entwined with darker forces of death and decay. Whereas Art Deco is primarily an appeal to the pleasures of pattern, texture, and color, the art and craft collected by Beech introduces stories of people and places in which the mysteries of psychology and desire play themselves out. Art history tells us that the fascination with the naked female figure in Art Deco was a continuation from the earlier Art Nouveau movement, but the dangerous, overt sexuality of the earlier style was left behind in the later one. The Art Deco nude became subdued, sensuous, and playful. Beech's choices of art and craft undo this tame and safe approach and liberate what lies beneath the benign naked bodies of Art Deco. In Beech's house there are glimpses of erotic pleasure, and more complicated narratives of unease that curdle and make strange both human desire and the landscapes in which these encounters occur.

In the downstairs family room, Beech has Melanie Pullen's *Station (Metro Series)* (2005) hanging above the Art Deco fireplace. It is a lovely juxtaposition, as the softly Deco architectural details of the dramatically lit train station in Pullen's photograph play off the sharp angles and carved glass decoration below. Not immediately, perhaps, but soon after taking in the yellow lighting and dark shadows of the station's architecture, you see the fallen woman on the ramp leading underground, fingers of blood following the pull of gravity, one high-heeled shoe knocked off her foot. This is a crime scene. It is part of a series by Pullen based on vintage crime scene photos that she found in the files of the Los Angeles Police Department and the Los Angeles County Coroner's Office. Beech chose this particular image because it reminded her of a noir movie from 1950 called *Union Station*, in which the final confrontation between the hero and the villain takes place in a subway tunnel just like this one. We are the only witness to the crime that Pullen stages in this photograph, stumbling unexpectedly upon the woman in her diaphanous, sleeveless dress, blond hair pooling in a gruesome double to the darkening pond of blood that flows from her unseen wound.

———

This might be the perfect place to end a tour of Beech's house, looking at a contemporary artwork that riffs on Art Deco and film noir and finds a dubious beauty in violent death, hanging above a beautifully crafted fireplace that is an homage to Art Deco style and materials. In Beech's interior, animals and people misbehave, nature revolts, patterns explode. The result is unsettling, mysterious, and luxurious—a perfect home for the feast that Beech's contemporary jewelry collection offers to all those who are invited to her dining room table. ∎

4.22
MELANIE PULLEN
Station (Metro Series)
2005
C-print
42.5 × 54.5 inches
Susan Beech Collection

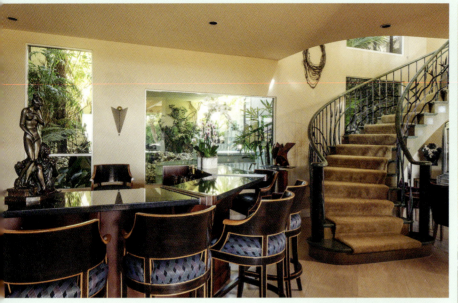
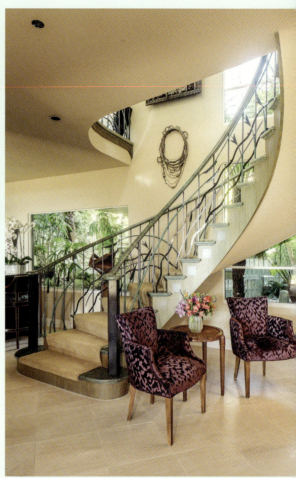
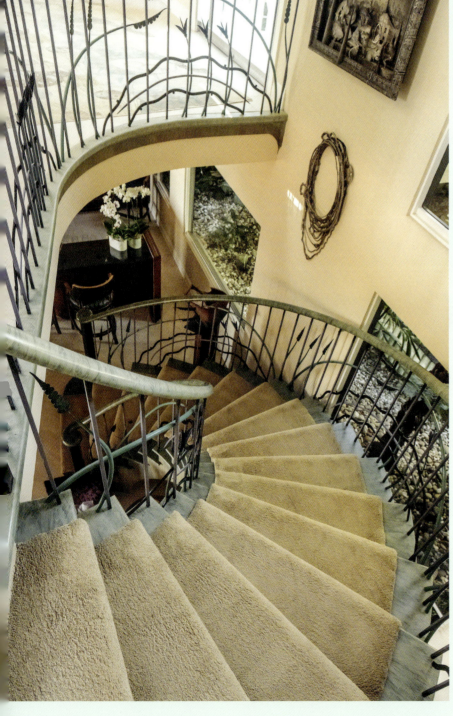
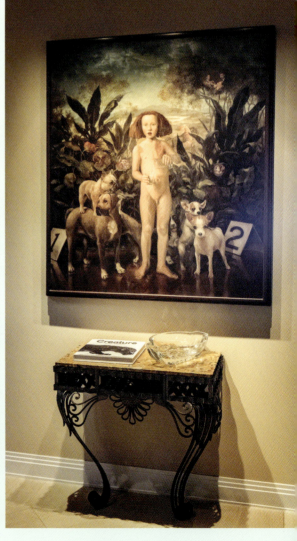

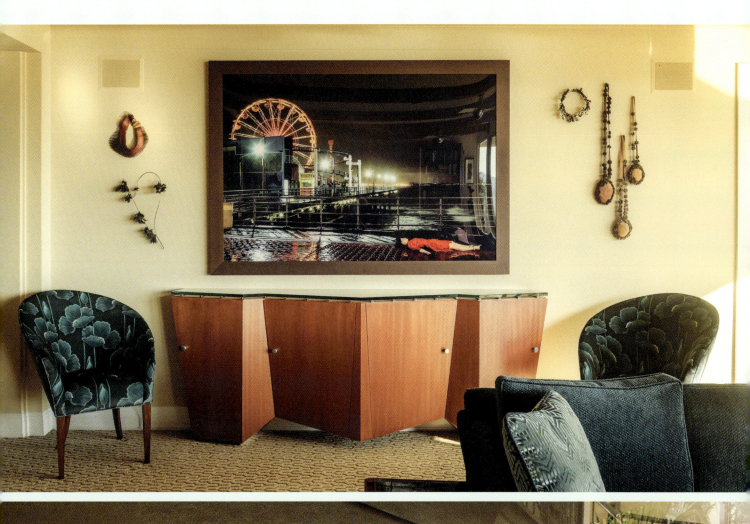
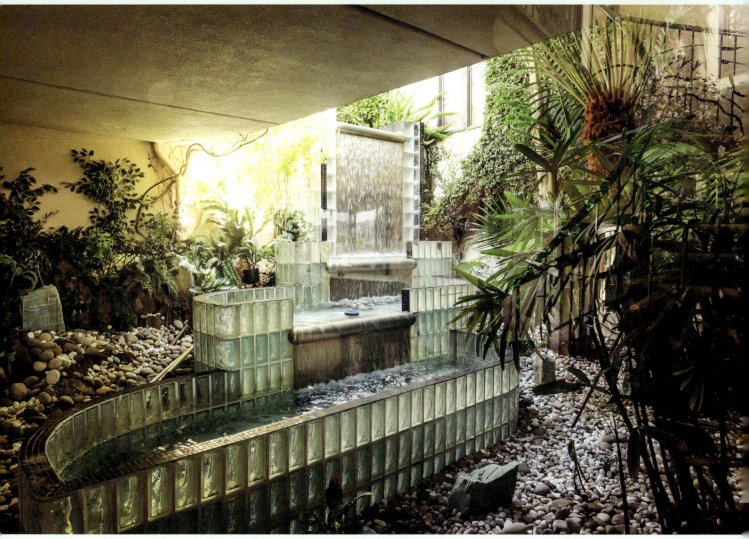

CONTEMPORARY JEWELRY FROM THE SUSAN BEECH COLLECTION

This selection of contemporary jewelry from the Susan Beech Collection focuses on her substantial donations to the Renwick Gallery, Smithsonian American Art Museum, in Washington, DC, and the Museum of Arts and Design, in New York City, and includes some key works that Susan Beech is retaining so she can continue to wear them. The jewelry has been arranged by maker, in alphabetical order.

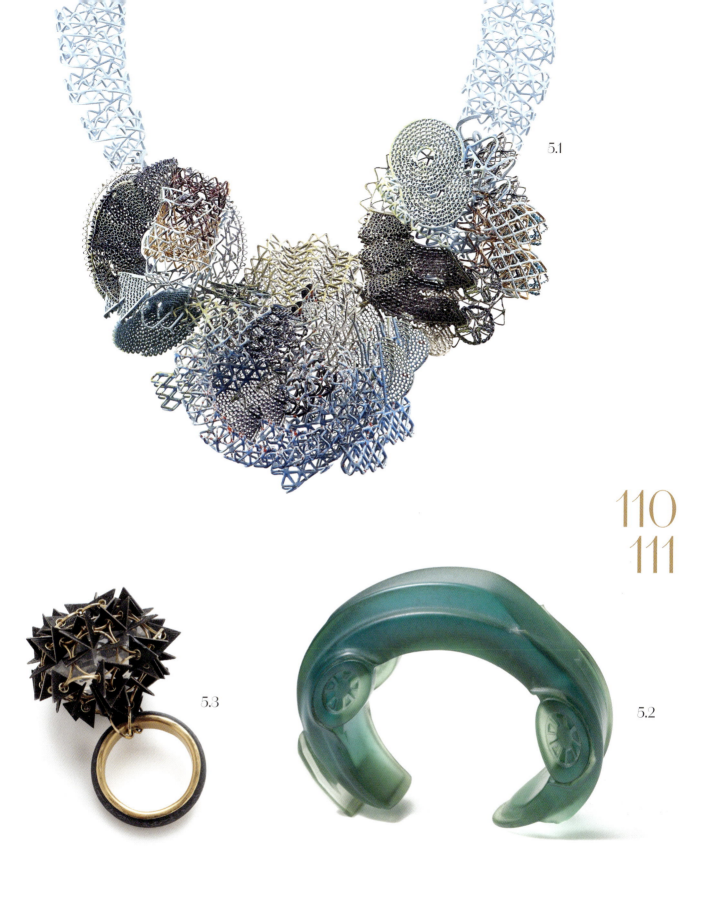

110
111

5.1
ROBERT BAINES
Hey True Blue
Necklace
2014
Silver, powder coat, paint
10.75 × 7.25 × 2.125 inches
Susan Beech Collection

5.2
GIJS BAKKER
Porsche
Bracelet
2002
Polyurethane
1.37 × 3.74 × 2.95 inches
Gift to the Museum of Arts and Design

5.3
RALPH BAKKER
Solitaire Dark-Sharp
Ring
2012
Gold, silver, niello, quartz
1.75 × 1.125 inches
Gift to the Museum of Arts and Design

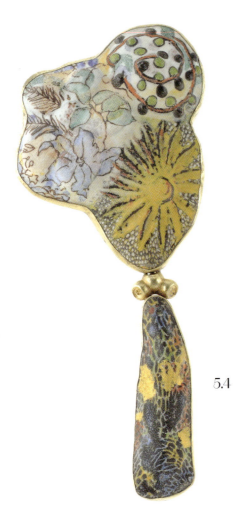

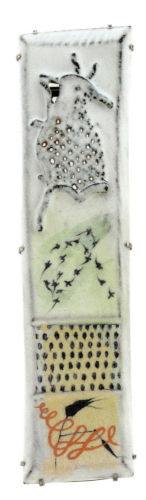

5.4
JAMIE BENNETT
Florilegium #3
Brooch
2003
Enamel, 18-karat gold, copper
5×2 inches
Gift to the Renwick Gallery, Smithsonian American Art Museum

5.5
JAMIE BENNETT
Posteriori #14
Brooch
2008
Enamel, 18-karat gold, copper
5.75×1.5 inches
Gift to the Renwick Gallery, Smithsonian American Art Museum

5.6
DORIS BETZ
Untitled
Brooch
2004
Silver, marcasite, chromium glass
2×1.75×1 inches
Gift to the Museum of Arts and Design

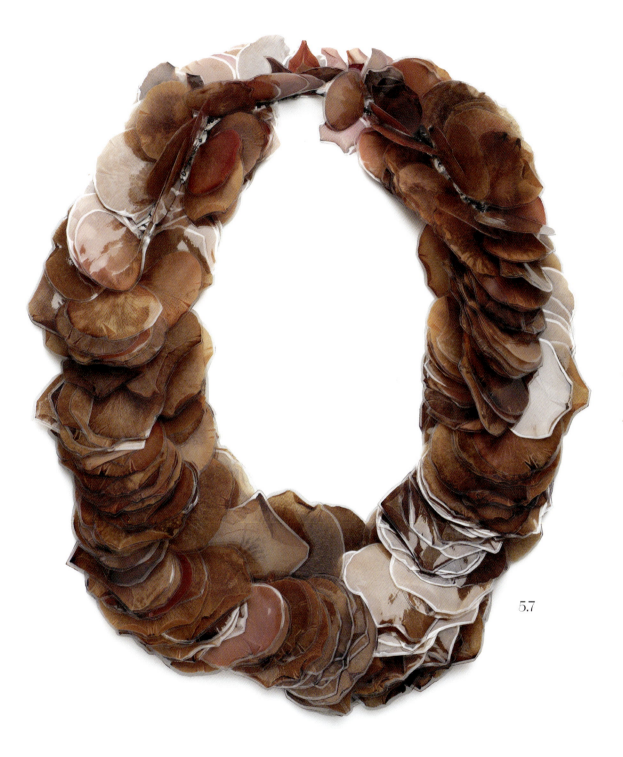

5.7
RENEE BEVAN
Rose Petal Lei
Necklace
2009
Laminated rose petals, oxidized silver, cord
31.5 inches long
Gift to the Museum of Arts and Design

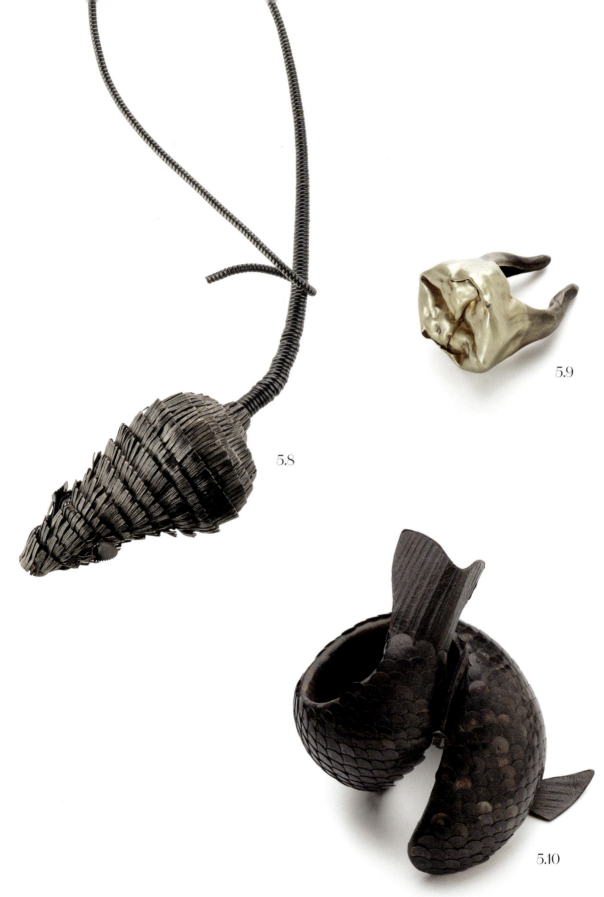

5.8
DAVID BIELANDER
Rat
Necklace
2010
Sterling silver
4.5 × 2.25 × 1.875 inches
Gift to the Museum
of Arts and Design

5.9
DAVID BIELANDER
Gold Grinder
Ring
2010
Gold
1 × 1.25 × 1.75 inches
Gift to the Museum
of Arts and Design

5.10
DAVID BIELANDER
Bronze Koi
Bracelet
2013
Leather, thumb tacks
(brass-plated steel), silver
5 × 4 × 3.75 inches
Gift to the Museum
of Arts and Design

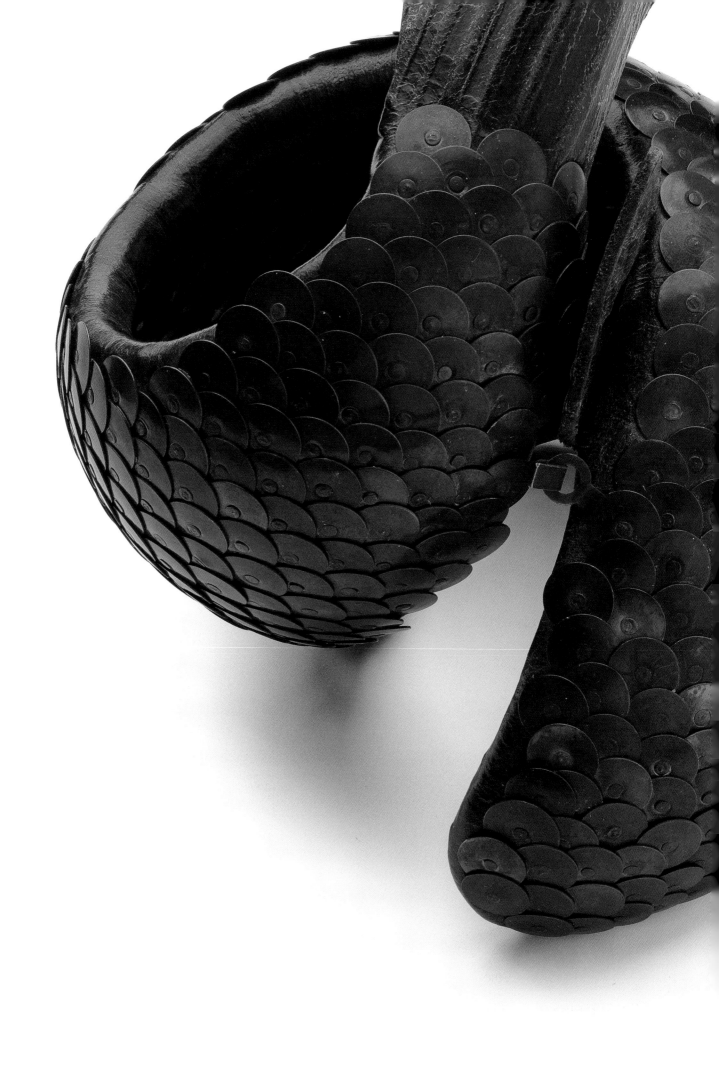

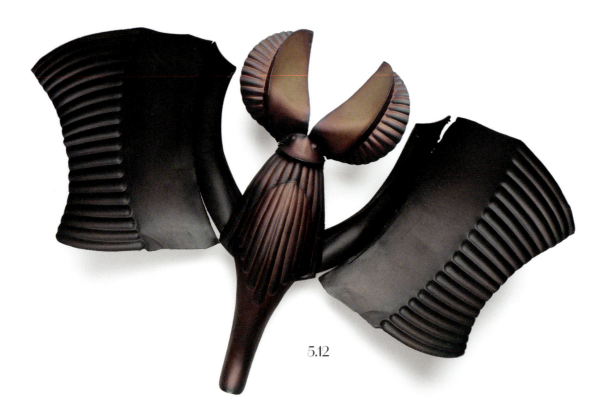

5.12

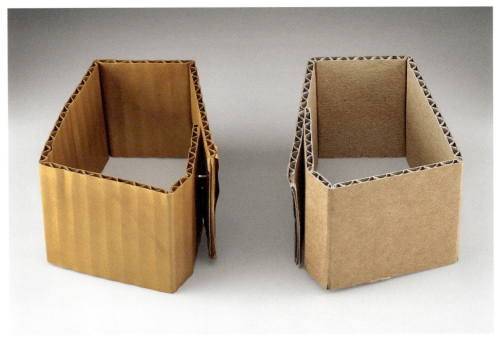

5.11

5.11
DAVID BIELANDER
Cardboard and its model
Bracelet
2015
Left: 18-karat gold,
white gold staples,
right: cardboard
3.5 × 2.75 × 2 inches
Susan Beech Collection

5.12
DAVID BIELANDER
Bat
Brooch
2017
Silver (originally a
Queen Anne teapot)
11 × 7.5 × 3.25 inches
Gift to the Museum
of Arts and Design

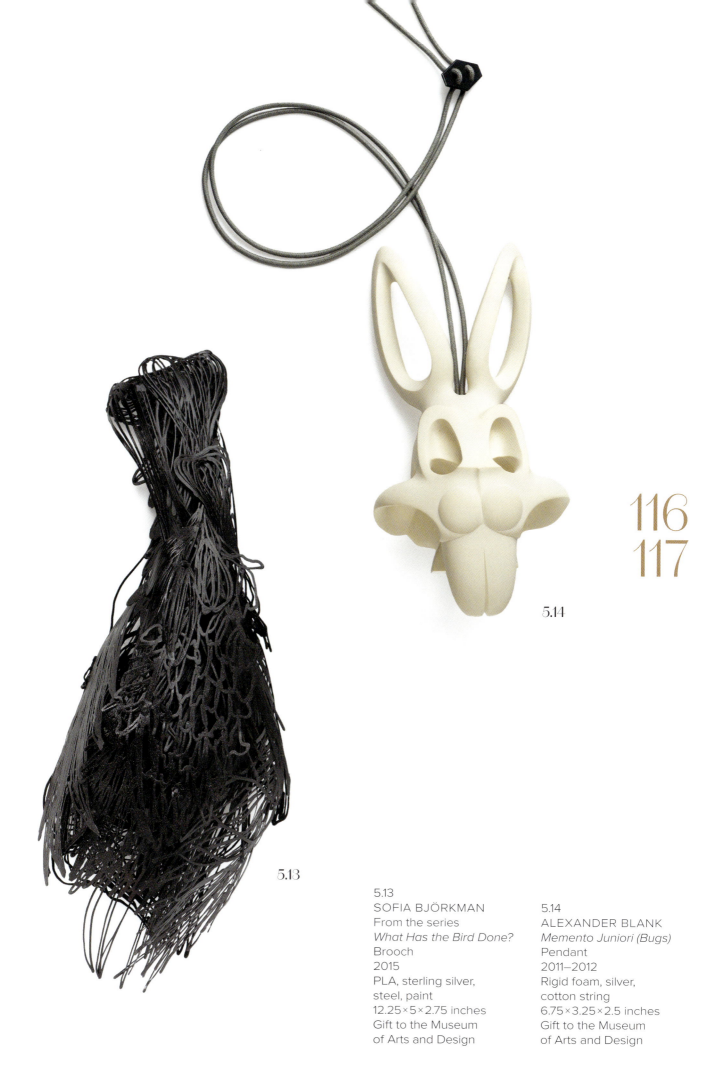

5.13
SOFIA BJÖRKMAN
From the series
What Has the Bird Done?
Brooch
2015
PLA, sterling silver,
steel, paint
12.25 × 5 × 2.75 inches
Gift to the Museum
of Arts and Design

5.14
ALEXANDER BLANK
Memento Juniori (Bugs)
Pendant
2011–2012
Rigid foam, silver,
cotton string
6.75 × 3.25 × 2.5 inches
Gift to the Museum
of Arts and Design

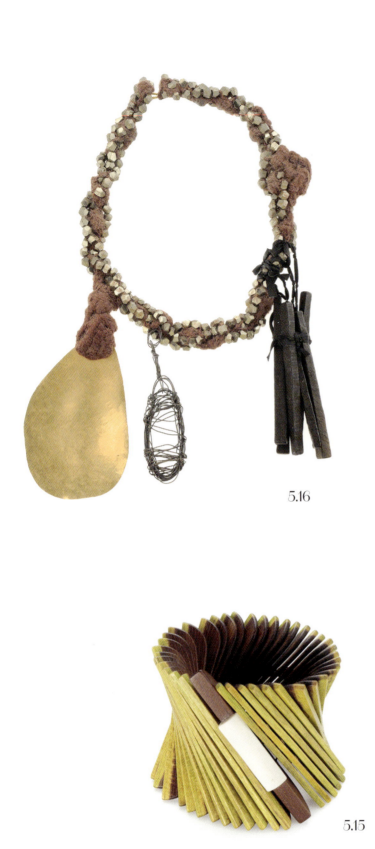
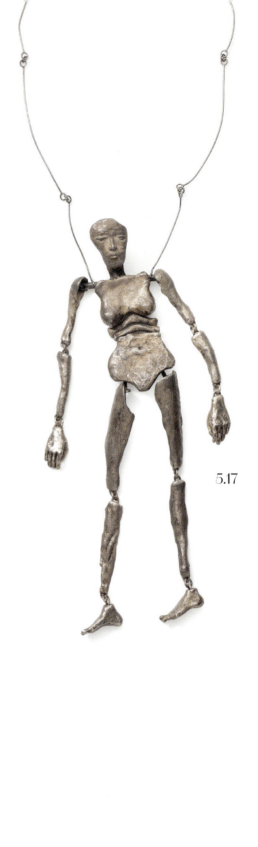

5.15
LIV BLÅVARP
Untitled
Bracelet
Circa 2004
Stained birdseye maple and palisander, pear wood, whale tooth
3.25 × 2.5 × 3 inches
Gift to the Museum of Arts and Design

5.16
IRIS BODEMER
Ingredients
Necklace
2008
18-karat gold, ebony, iron, pyrite, ribbon, wool
11.75 × 7.75 × 1 inches
Gift to the Museum of Arts and Design

5.17
JANA BREVICK
Gradiva
Necklace
1998
Cast and fabricated sterling silver
Pendant: 8 × 2.25 × 0.5 inches
Gift to the Renwick Gallery, Smithsonian American Art Museum

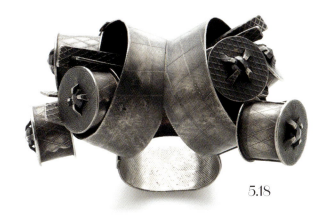

5.18

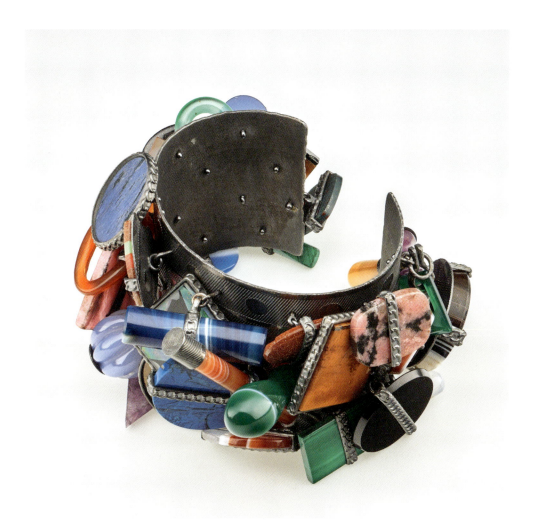

5.19

5.18
HELEN BRITTON
Untitled
Ring
2014
Silver, paint, diamonds
2.25 × 2 × 1.25 inches
Gift to the Museum
of Arts and Design

5.19
HELEN BRITTON
Idar
Bracelet
2016
Silver, antique and
vintage stones
3.2 × 2.4 × 2 inches
Susan Beech Collection

PURCHASING SOMETHING IS A KIND OF RESPONSIBILITY, AND AN INVITATION TO PAY ATTENTION.

IF I'M GOING TO INVEST IN ONE PIECE, THEN THERE IS A POSSIBILITY I WILL FOLLOW THAT ARTIST'S CAREER. I DON'T HAVE TO BUY MORE, BUT IT ESTABLISHES A CONNECTION. IF A PIECE IS BY AN ARTIST I AM FAMILIAR WITH AND ALREADY COLLECT, I WANT THE WORK TO ADD TO THE STORY OR TELL A NEW STORY. I LOOK FOR A NEW OR DEEPER INVESTIGATION OF MATERIALS, OR EXPERIMENTATION WITH FORM, OR A CONCEPT THAT EXCITES ME. IF AN ARTIST IS NEW TO ME, I DO SOME RESEARCH TO LEARN MORE ABOUT THAT ARTIST. I GIVE THE WORK A LOT OF THOUGHT BEFORE I PURCHASE IT.
—SUSAN BEECH

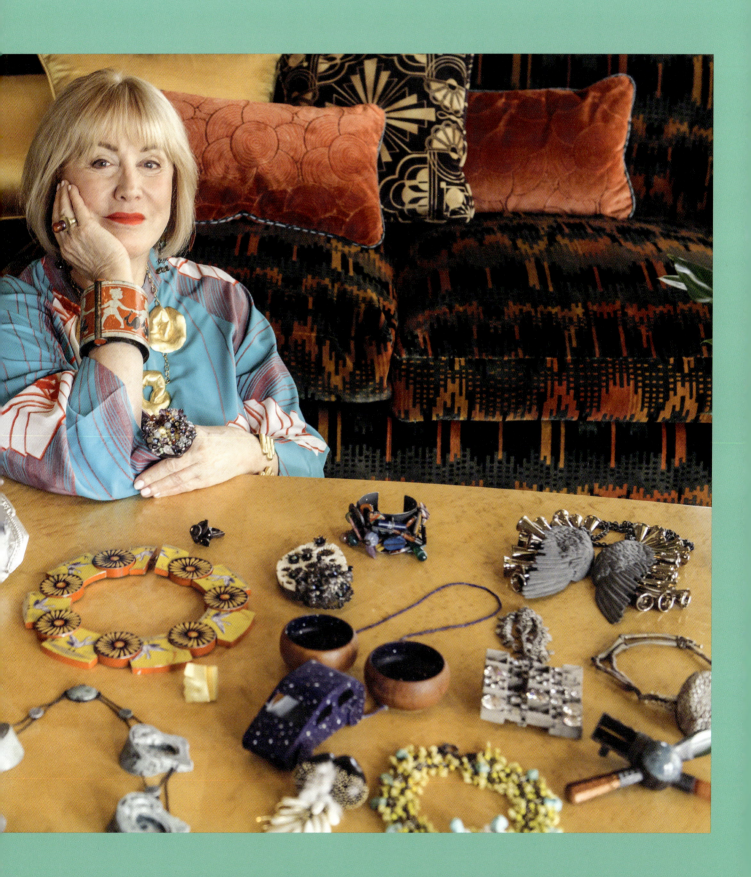

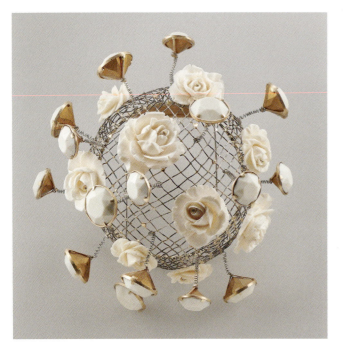

5.20

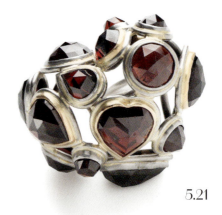

5.21

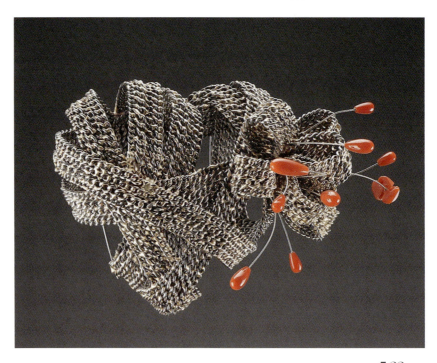

5.22

5.20
LOLA BROOKS
ivory&roses
Brooch
2009
Stainless steel, 14-karat gold, vintage rhinestones, vintage ivory roses
4.25 × 5 × 2.75 inches
Susan Beech Collection

5.21
LOLA BROOKS
garnetheart finger jewel
2010
Stainless steel, vintage rose cut garnets, 18-karat gold
1.75 × 1.75 × 1.5 inches
Gift to the Renwick Gallery, Smithsonian American Art Museum

5.22
LOLA BROOKS
boundheart
Brooch
2013
Stainless steel chain, 14-karat gold solder, Mediterranean coral
3 × 4.25 × 3.25 inches
Gift to the Renwick Gallery, Smithsonian American Art Museum

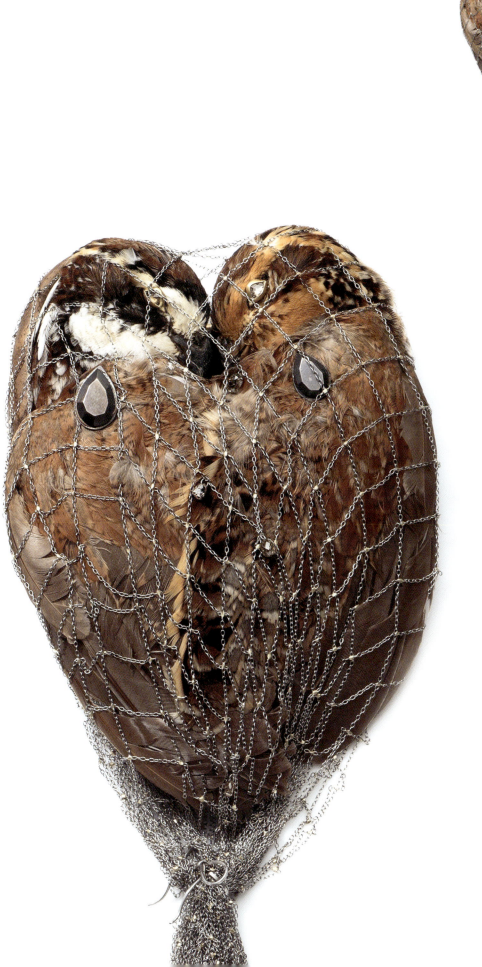
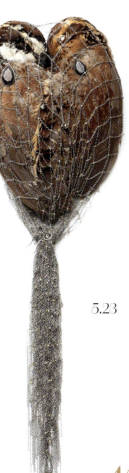

5.23
LOLA BROOKS
twointhehand
Brooch
2015
Male and female taxidermy quails, walnut, stainless steel, diamonds, 14-karat gold, sterling silver
Quails: 5.5 × 4.5 × 2 inches, overall: 13 inches long
Susan Beech Collection

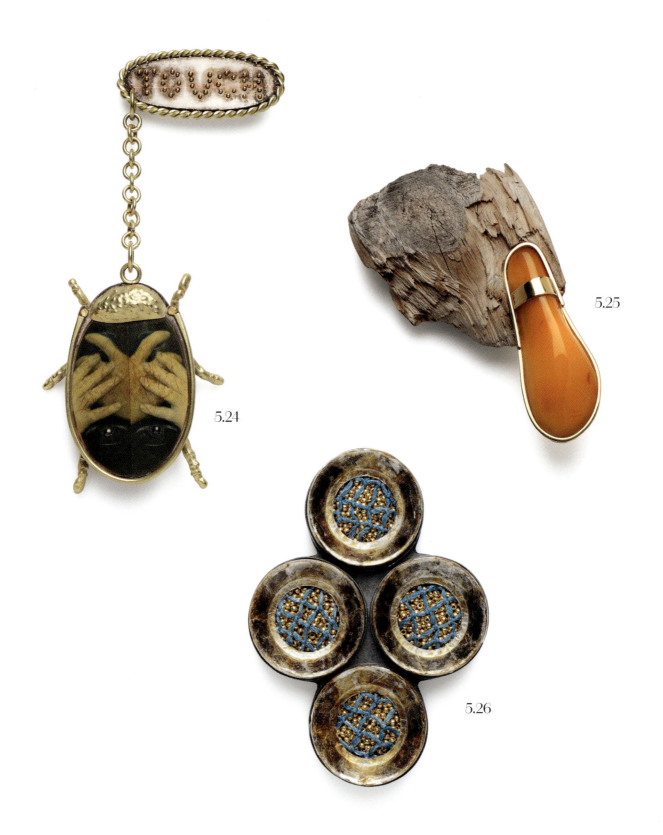

5.24
KATHLEEN BROWNE
Touch
Double brooch
1998
Sterling silver, 18-karat gold, hand-painted photos, Mylar
5 × 2 × 0.5 inches
Gift to the Renwick Gallery, Smithsonian American Art Museum

5.25
CHRISTINE BUKKEHAVE
Cast Away—Weeping Tree
Brooch
2015
18-karat gold, amber, driftwood
4 × 2.5 × 0.625 inches
Gift to the Museum of Arts and Design

5.26
RAÏSSA BUMP
Within
Brooch
2015
Sterling silver, mica, silk, 24-karat gold-plated crystal beads
3.75 × 2.25 × 0.375 inches
Gift to the Renwick Gallery, Smithsonian American Art Museum

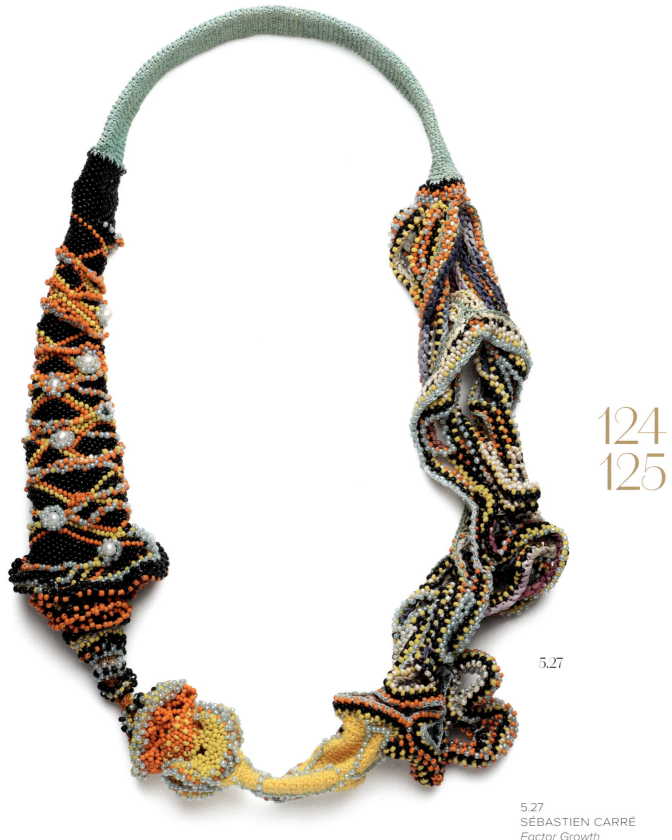

124
125

5.27

5.27
SÉBASTIEN CARRÉ
Factor Growth
Necklace
2019
Japanese paper, pearls, beads, cotton, silk, nylon, jasper thread
30 × 2.5 × 1.75 inches
Gift to the Museum of Arts and Design

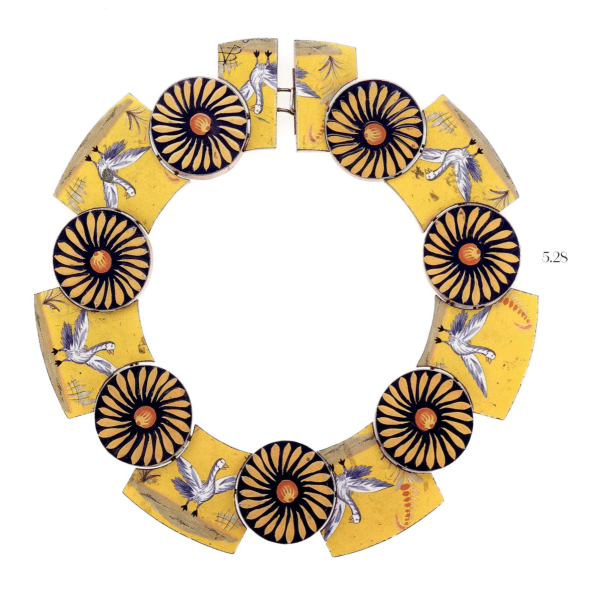

5.28

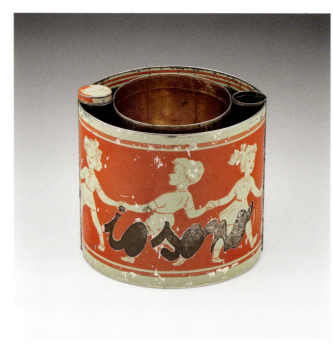

5.29

5.28
MONICA CECCHI
Il Gioco dell'Oca
[The Game of the Goose]
Necklace
2015
Printed tin
9.5 inches in diameter
Susan Beech Collection

5.29
MONICA CECCHI
Lo Sono Infantile
[I Am Childish]
Bracelet
2017
Printed tin
3.25 × 3.5 inches
Susan Beech Collection

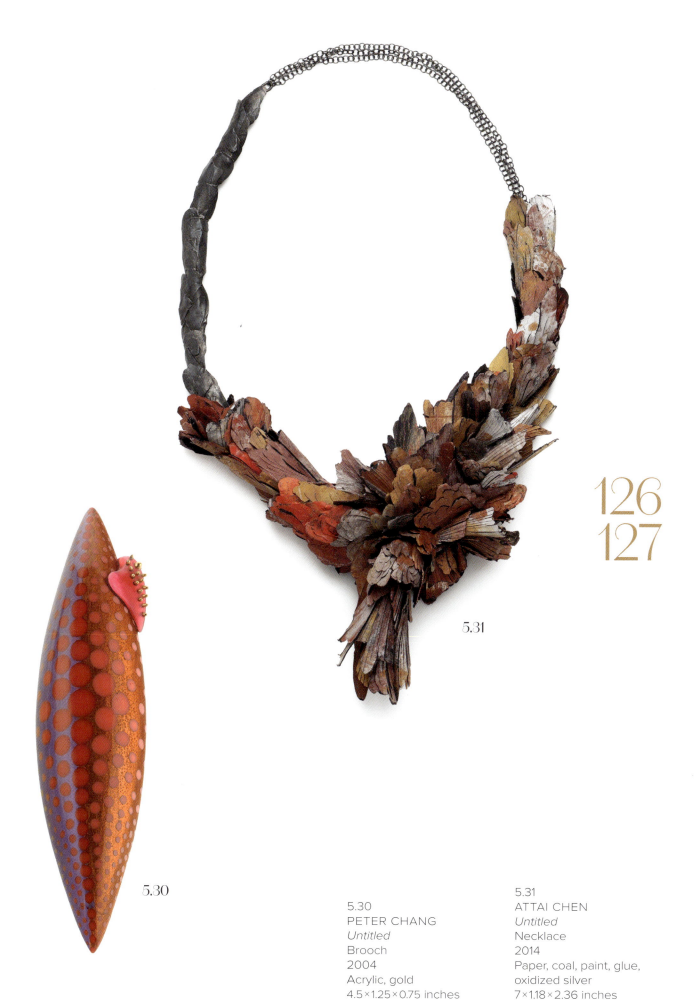

126
127

5.31

5.30

5.30
PETER CHANG
Untitled
Brooch
2004
Acrylic, gold
4.5 × 1.25 × 0.75 inches
Gift to the Museum
of Arts and Design

5.31
ATTAI CHEN
Untitled
Necklace
2014
Paper, coal, paint, glue,
oxidized silver
7 × 1.18 × 2.36 inches
Gift to the Museum
of Arts and Design

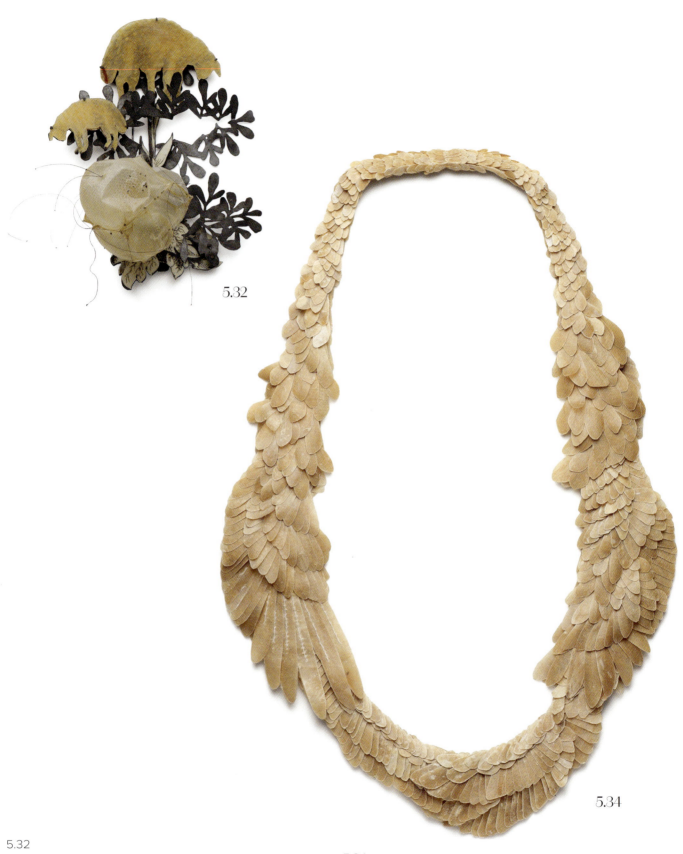

5.32
EUNMI CHUN
Untitled
Brooch
2008
Pig skin, human hair, cow intestine, seeds, silver, steel, paper
5.5 × 4.25 × 2.25 inches
Gift to the Museum of Arts and Design

5.33
EUNMI CHUN
Gorilla Brooch
2011
Human hair, gold leaf, cow intestine, seeds, silver
4.5 × 3 × 4.25 inches
Susan Beech Collection

5.34
EUNMI CHUN
Wings
Necklace
2017
Cow's small intestine, gold wire, thread
17.3 × 11.8 × 0.6 inches
Gift to the Museum of Arts and Design

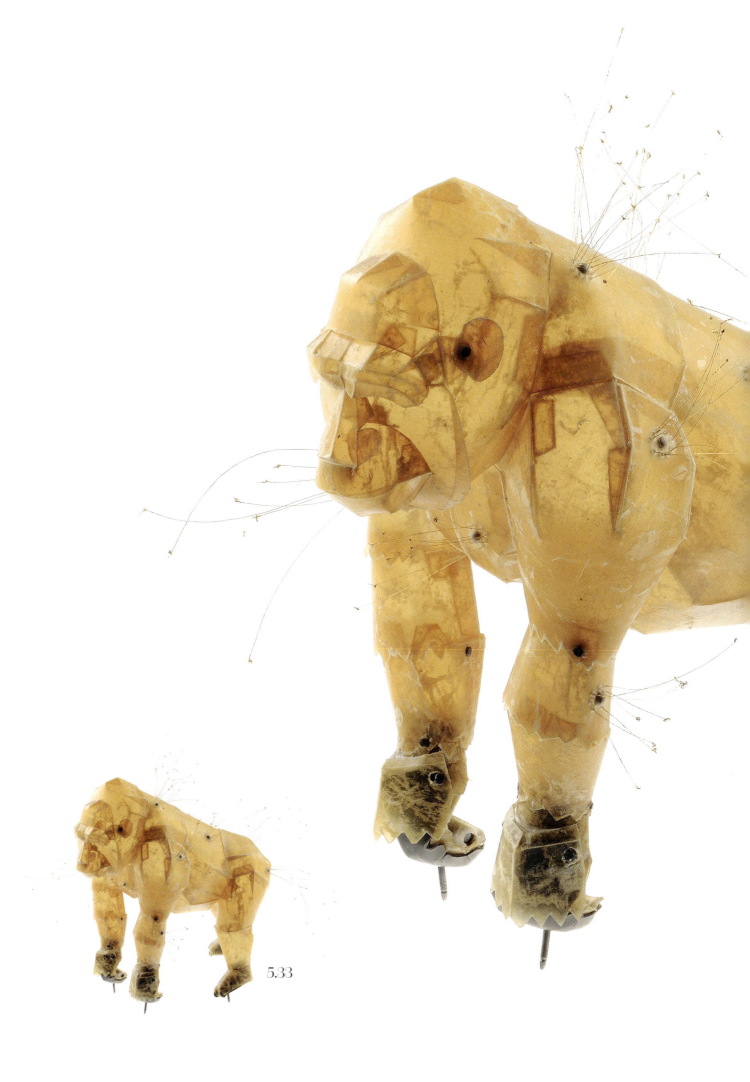
5.33

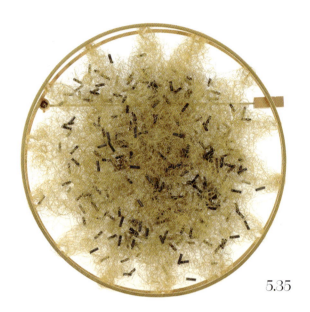

5.35

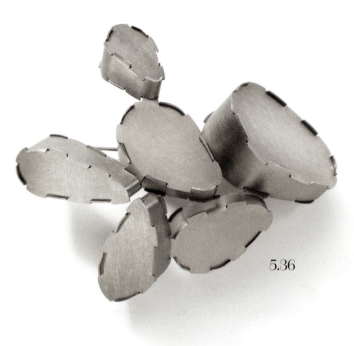

5.36

5.35
GIOVANNI CORVAJA
Untitled
Brooch
1998
18-karat gold, 20-karat gold, palladium
2.6 inches in diameter × 0.5 inches
Susan Beech Collection

5.36
SIMON COTTRELL
Six Loose Forms, Dense
Brooch
2004
Monel 400, stainless steel
3.5 × 3 × 1 inches
Gift to the Museum of Arts and Design

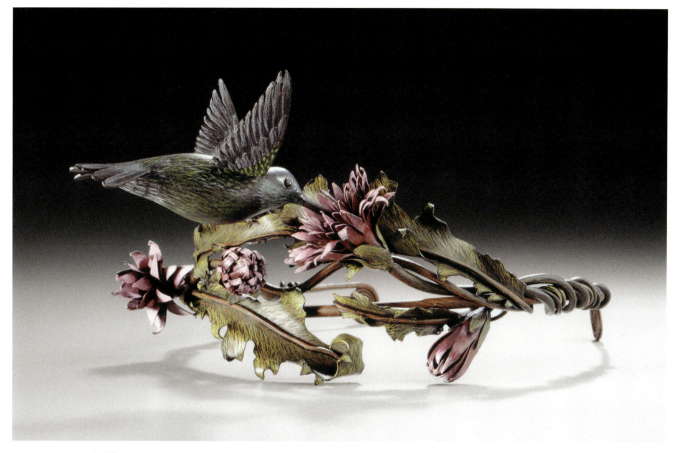

5.38

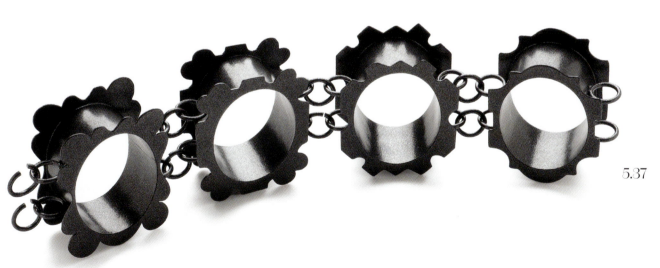

5.37

5.37
PAULA CRESPO
Untitled
Bracelet
2018
Copper, powder coat
11 × 2.5 × 0.75 inches
Gift to the Museum
of Arts and Design

5.38
MARILYN DA SILVA
Beija Flor Tiara II
[Hummingbird Tiara II]
2001
Copper, brass, wood,
gesso, colored pencil
4 × 8 × 7 inches
Gift to the Renwick
Gallery, Smithsonian
American Art Museum

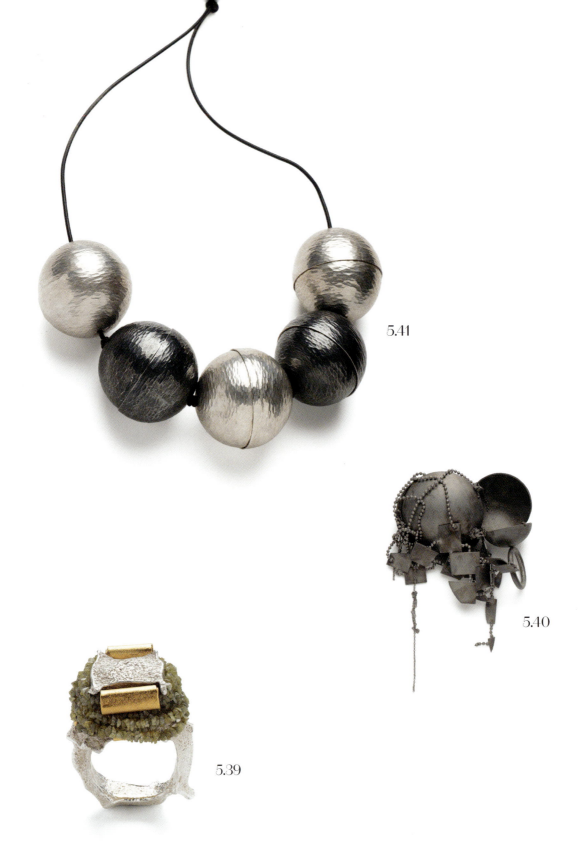

5.41

5.40

5.39

5.39
JOHANNA DAHM
Enhancement
Ring
(Original silver ring) 2002,
2011
Pure silver, pure gold,
raw yellow diamonds
1.75 × 1 × 1 inches
Susan Beech Collection

5.40
AARON DECKER
Leftover Toy
Brooch
2015
Nickel, silver
1.18 × 1.18 × 0.78 inches
Gift to the Renwick
Gallery, Smithsonian
American Art Museum

5.41
PAUL DERREZ
Ball Pendant
2011
Fine silver, rubber
Each ball: 1.57 inches in
diameter
Gift to the Museum
of Arts and Design

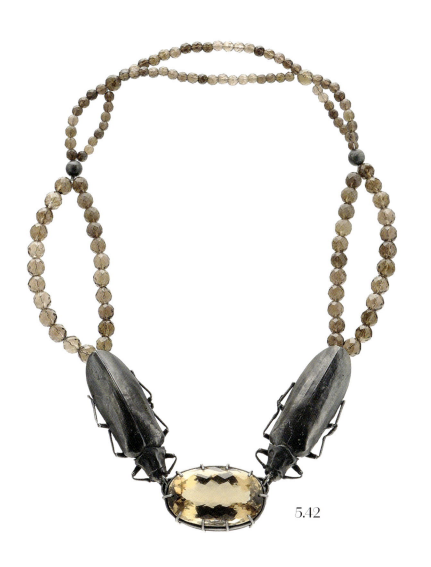

5.42

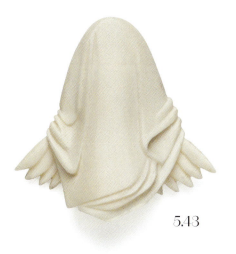

5.43

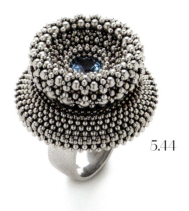

5.44

5.42
GEORG DOBLER
Beetle Necklace
2007
Silver, citrine, smoky quartz
7.5 × 8.5 × 0.75 inches
Gift to the Museum of Arts and Design

5.43
JANE DODD
Cull
Pendant/brooch
2015
Cow bone, sterling silver
2.375 × 2.125 × 0.625 inches
Gift to the Museum of Arts and Design

5.44
BEN DORY
Blue Ring II
2019
Stainless steel, blue topaz
1.25 × 1.25 × 1.25 inches
Gift to the Renwick Gallery, Smithsonian American Art Museum

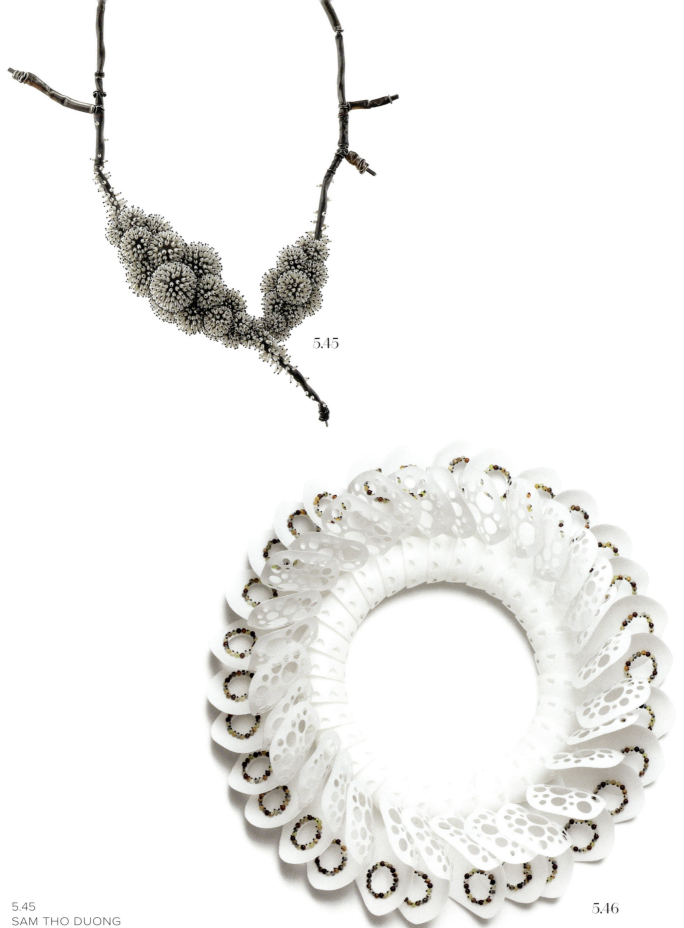

5.45
SAM THO DUONG
Frozen
Necklace
2011
Silver, freshwater
pearls, nylon
12.5 × 9.75 × 1.75 inches
Gift to the Museum
of Arts and Design

5.46
SAM THO DUONG
lemitcA Necklace VD2
2012
Plastic yogurt containers,
mixed stone beads, nylon
14 inches in diameter
Susan Beech Collection

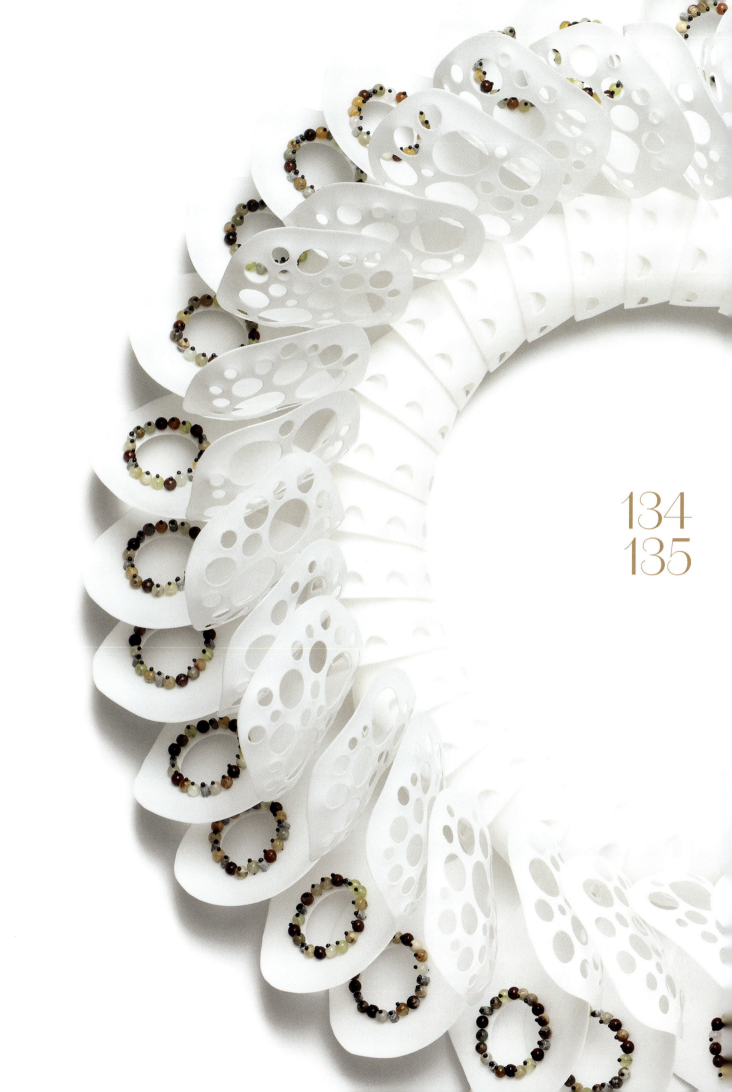

134
135

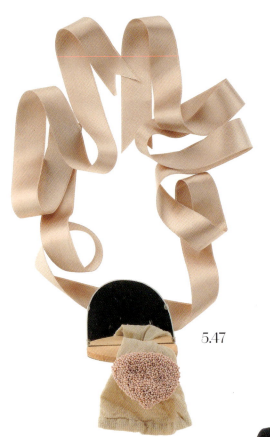

5.47

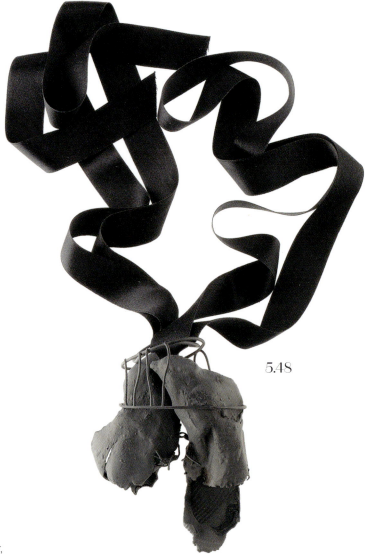

5.48

5.47
IRIS EICHENBERG
Untitled
Necklace
2009
Mirror, leather, stocking,
glass beads, silver, silk
4.75 × 2.857 × 2 inches
Gift to the Museum
of Arts and Design

5.48
IRIS EICHENBERG
Birds of Michigan
Necklace
2010
Electroformed copper,
oxidation, silk
5.25 × 4 × 2 inches
Gift to the Museum
of Arts and Design

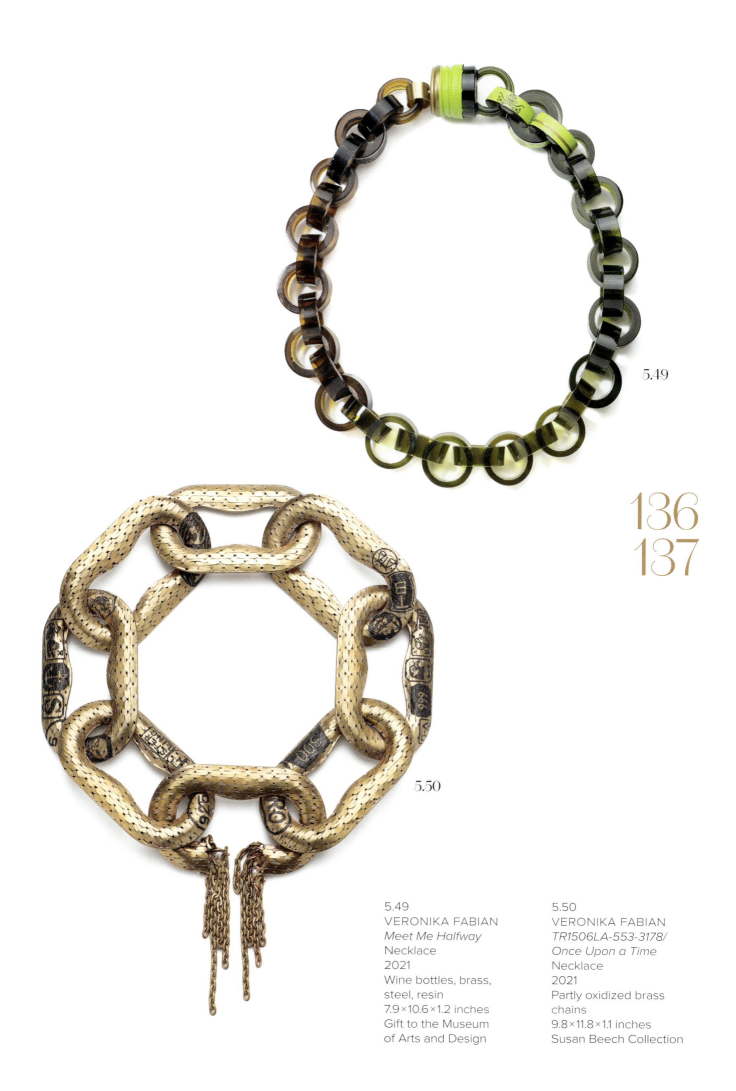

5.49
VERONIKA FABIAN
Meet Me Halfway
Necklace
2021
Wine bottles, brass, steel, resin
7.9 × 10.6 × 1.2 inches
Gift to the Museum of Arts and Design

5.50
VERONIKA FABIAN
TR1506LA-553-3178/ Once Upon a Time
Necklace
2021
Partly oxidized brass chains
9.8 × 11.8 × 1.1 inches
Susan Beech Collection

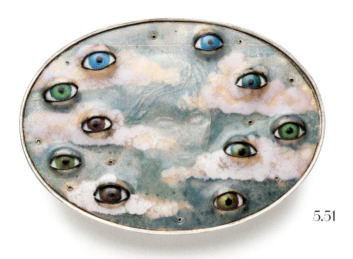

5.51

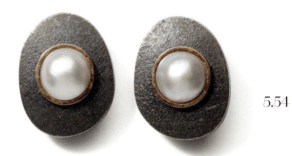

5.54

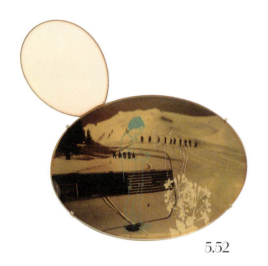

5.52

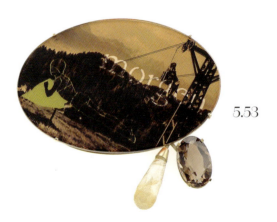

5.53

5.51
KATHLEEN FINK
Augen 2 [Eyes 2]
Brooch
2004
Silver, enamel, copper
4.25×3×0.25 inches
Gift to the Museum
of Arts and Design

5.52
JANTJE FLEISCHHUT
Bubble
Brooch
2007
14-karat gold, resin,
print on foil
4.25×4×1 inches
Gift to the Museum
of Arts and Design

5.53
JANTJE FLEISCHHUT
Morgan
Brooch
2007
14-karat gold, resin,
print, quartz, topaz
3.625×3.5×0.5 inches
Gift to the Museum
of Arts and Design

5.54
PAT FLYNN
Untitled
Earrings
1994
Sterling silver, 18-karat
gold, mabé pearls
1.25×1×0.75 inches
Gift to the Renwick
Gallery, Smithsonian
American Art Museum

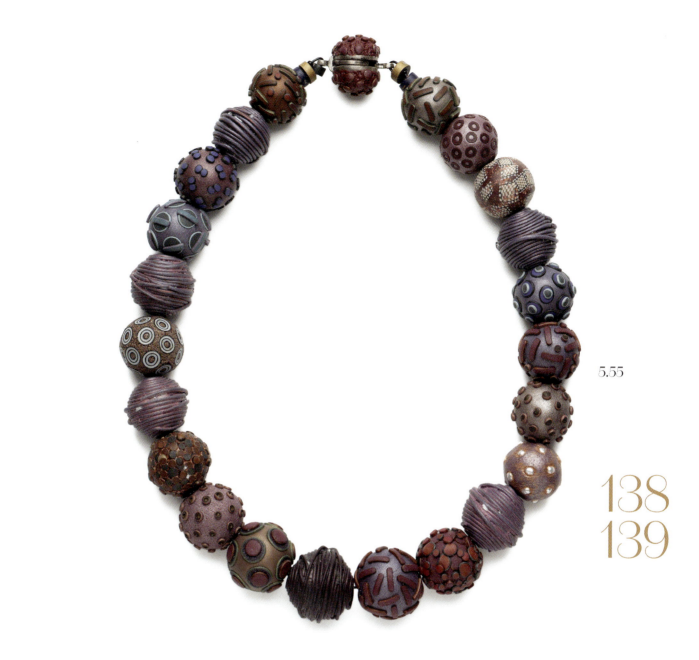

5.55

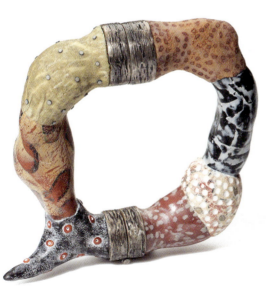

5.56

5.55
FORD AND FORLANO
Untitled
Necklace
2001
Polymer clay,
sterling silver
Each bead: 0.875 inches
in diameter
Gift to the Renwick
Gallery, Smithsonian
American Art Museum

5.56
FORD AND FORLANO
Untitled
Bracelet
2003
Polymer clay,
sterling silver
4.25 × 3.75 × 1.125 inches
Gift to the Renwick
Gallery, Smithsonian
American Art Museum

I HAVE LARGE JEWELRY CABINETS WHERE I KEEP MOST OF MY JEWELRY COLLECTION.

THE TWO LARGEST CABINETS WERE COMMISSIONED TO GO WITH THE ART DECO STYLE OF MY HOUSE. SOMETIMES I GET DRESSED FIRST AND THEN DECIDE WHAT TO WEAR; SOMETIMES I WANT TO WEAR A PARTICULAR PIECE AND I FIGURE OUT WHAT I'M GOING TO WEAR THAT WILL SHOW OFF THAT PIECE. I MOVE THE JEWELRY AROUND. I REARRANGE THE CABINETS. I DO KEEP A FEW PIECES IN THE SAFE. I DON'T WEAR THOSE PIECES AS OFTEN.
—SUSAN BEECH

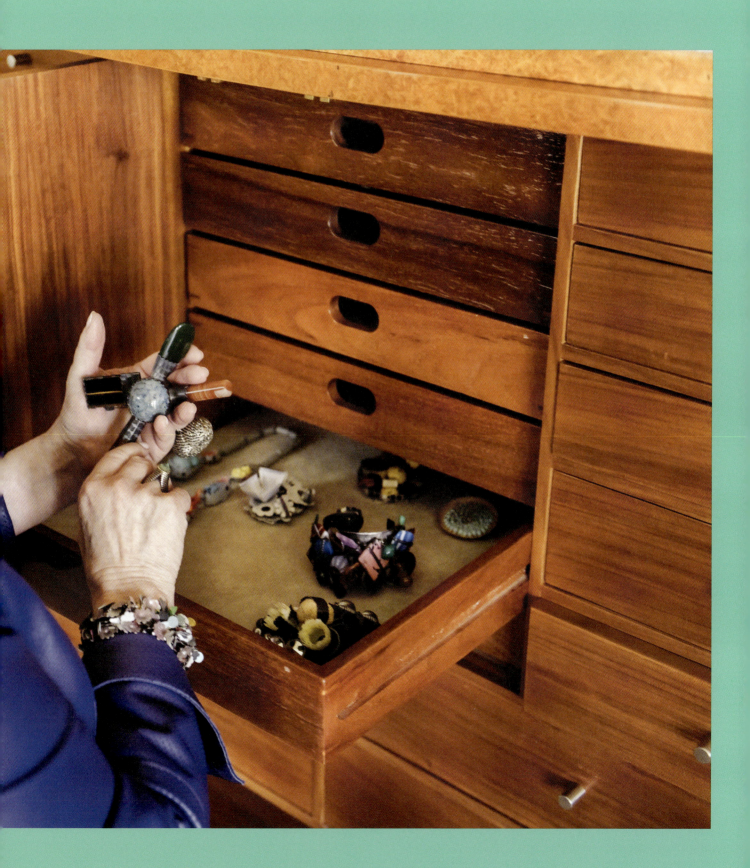

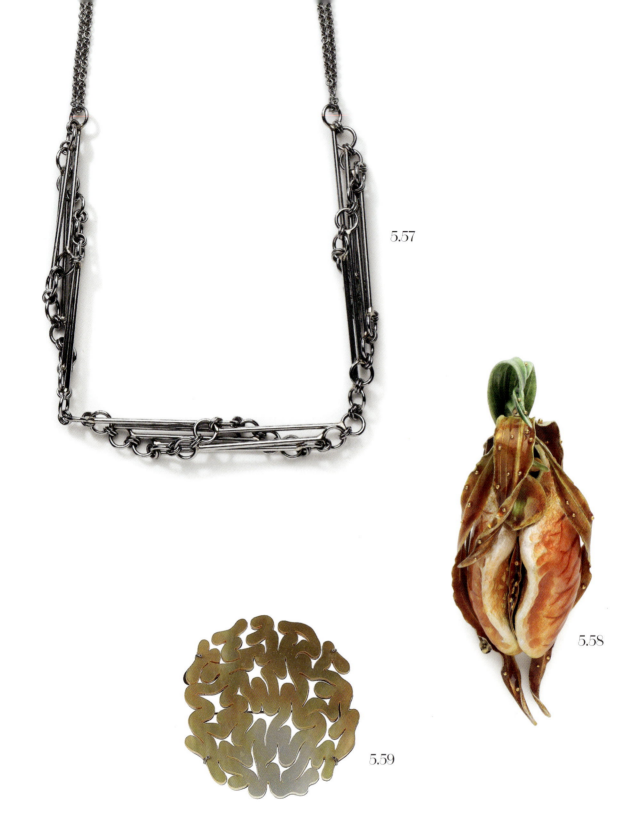

5.57
REBEKAH FRANK
*Triple Spiral,
Contained Series*
Necklace
2019
Steel
16×8×1.5 inches
Gift to the Renwick
Gallery, Smithsonian
American Art Museum

5.58
DAVID FREDA
Pink Lady Slipper Brooch
2003
Fine silver, 24-karat yellow
gold, 18-karat yellow gold,
14-karat yellow gold,
enamel, pearls
3.5×1×1.25 inches
Gift to the Renwick
Gallery, Smithsonian
American Art Museum

5.59
WARWICK FREEMAN
Worm Brooch
2004
Gold-lipped oyster shell,
sterling silver
2.2 inches in diameter
Gift to the Museum
of Arts and Design

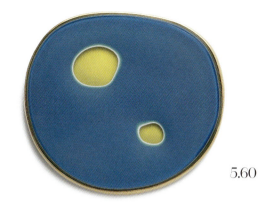

5.60

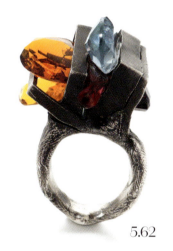

5.62

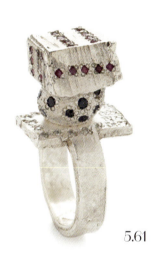

5.61

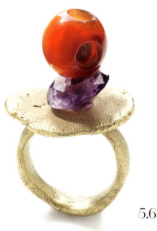

5.63

5.60
DONALD FRIEDLICH
Translucence Series
Brooch
2004
Blown glass, 22-karat gold, 18-karat gold, niobium, sterling silver
2.25 × 2.75 × 0.25 inches
Gift to the Renwick Gallery, Smithsonian American Art Museum

5.61
KARL FRITSCH
Untitled
Ring
2000
Sterling silver, sapphires, diamonds, rubies
1.375 × 0.875 × 0.625 inches
Gift to the Museum of Arts and Design

5.62
KARL FRITSCH
Untitled
Ring
2006
Silver, glass
2 × 1.25 × 1 inches
Susan Beech Collection

5.63
KARL FRITSCH
Untitled
Ring
2008
18-karat gold, carnelian, amethyst
1.625 × 1 × 0.75 inches
Susan Beech Collection

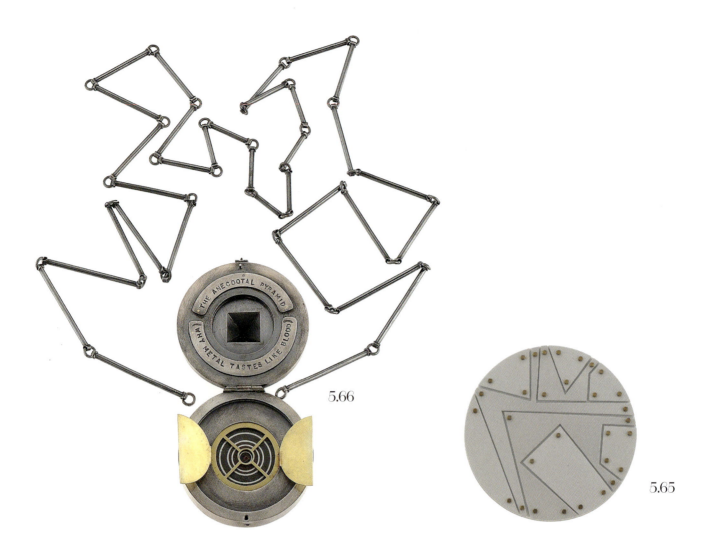

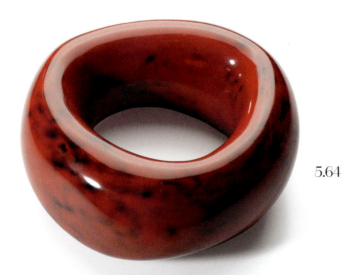

5.64
KYOKO FUKUCHI
Urushi Bracelet
2003
Paulownia wood,
Japanese lacquer
5 × 5 × 1.6 inches
Gift to the Museum
of Arts and Design

5.65
THOMAS GENTILLE
Brooch
Twentieth century
Aluminum, acrylic, bronze
3 inches in diameter
Gift to the Renwick
Gallery, Smithsonian
American Art Museum

5.66
LISA GRALNICK
*The Anecdotal Pyramid
(Why Metal Tastes like Blood)*
Necklace
1995
Gold, silver, glass, blood
Pendant: 2 inches in
diameter
Gift to the Renwick Gallery,
Smithsonian American
Art Museum

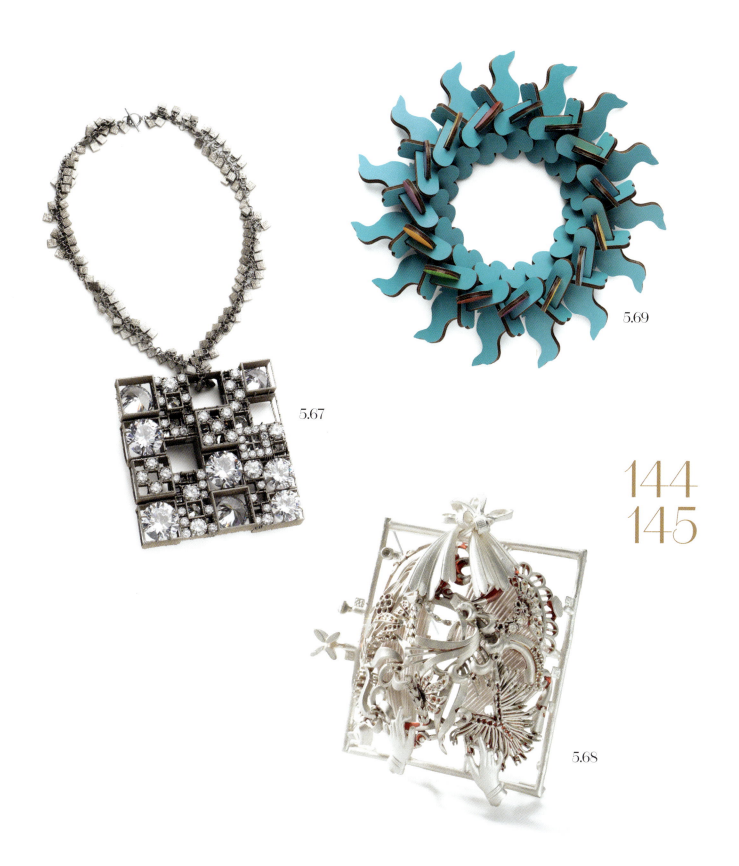

5.67
ADAM GRINOVICH
Tropical Space
Necklace
2017
Stainless steel, cubic zirconia, string
3.5 × 3.5 × 0.75 inches
Susan Beech Collection

5.68
MARY HALLAM PEARSE
Chromeo Brooch
2016
Silver, aluminum
3.25 × 3.375 × 1.25 inches
Gift to the Renwick Gallery, Smithsonian American Art Museum

5.69
REBECCA HANNON
Doxie
Bracelet
2017
Laminate
5 × 5 × 0.5 inches
Gift to the Renwick Gallery, Smithsonian American Art Museum

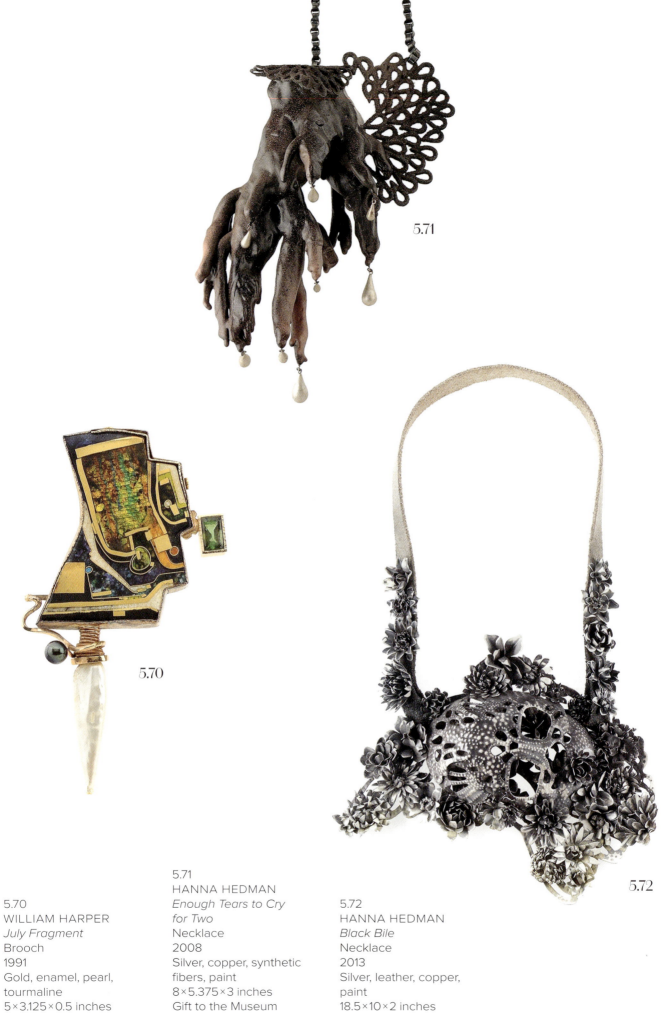

5.70
WILLIAM HARPER
July Fragment
Brooch
1991
Gold, enamel, pearl, tourmaline
5 × 3.125 × 0.5 inches
Susan Beech Collection

5.71
HANNA HEDMAN
Enough Tears to Cry for Two
Necklace
2008
Silver, copper, synthetic fibers, paint
8 × 5.375 × 3 inches
Gift to the Museum of Arts and Design

5.72
HANNA HEDMAN
Black Bile
Necklace
2013
Silver, leather, copper, paint
18.5 × 10 × 2 inches
Susan Beech Collection

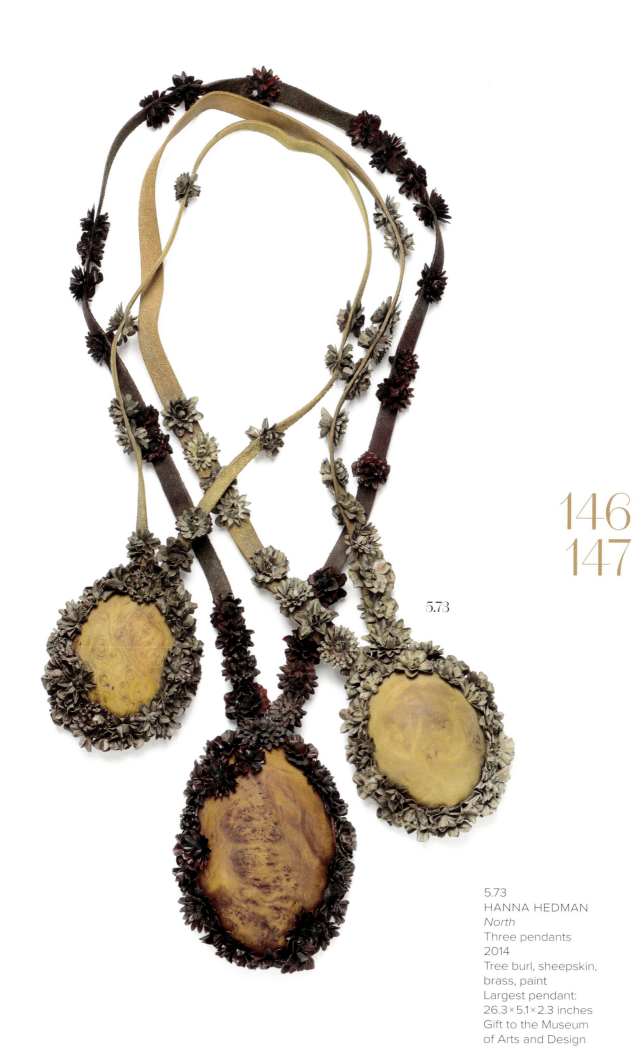

5.73

5.73
HANNA HEDMAN
North
Three pendants
2014
Tree burl, sheepskin,
brass, paint
Largest pendant:
26.3 × 5.1 × 2.3 inches
Gift to the Museum
of Arts and Design

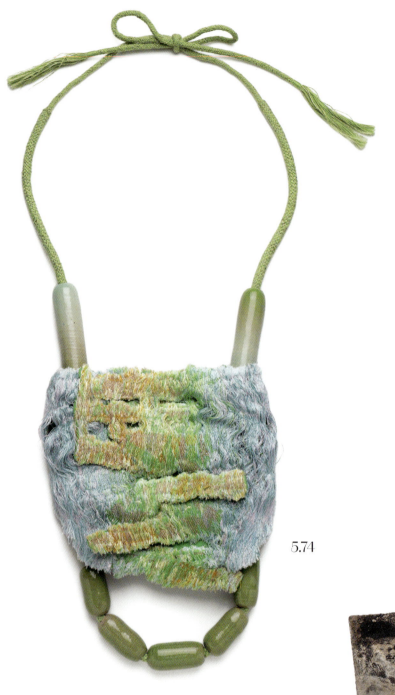

5.74

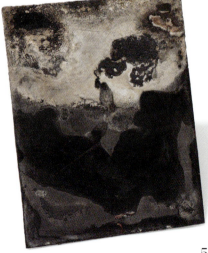

5.75

5.74
INEKE HEERKENS
Furry Forest
Necklace
2013–2014
Ceramic, copper,
polyethylene, cotton,
artificial silk
16 × 6.75 × 1.25 inches
Gift to the Museum
of Arts and Design

5.75
STEFAN HEUSER
Star
Brooch
2008
Silver, enamel, spinel
3.125 × 4 × 0.25 inches
Gift to the Museum
of Arts and Design

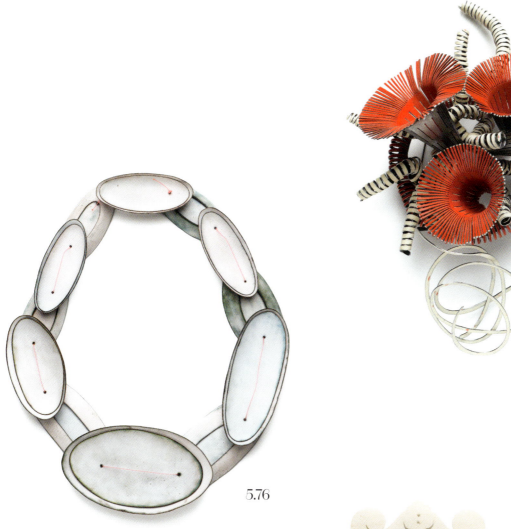

5.76

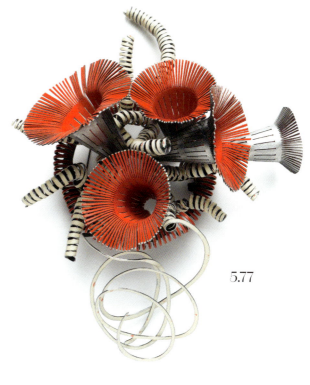

5.77

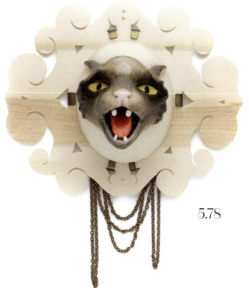

5.78

148
149

5.76
MIRJAM HILLER
Untitled
Necklace
2005
Copper, enamel,
fishing line
8.25 × 8.25 × 0.75 inches
Gift to the Museum
of Arts and Design

5.77
MIRJAM HILLER
Atrosanea Rot
Brooch
2012
Stainless steel, pigment
6.5 × 5.5 × 3 inches
Gift to the Museum
of Arts and Design

5.78
AUD CHARLOTTE HO
SOOK SINDING
Pets Trophy—Cat
Brooch
2005
Silicone, linoleum, brass
7 × 8 × 3 inches
Gift to the Museum
of Arts and Design

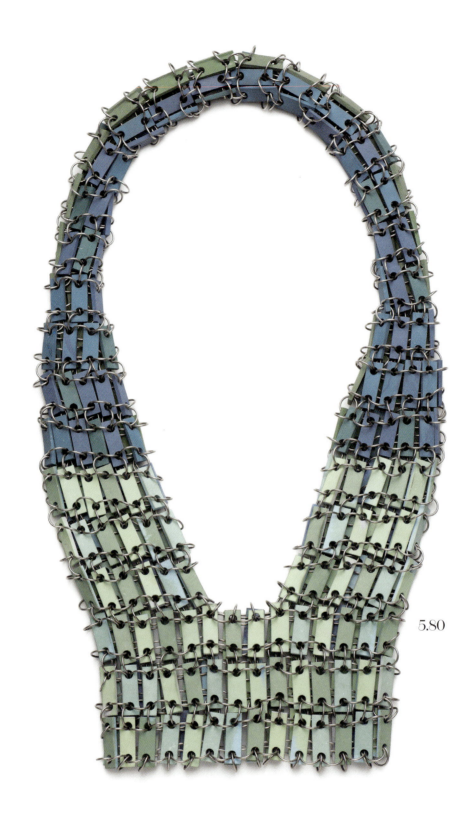

5.80

5.79
PETER HOOGEBOOM
Mother Dao
Necklace
1995
Ceramic, silver, brass
10 inches in diameter
Susan Beech Collection

5.80
PETER HOOGEBOOM
Skellig Islands
Necklace
2007
Porcelain, steel
14.5 × 5.75 × 0.5 inches
Gift to the Museum
of Arts and Design

5.81
PETER HOOGEBOOM
Clay Feet
Necklace
2011
Ceramic, silver, cork
9.44 inches in diameter
Susan Beech Collection

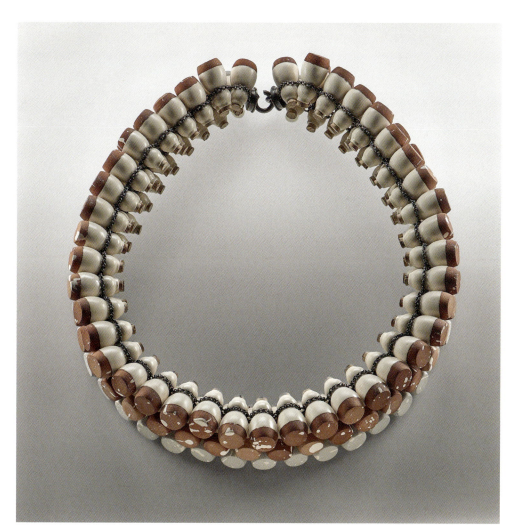

5.81

5.79

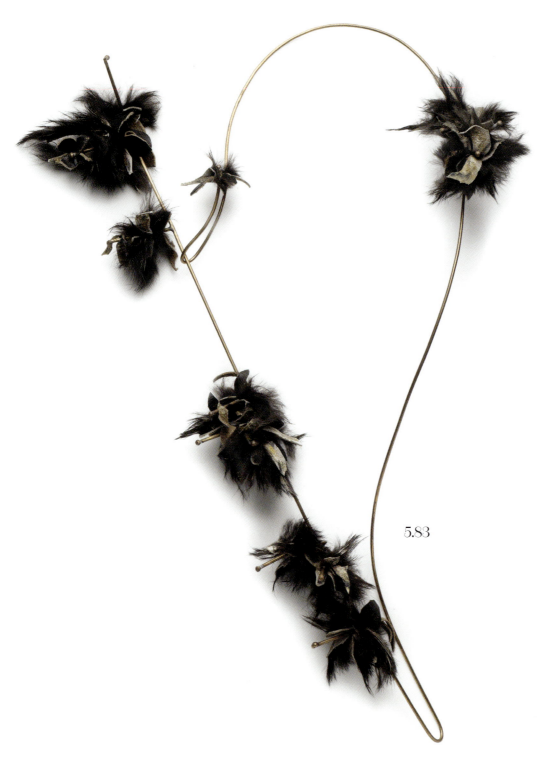

5.82
MARIAN HOSKING
Kinetic Saw-Pierced Brooch
1987
Sterling silver
3 inches in diameter
Gift to the Museum of Arts and Design

5.83
IDIOTS
Untitled
Necklace
2012
Rabbit fur, leather, bronze welding rod
21×11×3 inches
Gift to the Museum of Arts and Design

5.84

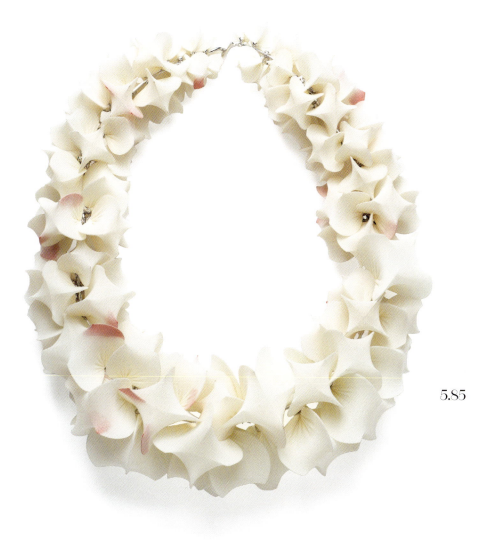

5.85

5.84
JOHN IVERSEN
Untitled
Brooch
1997
18-karat gold, enamel
2.875 inches in diameter
Gift to the Renwick Gallery, Smithsonian American Art Museum

5.85
CHOI JEONGSUN
Warm Dot 01
Necklace
2012
Brass, nylon, PVC, acrylic painting
11 × 11.5 × 4.5 inches
Gift to the Museum of Arts and Design

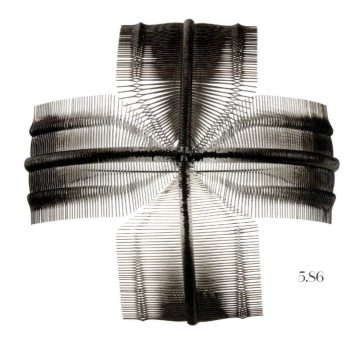

5.86

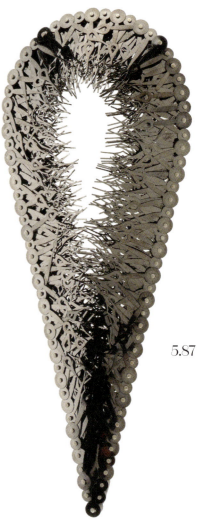

5.87

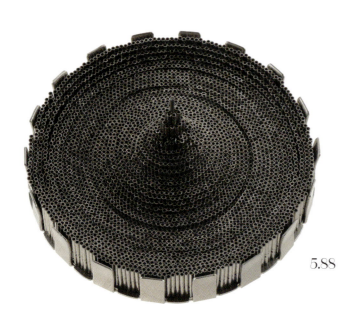

5.88

5.86
SERGEY JIVETIN
Intersection
Brooch
2005
Watch hands, sterling silver, steel
3.25×3.25×1 inches
Gift to the Renwick Gallery, Smithsonian American Art Museum

5.87
SERGEY JIVETIN
Shield #3
Brooch
2005
Watch hands, sterling silver, steel
4.75×2×0.75 inches
Gift to the Renwick Gallery, Smithsonian American Art Museum

5.88
SERGEY JIVETIN
12 Feet Long Brooch
2006
Hypodermic needles, stainless steel, nitinol
Rolled up: 3 inches in diameter, unrolled: 12 feet long
Susan Beech Collection

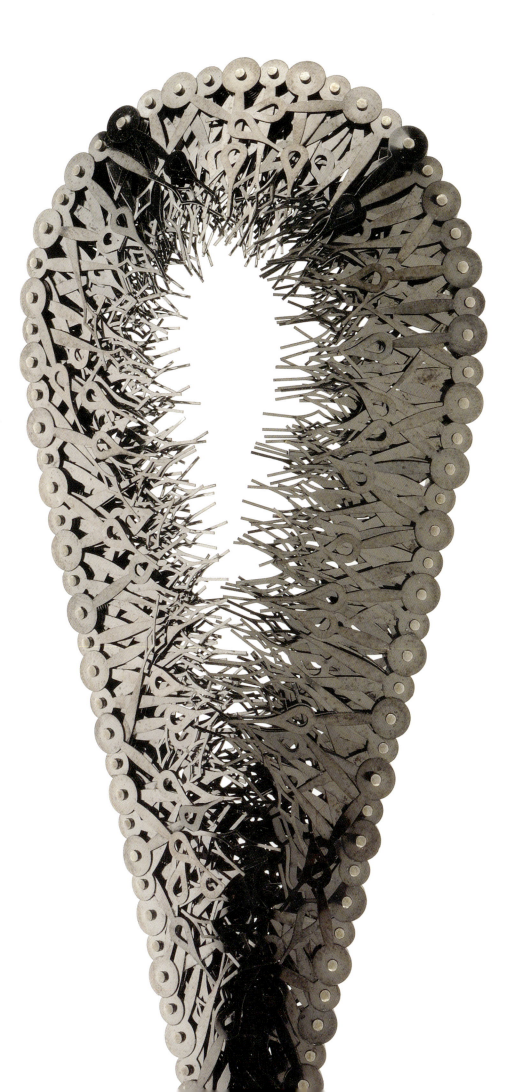

154
155

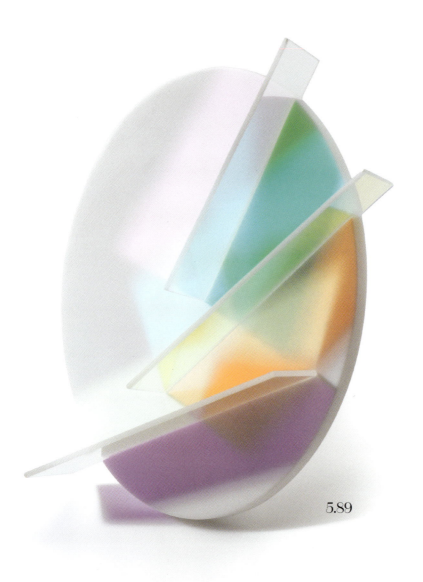

5.89

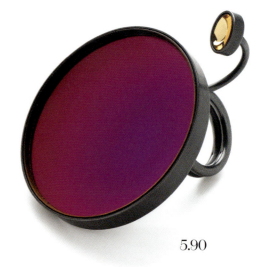

5.90

5.89
JIRO KAMATA
Palette
Brooch
2015
Dichroic mirror,
Corian, silver
8.5 × 7.5 × 2.5 inches
Gift to the Museum
of Arts and Design

5.90
JIRO KAMATA
Big Stellar Holon Ring
2022
Oxidized sterling silver,
camera lens with PVD
2.5 × 2.25 × 1.75 inches
Gift to the Museum
of Arts and Design

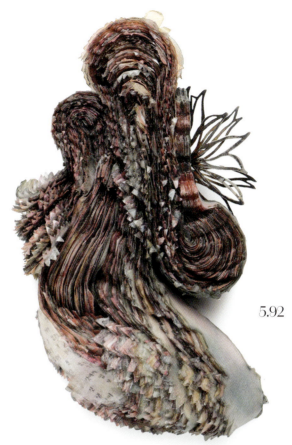

5.92

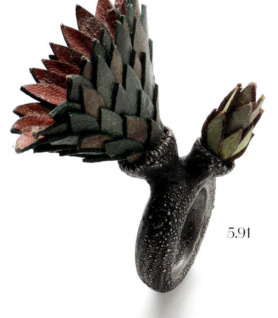

5.91

5.91
HEEJOO KIM
Fifth Season
Ring
2012
Sterling silver, colored leather
2.25 × 1.5 × 2 inches
Gift to the Museum of Arts and Design

5.92
JIMIN KIM
Untitled
Brooch
2010
Paper, latex, sterling silver
5.375 × 3.5 × 3.75 inches
Gift to the Museum of Arts and Design

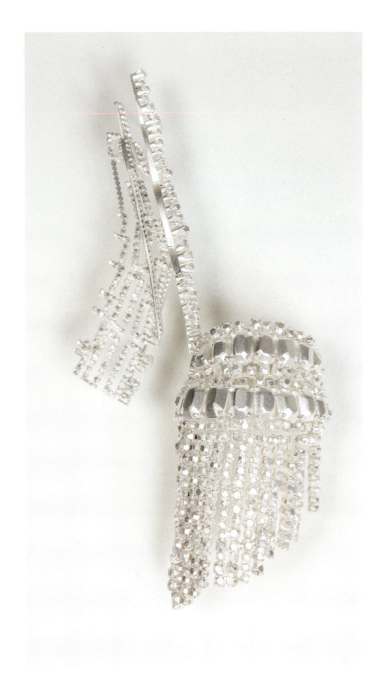

5.95

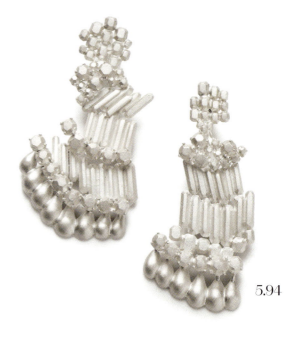

5.94

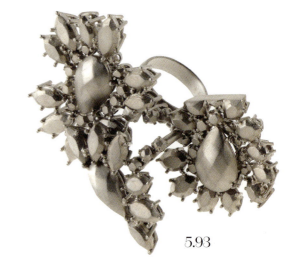

5.93

5.93
ANYA KIVARKIS
Wynona Ryder, Lost Jewels, 3 Views, 2008 (Ring)
2009
Rhodium-plated silver
2.5 × 3.5 × 2.5 inches
Gift to the Renwick Gallery, Smithsonian American Art Museum

5.94
ANYA KIVARKIS
September Issue #4
Earrings
2014
Silver, white gold
Each: approximately 3.5 × 1.5 × 0.5 inches
Susan Beech Collection

5.95
ANYA KIVARKIS
September Issue #1
Brooch
2014
Sterling silver
9 × 5 × 2 inches
Susan Beech Collection

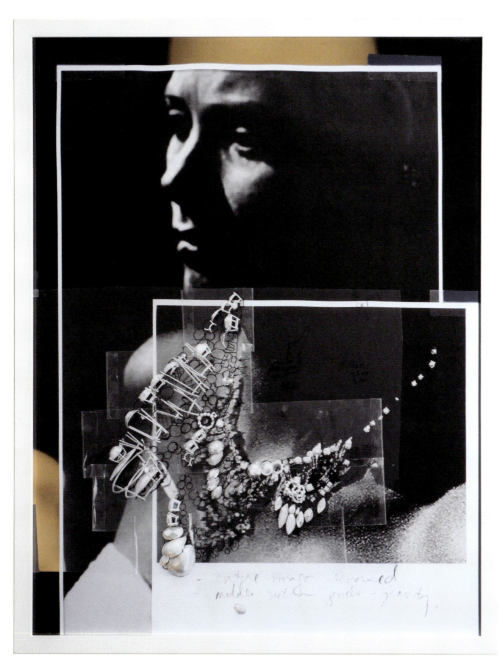

5.96

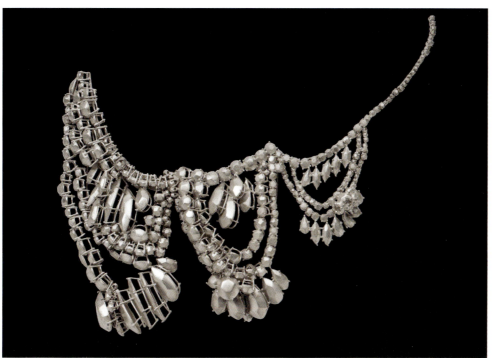

5.96
ANYA KIVARKIS
Depth Cue
Brooch and photograph
2016
Sterling silver (brooch), Plexiglas, photograph
Brooch: 10 × 7 × 0.5 inches, overall: 64 × 18 × 2.5 inches
Gift to the Renwick Gallery, Smithsonian American Art Museum

MY HUSBAND AND I LIVE IN A HOUSE FULL OF ART DECO FURNITURE, CERAMICS, AND BRONZES.

WE ALSO COLLECT CONTEMPORARY CERAMICS WITH AN EDGY TWIST, AND SURREAL PAINTINGS AND PHOTOGRAPHY. SOMETIMES I THINK THE HOUSE IS LIKE A WALK-IN CABINET OF CURIOSITY, FILLED WITH STRANGE AND ENTICING OBJECTS. I CAN WEAR THE ART JEWELRY, WHEREAS I CAN'T WEAR THE OTHER OBJECTS, BUT ALL OF THEM ARE EXPLORING ARTISTIC CREATIVITY AND RESPONDING TO IDEAS IN THE WIDER CULTURE. THEY ARE ALL FORMS OF VISUAL ART, ALTHOUGH THEY HAVE THEIR OWN UNIQUE HISTORIES AND CONCERNS.
—SUSAN BEECH

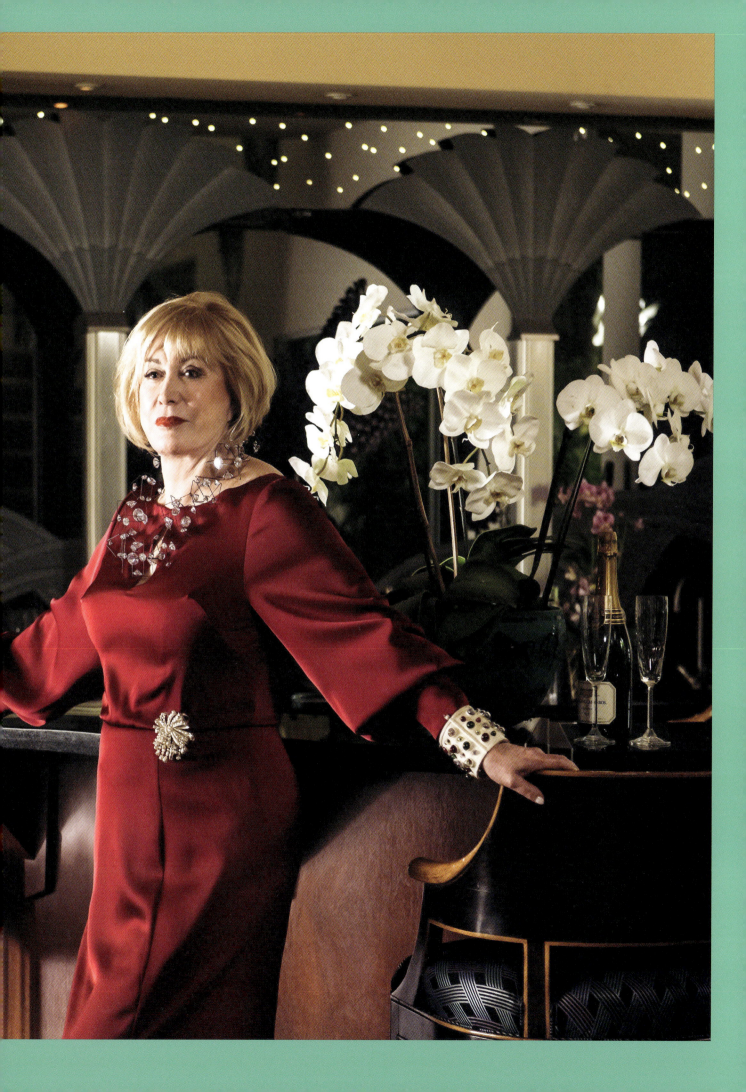

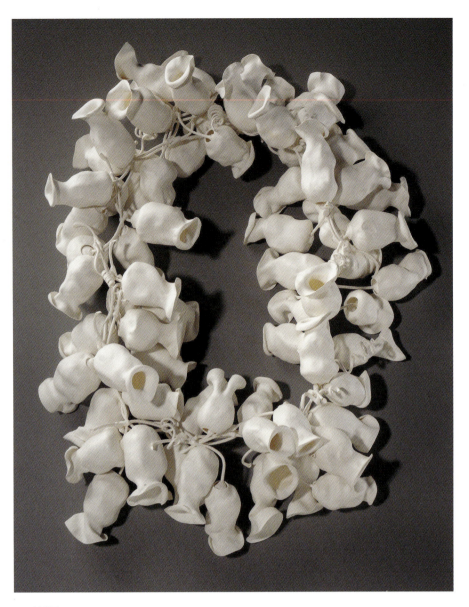

5.97

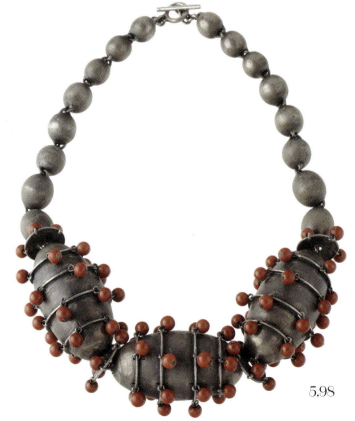

5.97
SUSANNE KLEMM
Frozen
Necklace
2007
Polyolefin
17 × 15 × 4.5 inches
Gift to the Museum
of Arts and Design

5.98
DANIEL KRUGER
Necklace
2000
Sterling silver, jasper
8.25 × 4.25 × 1.5 inches
Gift to the Museum
of Arts and Design

5.98

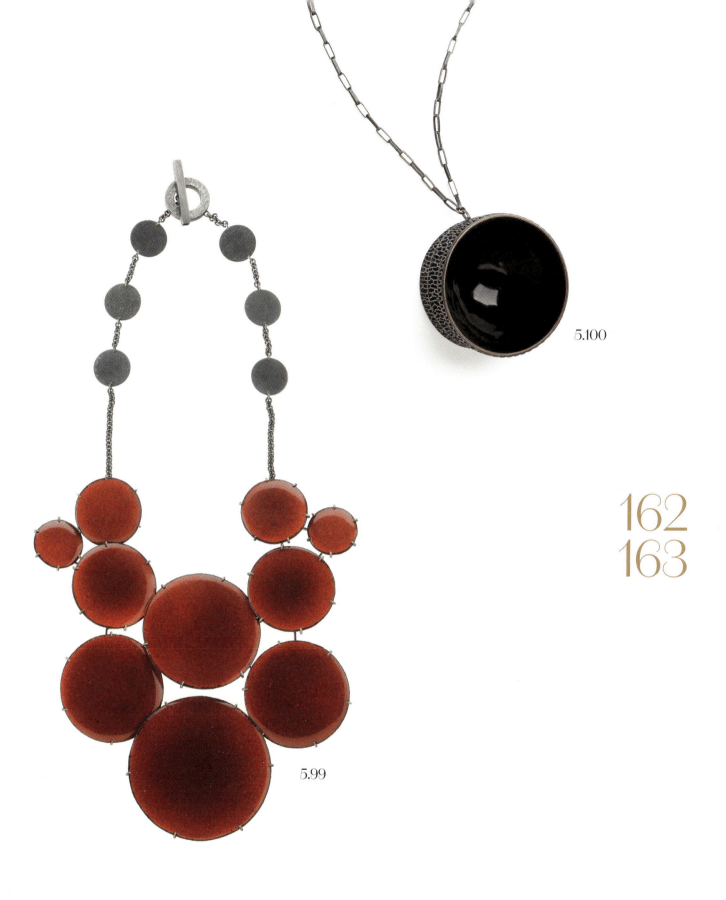

5.99
DANIEL KRUGER
Necklace
2011
Enamel, copper,
sterling silver
Pendant: 6.25 × 6.5 ×
0.25 inches
Gift to the Museum
of Arts and Design

5.100
DANIEL KRUGER
Untitled
Necklace
2013
Silver, enamel on copper
Pendant: 2.75 × 2.75 ×
1.75 inches
Gift to the Museum
of Arts and Design

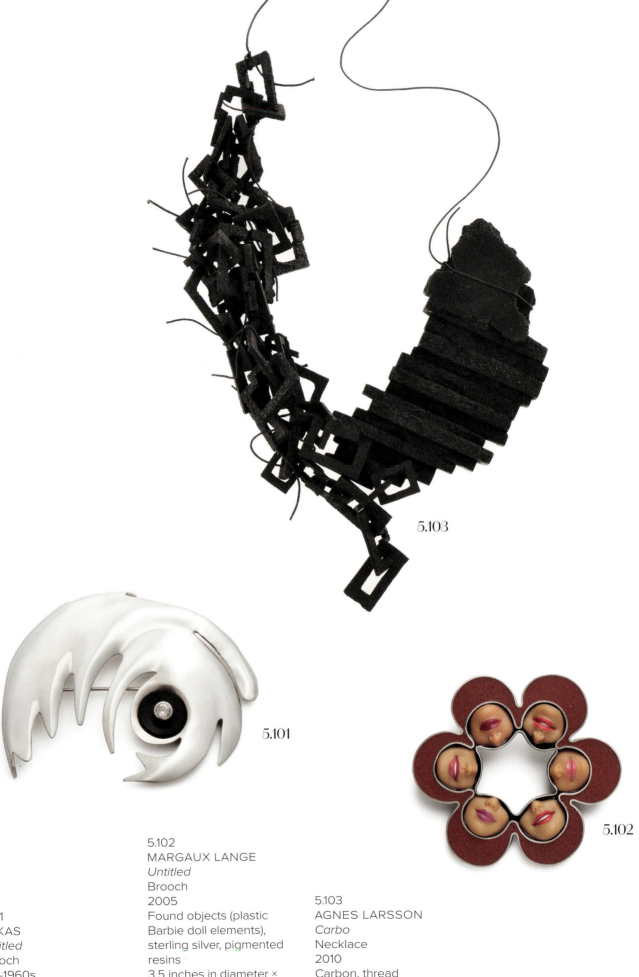

5.101
KUKAS
Untitled
Brooch
Mid-1960s
Sterling silver, onyx, quartz
4.5 × 3.25 × 0.625 inches
Susan Beech Collection

5.102
MARGAUX LANGE
Untitled
Brooch
2005
Found objects (plastic Barbie doll elements), sterling silver, pigmented resins
3.5 inches in diameter × 0.25 inches
Gift to the Renwick Gallery, Smithsonian American Art Museum

5.103
AGNES LARSSON
Carbo
Necklace
2010
Carbon, thread
Pendant: 7.75 × 3.875 × 1.25 inches
Gift to the Museum of Arts and Design

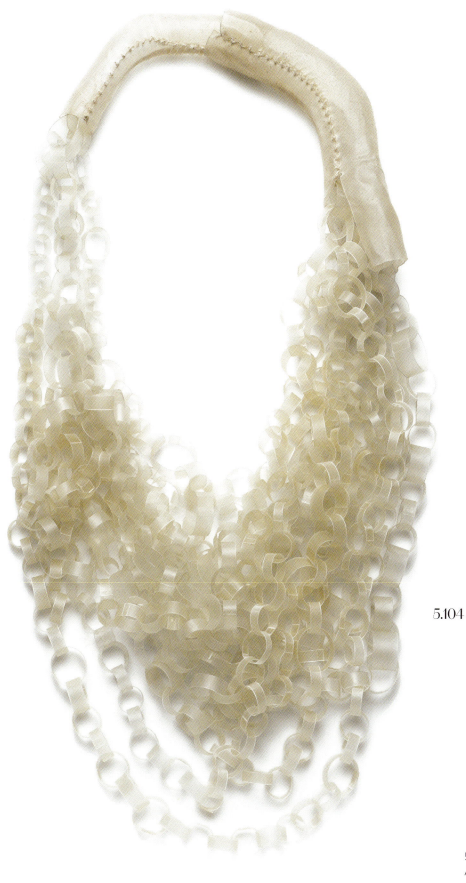

164
165

5.104

5.104
AGNES LARSSON
Remains 6
Necklace
2015
Calfskin, thread
20 × 8.5 × 2.75 inches
Gift to the Museum
of Arts and Design

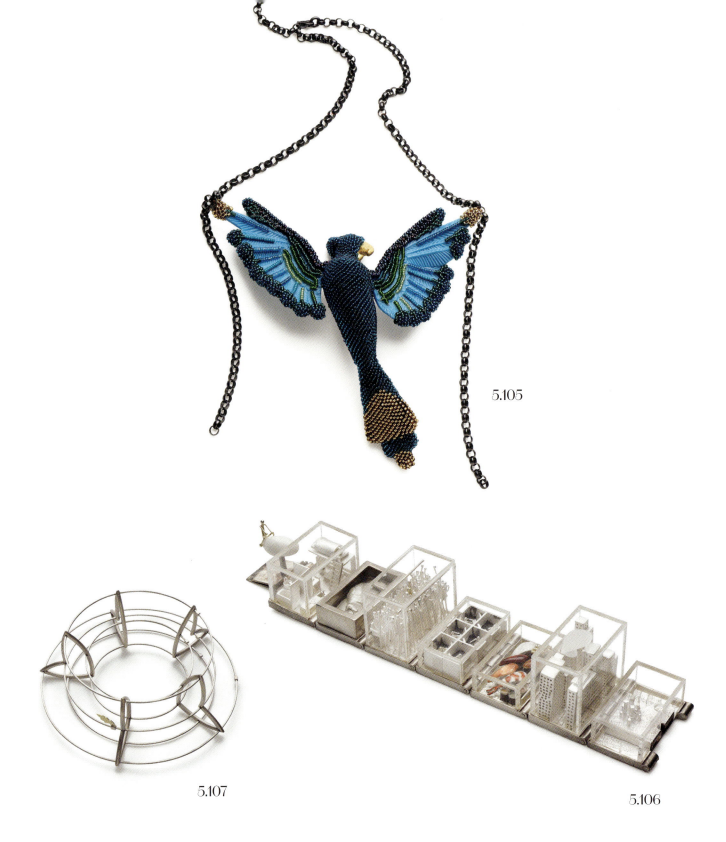

5.105
SARI LIIMATTA
Free Will
Necklace
2015
Glass beads, oxidized silver chain, gold leaf, oxidized silver lock, polyamide thread, plastic toy
8 × 8.5 × 1.75 inches
Gift to the Museum of Arts and Design

5.106
ASAGI MAEDA
Boxes in Life
Bracelet
2004
Sterling silver, 18-karat gold, enamel, plastic, found objects
8.375 × 1.5 inches
Susan Beech Collection

5.107
CARLIER MAKIGAWA
Untitled
Bracelet
1996
Sterling silver, Monel, 9-karat gold
3.875 × 5.5 × 2 inches
Gift to the Museum of Arts and Design

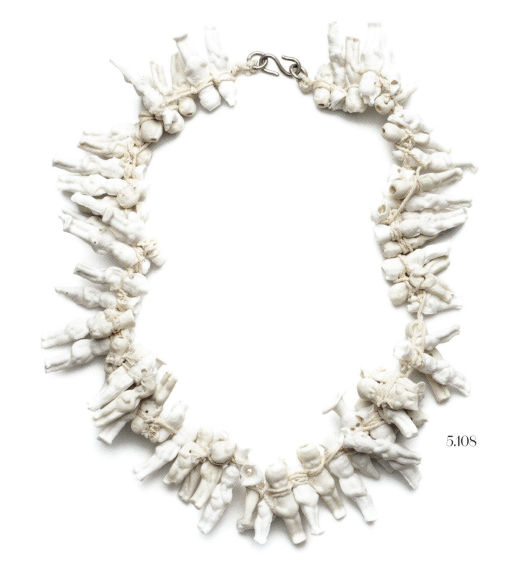

5.108

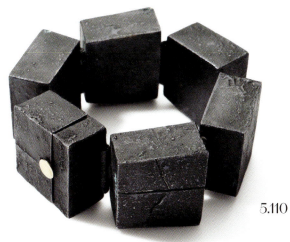

5.110

5.109

5.108
JORGE MANILLA
Titieres
[Puppeteers]
Necklace
2006
Porcelain, silver, cotton thread
Each element: 1.75 × 0.125 inches
Gift to the Museum of Arts and Design

5.109
STEFANO MARCHETTI
Untitled
Brooch
2004
Gold
2.625 × 2.75 × 1 inches
Gift to the Museum of Arts and Design

5.110
GIGI MARIANI
Stonehenge
Bracelet
2012
Silver, 18-karat yellow gold, niello, patina
7.75 × 1.25 × 0.625 inches
Gift to the Museum of Arts and Design

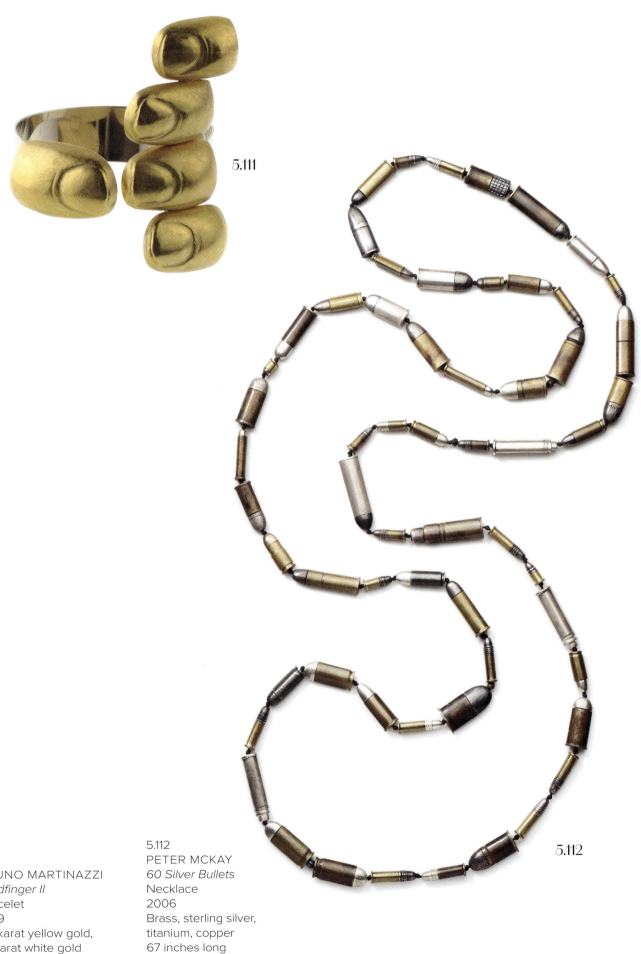

5.111
BRUNO MARTINAZZI
Goldfinger II
Bracelet
1969
20-karat yellow gold,
18-karat white gold
2.875 × 2.5 × 2.25 inches
Susan Beech Collection

5.112
PETER MCKAY
60 Silver Bullets
Necklace
2006
Brass, sterling silver,
titanium, copper
67 inches long
Gift to the Museum
of Arts and Design

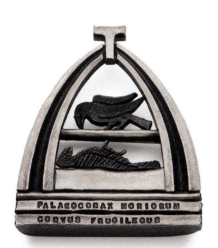

5.113

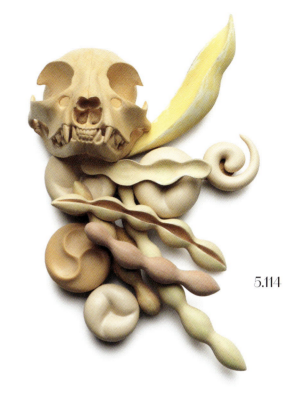

5.114

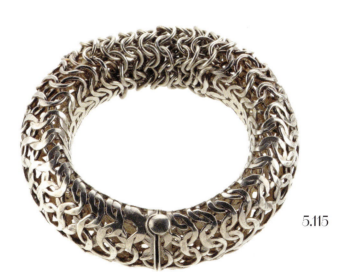

5.115

5.113
PETER MCKAY
Palaeocorax Moriorum Corvus Frugilegus I
Brooch
2006
Sterling silver
2 × 1.875 × 0.25 inches
Gift to the Museum of Arts and Design

5.114
BRUCE METCALF
Harvest
Brooch
2017
Maple, holly, Micarta, gold-plated brass
4.5 × 3.25 × 1 inches
Susan Beech Collection

5.115
MYRA MIMLITSCH-GRAY
Cuff
1999
Sterling silver
3.25 × 3 × 3 inches
Susan Beech Collection

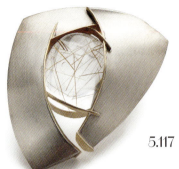

5.117

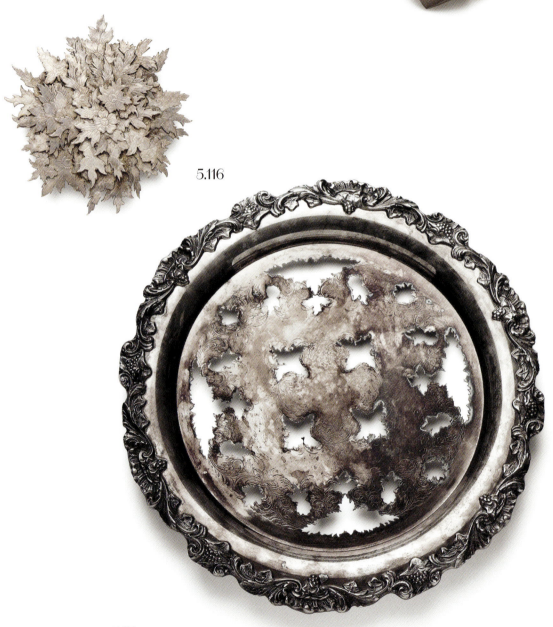

5.116

5.116
JAYDAN MOORE
Dissect/Direct #2
Object and brooch
2019
Found silver-plated platter
Brooch: 3.5 × 3.75 × 0.375 inches, platter: 13.5 inches in diameter
Gift to the Renwick Gallery, Smithsonian American Art Museum

5.117
ELEANOR MOTY
Kata
Brooch
1999
Sterling silver, 18-karat gold, 14-karat gold, rutilated quartz
3 × 2.25 × 0.75 inches
Gift to the Renwick Gallery, Smithsonian American Art Museum

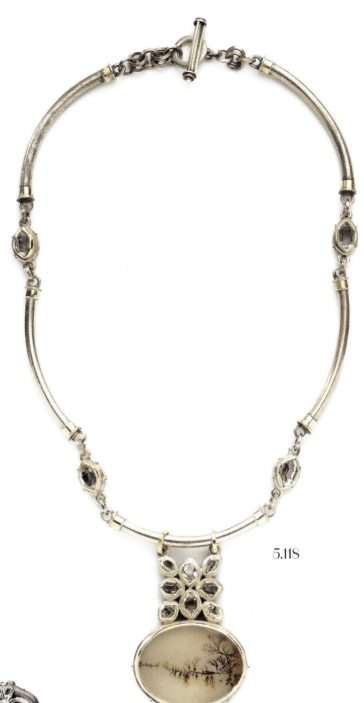

5.118

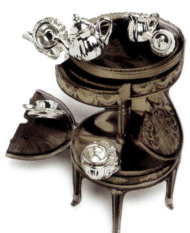

5.119

5.118
HEIDI NAHSER FINK
Dendritic Agate Necklace
2001
Silver, 18-karat gold, Herkimer diamonds
8.5 × 5 inches
Gift to the Renwick Gallery, Smithsonian American Art Museum

5.119
IRIS NIEUWENBURG
Invitation
Brooch
2008
Sterling silver, veneer layer, photo, found and adapted miniature dollhouse parts
3.75 × 3 × 1.25 inches
Gift to the Museum of Arts and Design

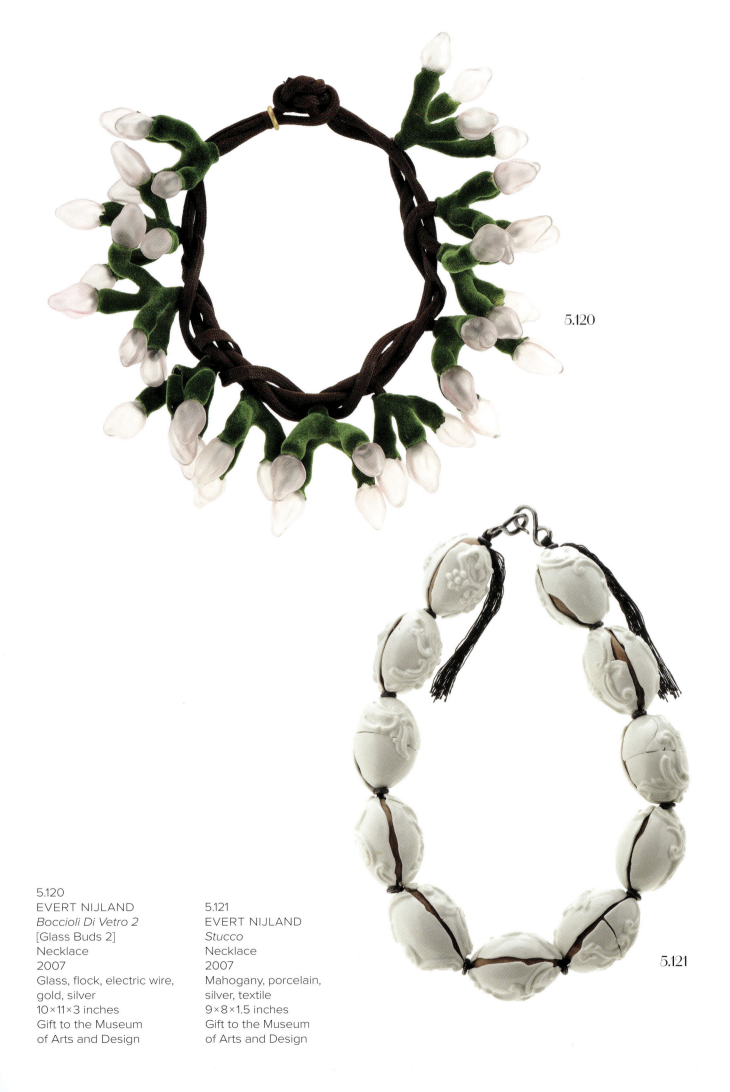

5.120
EVERT NIJLAND
Boccioli Di Vetro 2
[Glass Buds 2]
Necklace
2007
Glass, flock, electric wire, gold, silver
10 × 11 × 3 inches
Gift to the Museum of Arts and Design

5.121
EVERT NIJLAND
Stucco
Necklace
2007
Mahogany, porcelain, silver, textile
9 × 8 × 1.5 inches
Gift to the Museum of Arts and Design

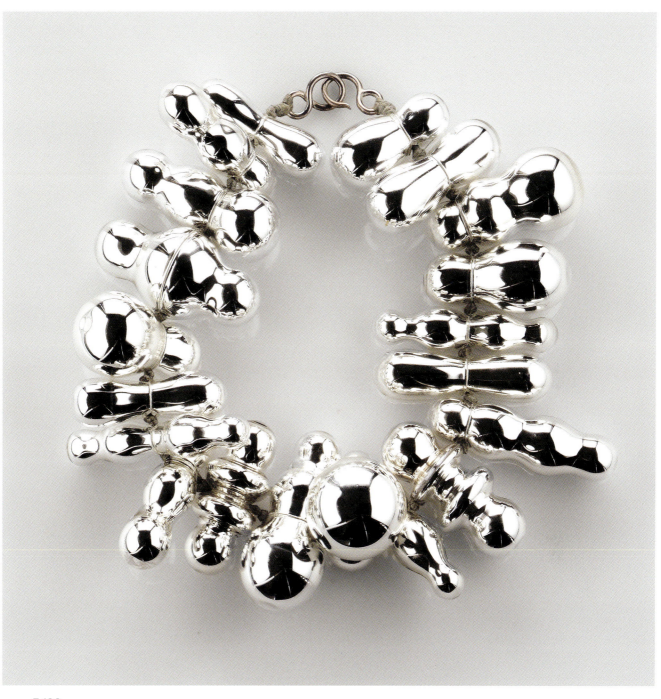

5.122

5.122
EVERT NIJLAND
Imagine Riflessa
Necklace
2007
Glass, silver nitrate, silver, textile
8.5 × 9 × 2 inches
Gift to the Museum of Arts and Design

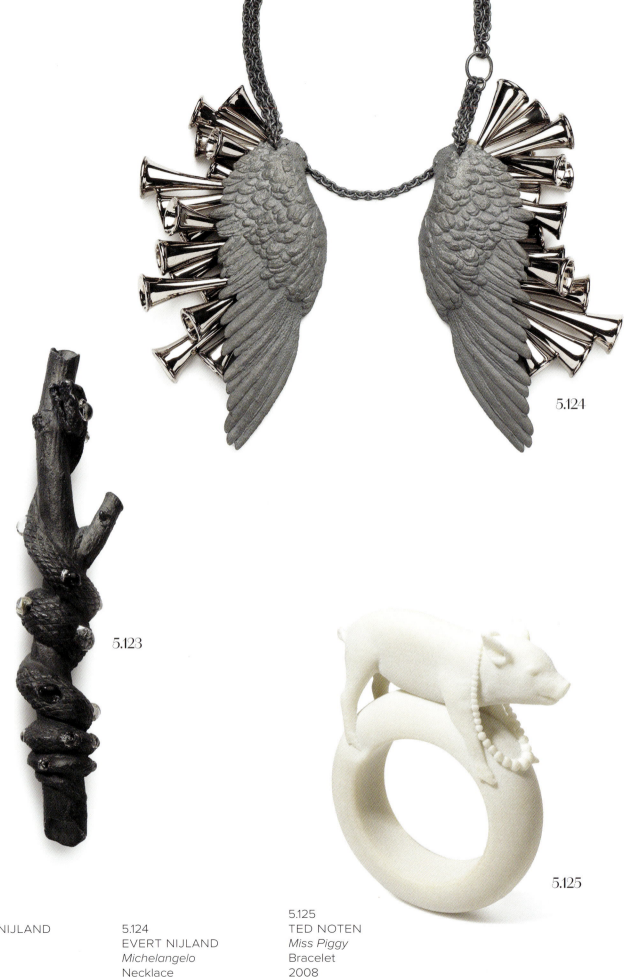

5.123
EVERT NIJLAND
Snake
Brooch
2015
Silver, glass
5.75×1.5×1 inches
Gift to the Museum
of Arts and Design

5.124
EVERT NIJLAND
Michelangelo
Necklace
2021
Silver, glass
9.5×6.3×1.25 inches
Susan Beech Collection

5.125
TED NOTEN
Miss Piggy
Bracelet
2008
Glass-filled nylon
4.58×3.75×1 inches
Gift to the Museum
of Arts and Design

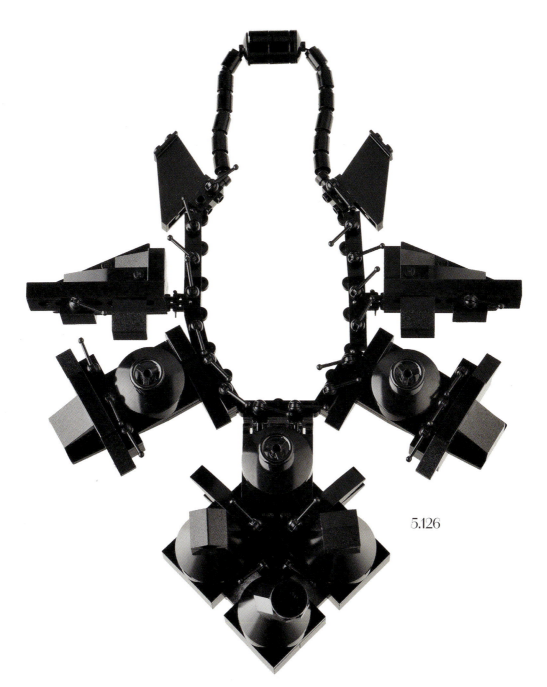

5.126

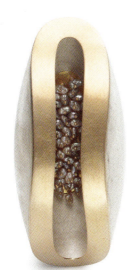

5.127

5.126
EMIKO OYE
The Duchess, from the
My First Royal Jewels
collection
Necklace
2008
Repurposed and recycled
LEGO, nylon-coated steel
cable, sterling silver
11 × 9.25 × 3 inches
Gift to the Renwick
Gallery, Smithsonian
American Art Museum

5.127
BARBARA PAGANIN
Ciprea
Brooch
2003
18-karat gold, sterling
silver, freshwater pearls,
Venetian glass seed
beads
3.75 × 1.375 × 1.25 inches
Gift to the Museum
of Arts and Design

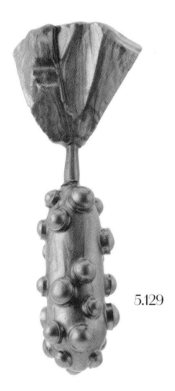
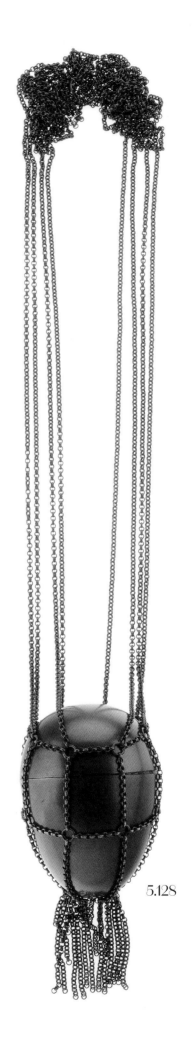

5.128
RUUDT PETERS
Rebecca
Necklace
1992
Oxidized silver
21 inches long
Gift to the Museum
of Arts and Design

5.129
RUUDT PETERS
Kazakstan
Ring
1994
Silver, hematite
4.5 × 1.75 × 1 inches
Susan Beech Collection

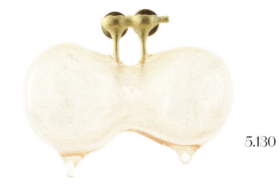

5.130

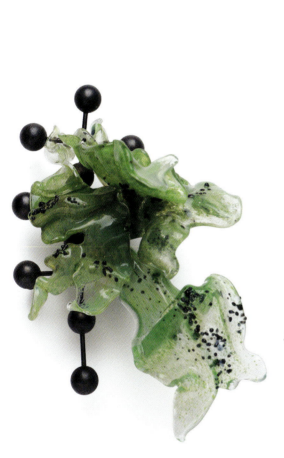

5.131

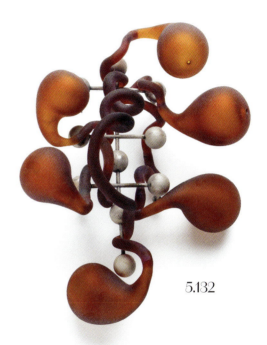

5.132

5.130
RUUDT PETERS
Pneuma
Brooch
2000
Epoxy, gold
3.125 × 2.5 × 1.5 inches
Gift to the Museum
of Arts and Design

5.131
RUUDT PETERS
Aufanim
Brooch
2006
Silver, glass
6 × 4 × 3.75 inches
Gift to the Museum
of Arts and Design

5.132
RUUDT PETERS
Asijah
Brooch
2007
Silver, glass
6.5 × 4 × 3 inches
Gift to the Museum
of Arts and Design

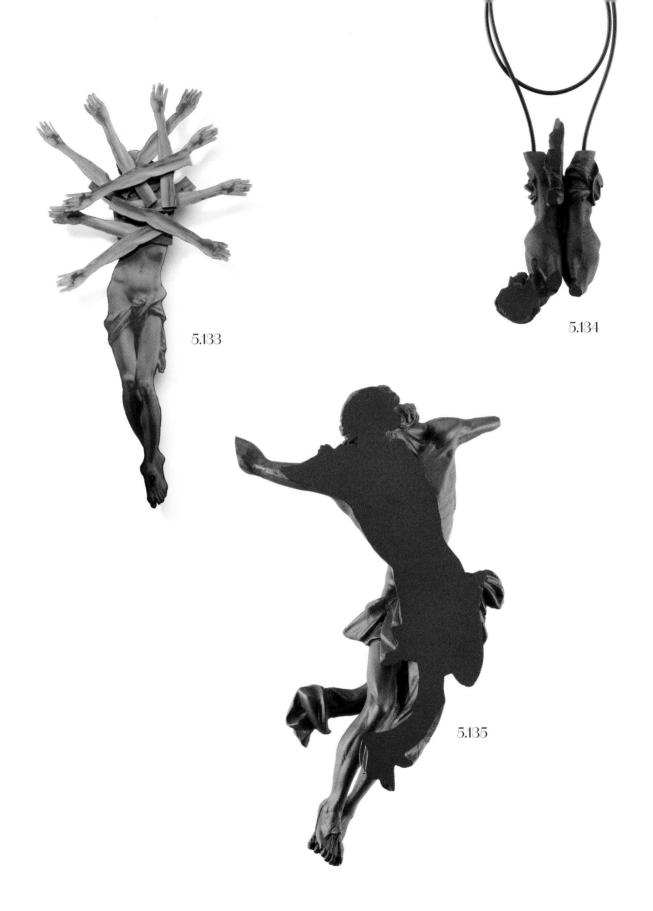

5.133
RUUDT PETERS
Corpus Tree
Brooch
2011
Aluminum, photo, polyester
10.75 × 6 × 0.75 inches
Susan Beech Collection

5.134
RUUDT PETERS
Corpus Talus
Necklace
2011
Polyurethane, rubber
5.75 × 3 × 1 inches
Gift to the Museum of Arts and Design

5.135
RUUDT PETERS
Corpus Cauda
Brooch
2012
Polyurethane, silver
17.5 × 7 × 3 inches
Susan Beech Collection

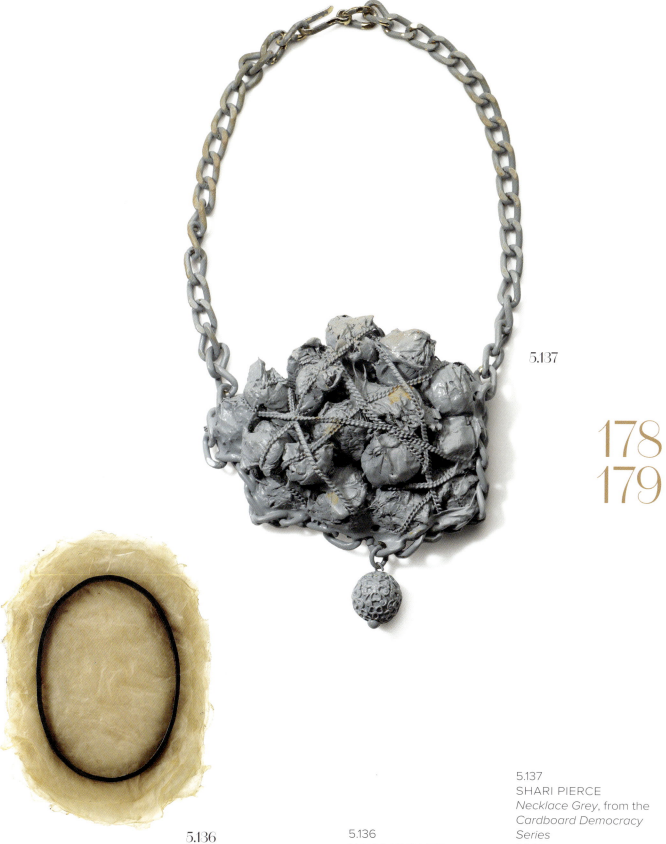

5.137

178
179

5.136
MARIA PHILLIPS
Portrait #1
Brooch
2011
Gut, steel, sterling silver
4.25 × 3 × 0.75 inches
Gift to the Renwick Gallery, Smithsonian American Art Museum

5.137
SHARI PIERCE
Necklace Grey, from the *Cardboard Democracy Series*
2008
Cardboard from boxes, paint (found, or incorrectly mixed colors from hardware store), metal
5 × 1.75 × 11.5 inches
Gift to the Renwick Gallery, Smithsonian American Art Museum

WHEN I FIRST STARTED WEARING THIS KIND OF JEWELRY, I THOUGHT I WOULD GET MORE QUESTIONS ABOUT IT BECAUSE IT IS SO DIFFERENT TO WHAT MOST PEOPLE WEAR.

BUT NOW I AM NOT SURPRISED THAT I ONLY GET OCCASIONAL QUESTIONS. I DO THINK ABOUT HOW I WOULD ANSWER A QUESTION IF SOMEONE ASKED. I WOULD NOT PUT A PIECE ON WITHOUT KNOWING WHO THE ARTIST IS, WHAT IT'S MADE OF, AND WHY IT WAS MADE. I WOULDN'T WANT SOMEONE ASKING QUESTIONS AND NOT BE ABLE TO ANSWER WELL. I AM VERY INTERESTED IN THE JEWELRY I WEAR, THAT I COLLECT. I DON'T JUST THROW JEWELRY ON FOR NO REASON.
—SUSAN BEECH

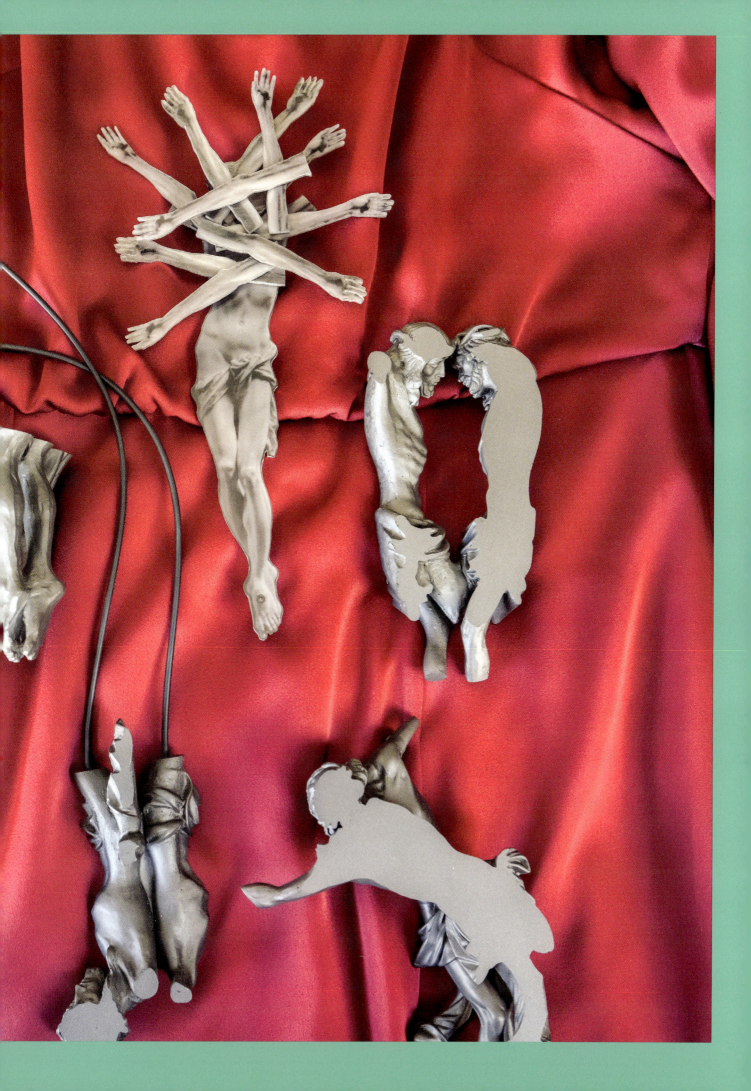

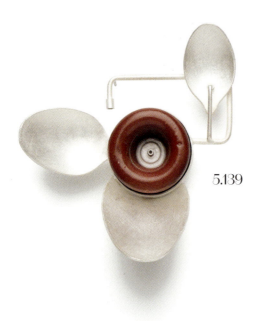

5.139

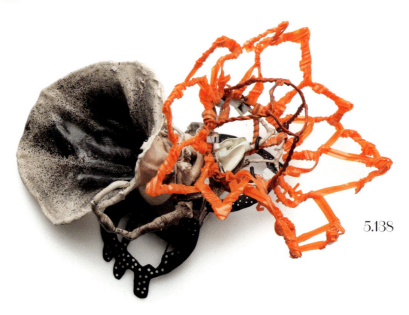

5.138

5.138
LAURA
PRIETO-VELASCO
Zap
Brooch
2011
Iron wire, latex paint,
copper, electrical wire,
tulle, twist ties, brass
3.25 × 5.18 × 6.78 inches
Gift to the Renwick
Gallery, Smithsonian
American Art Museum

5.139
KATJA PRINS
Continuum
Brooch
2007
Silver, sealing wax
3.125 × 2.875 × 1.375 inches
Gift to the Museum
of Arts and Design

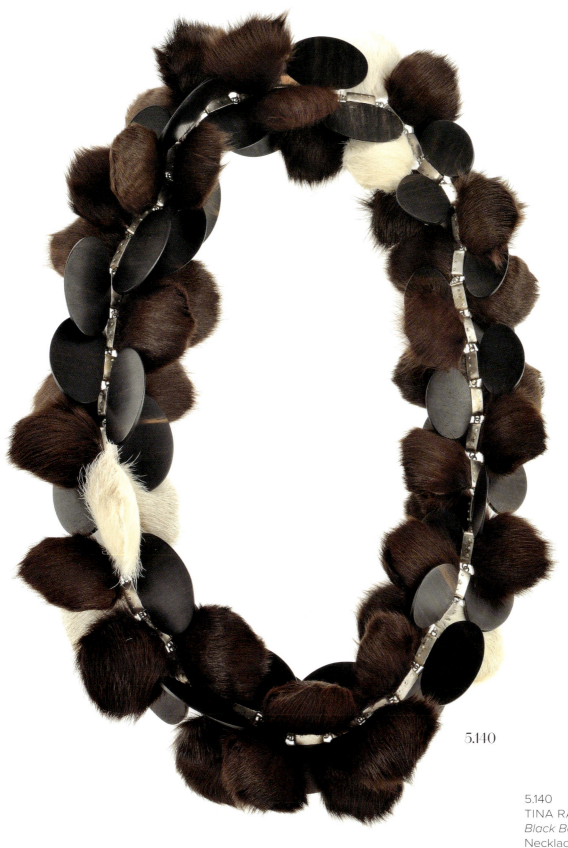

182
183

5.140

5.140
TINA RATH
Black Beauty Lei
Necklace
2004
Ebony, horsehair,
sterling silver
14 inches in diameter
Gift to the Renwick
Gallery, Smithsonian
American Art Museum

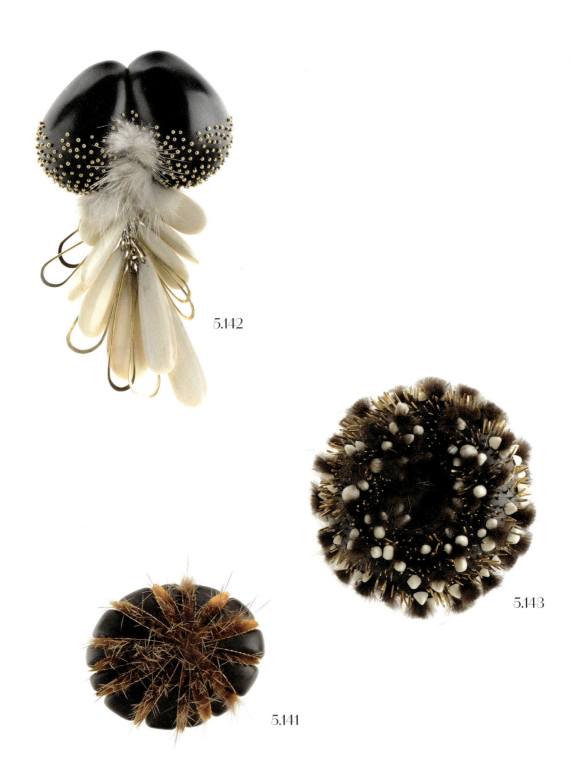

5.141
TINA RATH
Coralite I
Brooch
2006
African blackwood,
18-karat gold, mink
2.25 × 2 × 1 inches
Gift to the Renwick
Gallery, Smithsonian
American Art Museum

5.142
TINA RATH
Siphonopores I
Brooch
2007
African blackwood, ivory,
whale tooth, 18-karat gold,
mink
4.5 × 2.5 × 1.75 inches
Susan Beech Collection

5.143
TINA RATH
Sea Urchin
Brooch
2008
African blackwood, ivory,
18-karat gold, mink
2.75 inches in diameter ×
1.75 inches
Susan Beech Collection

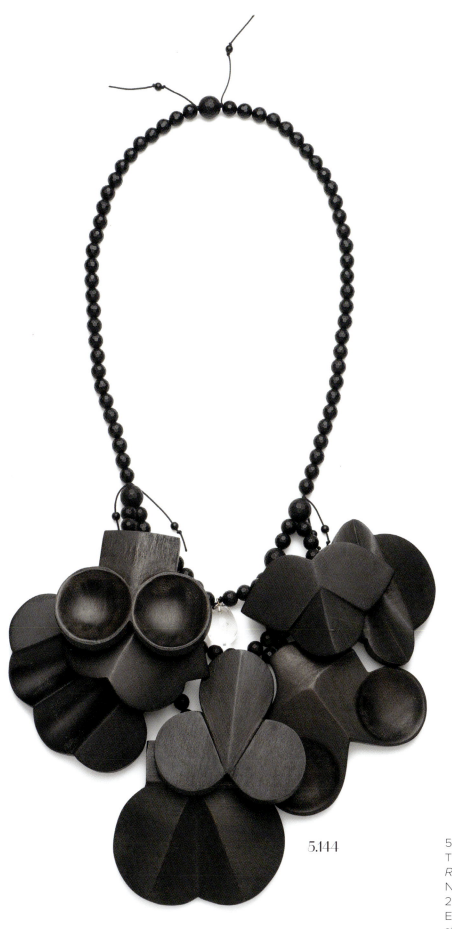

5.144

5.144
TINA RATH
Requiem Mala No. 7
Necklace
2022
Ebonized lime wood, sterling silver, faceted onyx, cord
Largest piece: 3 × 3.25 × 0.25 inches
Gift to the Renwick Gallery, Smithsonian American Art Museum

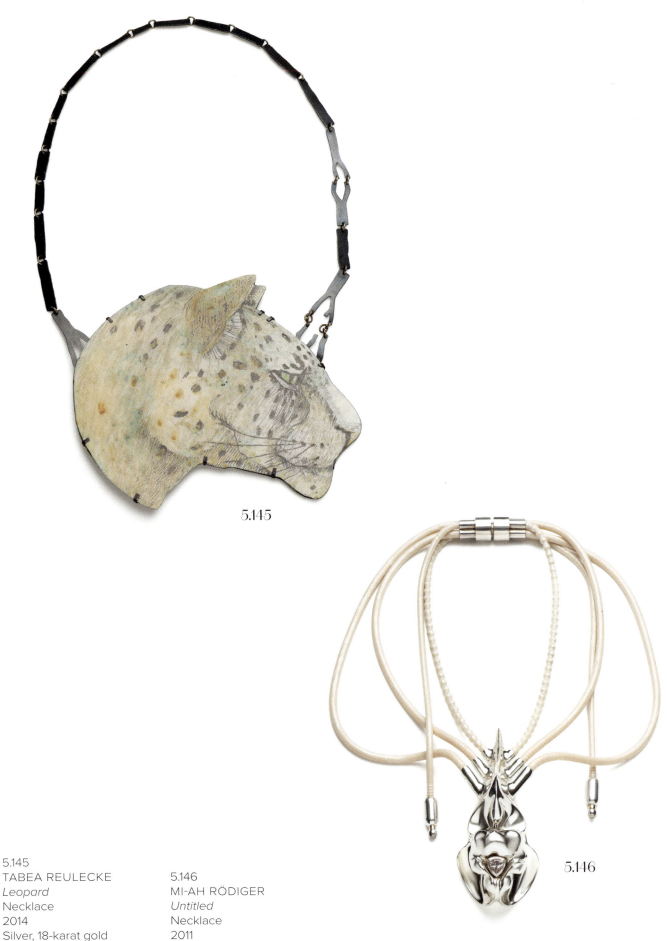

5.145

5.145
TABEA REULECKE
Leopard
Necklace
2014
Silver, 18-karat gold
enamel, copper
Pendant: 5.5 × 4.625 ×
0.125 inches
Susan Beech Collection

5.146
MI-AH RÖDIGER
Untitled
Necklace
2011
Silver, tourmaline, resin,
silver plate, silicon rubber
5 × 2.25 × 1.875 inches
Susan Beech Collection

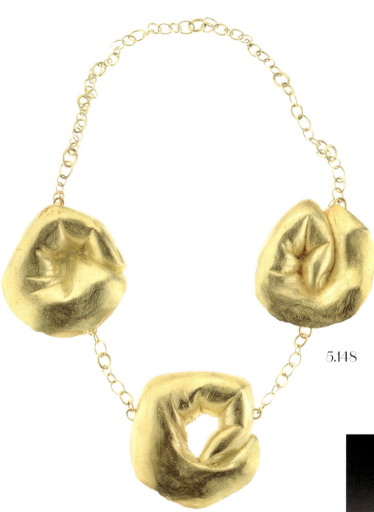

5.148

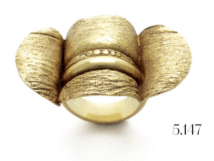

5.147

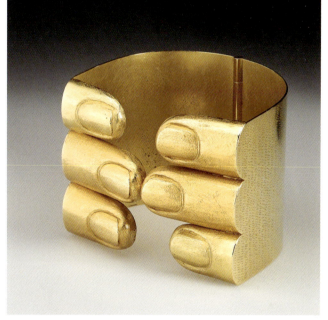

5.149

5.147
GERD ROTHMANN
Two Rings on Finger from Susan
Ring
2005
18-karat gold
1.75 × 1 × 0.875 inches
Susan Beech Collection

5.148
GERD ROTHMANN
Three Symbols
Necklace
2008
18-karat gold
8 × 8 × 0.5 inches
Susan Beech Collection

5.149
GERD ROTHMANN
Über die Berührung bei Michelangelo
[Touching Michelangelo]
Bracelet
2012
18-karat gold
2.375 × 1.75 × 2 inches
Susan Beech Collection

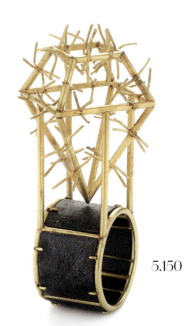

5.150

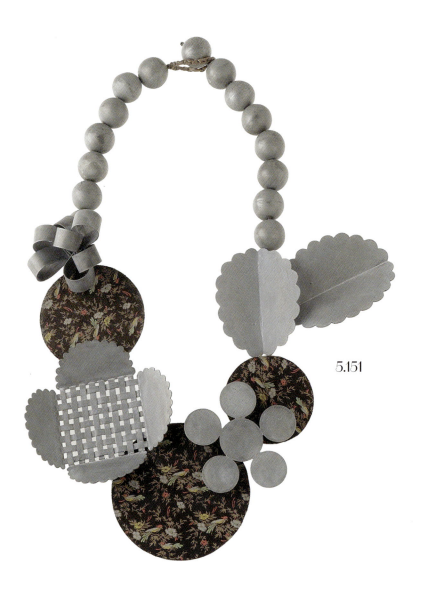

5.151

5.150
PHILIP SAJET
Cactus Ring
2010
Gold, silver, niello
2.25×1.25×1.25 inches
Gift to the Museum
of Arts and Design

5.151
LUCY SARNEEL
Untitled
Necklace
2008
Zinc, fabric
11×9×1.25 inches
Gift to the Museum
of Arts and Design

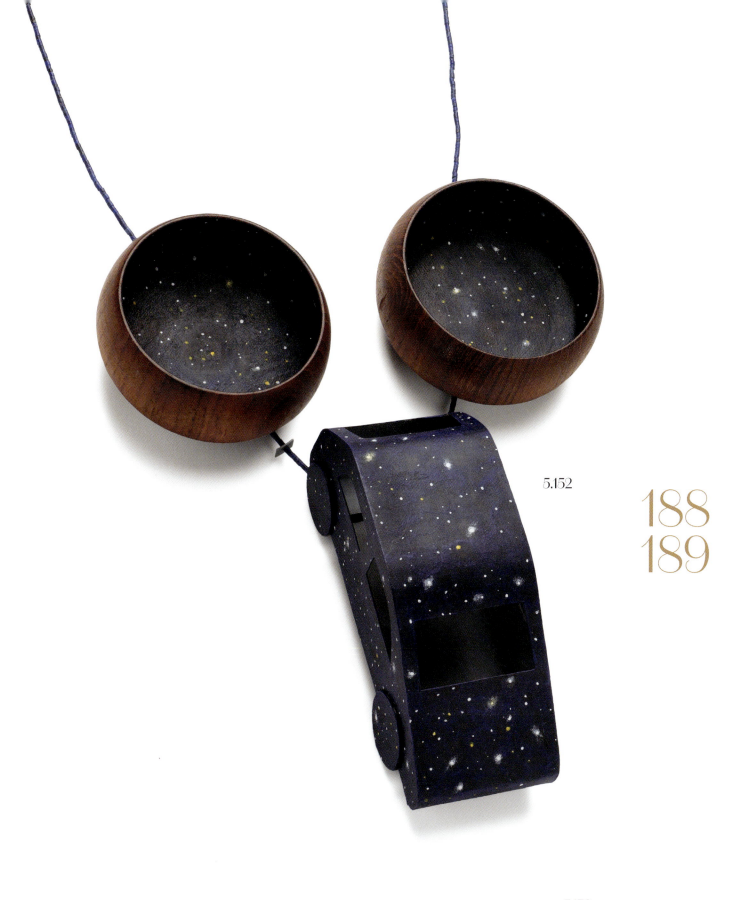

5.152
LUCY SARNEEL
Starry Sky Drive #2
Necklace
2014
Zinc, cotton thread, lapis lazuli, acrylic paint, varnish, wood
17.313 × 5.875 × 1.93 inches
Susan Beech Collection

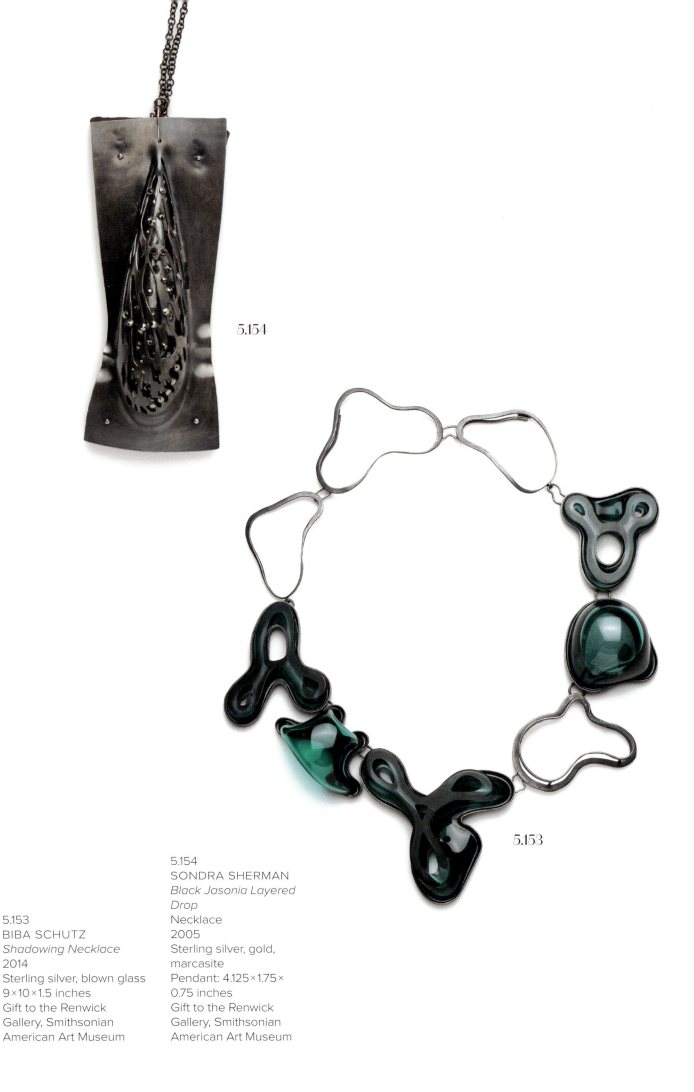

5.154

5.153

5.153
BIBA SCHUTZ
Shadowing Necklace
2014
Sterling silver, blown glass
9 × 10 × 1.5 inches
Gift to the Renwick Gallery, Smithsonian American Art Museum

5.154
SONDRA SHERMAN
Black Jasonia Layered Drop
Necklace
2005
Sterling silver, gold, marcasite
Pendant: 4.125 × 1.75 × 0.75 inches
Gift to the Renwick Gallery, Smithsonian American Art Museum

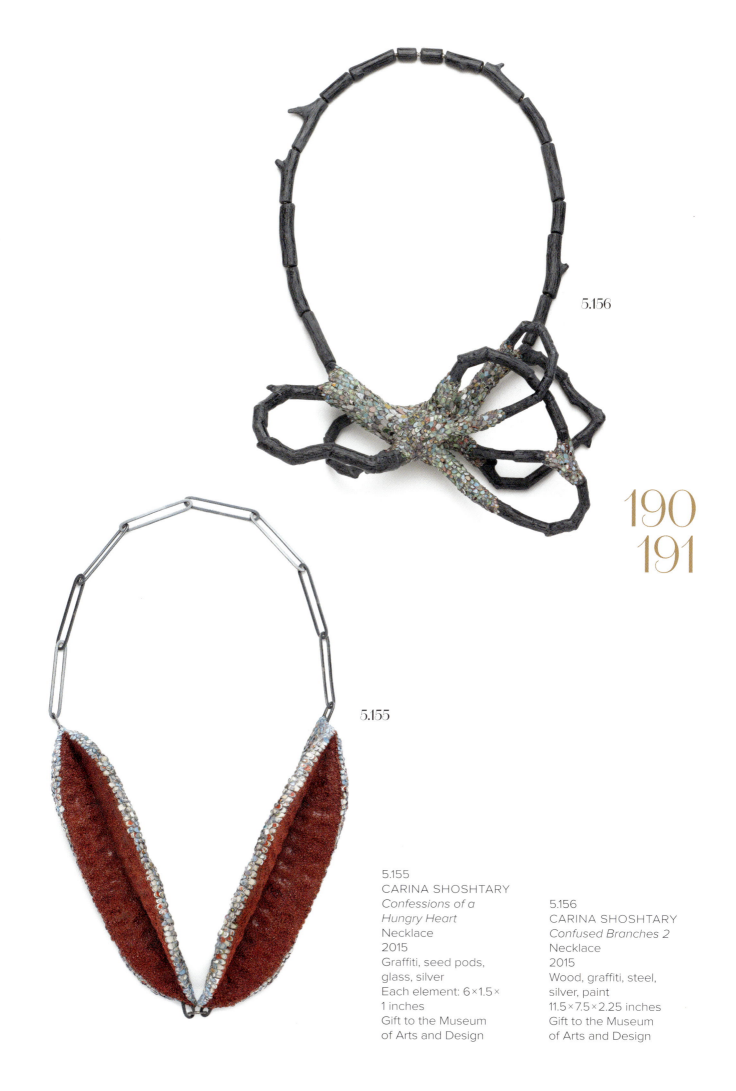

5.155
CARINA SHOSHTARY
Confessions of a Hungry Heart
Necklace
2015
Graffiti, seed pods, glass, silver
Each element: 6 × 1.5 × 1 inches
Gift to the Museum of Arts and Design

5.156
CARINA SHOSHTARY
Confused Branches 2
Necklace
2015
Wood, graffiti, steel, silver, paint
11.5 × 7.5 × 2.25 inches
Gift to the Museum of Arts and Design

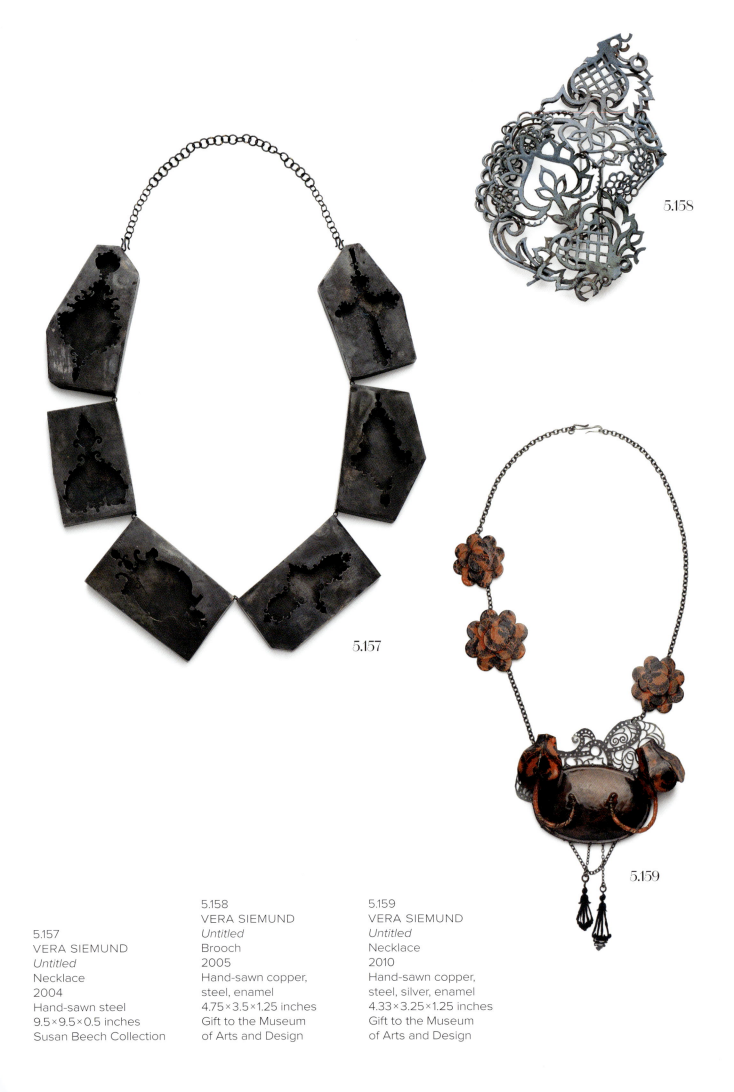

5.157
VERA SIEMUND
Untitled
Necklace
2004
Hand-sawn steel
9.5×9.5×0.5 inches
Susan Beech Collection

5.158
VERA SIEMUND
Untitled
Brooch
2005
Hand-sawn copper, steel, enamel
4.75×3.5×1.25 inches
Gift to the Museum of Arts and Design

5.159
VERA SIEMUND
Untitled
Necklace
2010
Hand-sawn copper, steel, silver, enamel
4.33×3.25×1.25 inches
Gift to the Museum of Arts and Design

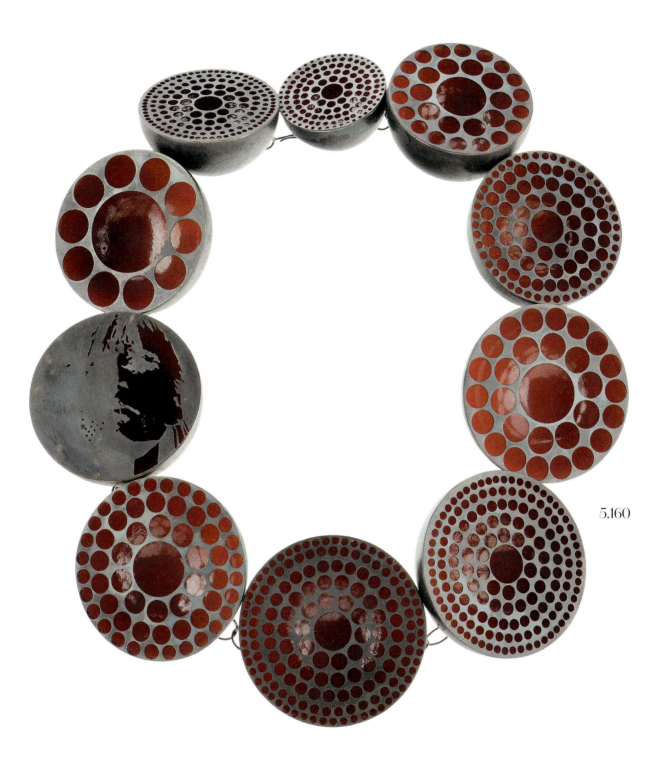

5.160
VERA SIEMUND
Untitled
Necklace
2011
Enameled steel
9 × 8.75 × 1.5 inches
Susan Beech Collection

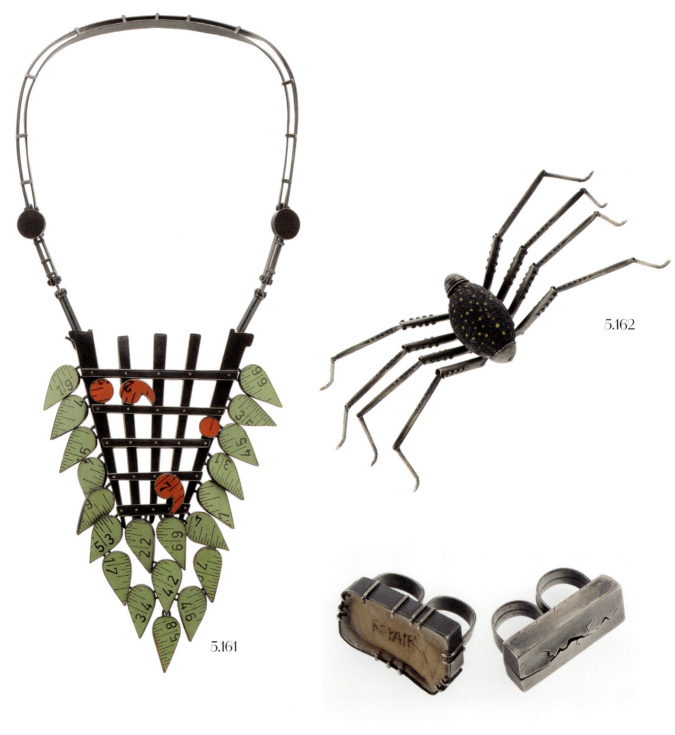

5.161
KIFF SLEMMONS
Green Thoughts
Necklace
2000
Silver, ebony, wooden ruler fragments
13.75 × 6 × 0.5 inches
Gift to the Renwick Gallery, Smithsonian American Art Museum

5.162
KIFF SLEMMONS
Aranea
Brooch
2005
Sterling silver, enameled copper, with found piece by Bettina Dittlmann
3 × 8 × 1.75 inches
Gift to the Renwick Gallery, Smithsonian American Art Museum

5.163
KIFF SLEMMONS
Relic (left)
Ring
2005
Silver, mica, wrapped synthetic resin, paper, with found piece by Thomas Gentille
1 × 1.75 × 1.25 inches
Gift to the Renwick Gallery, Smithsonian American Art Museum

Fault (right)
Ring
2005
Silver, with found piece by Thomas Gentille
1 × 1.75 × 1.25 inches
Gift to the Renwick Gallery, Smithsonian American Art Museum

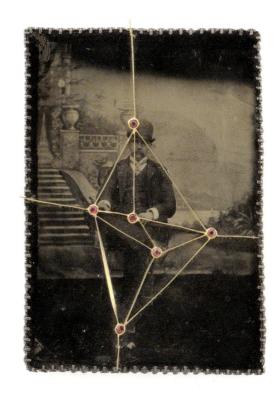

5.165

5.164

5.166

5.164
BETTINA SPECKNER
Untitled
Brooch
2004
Photograph in enamel, sterling silver, turquoise
1.875 × 3 × 0.25 inches
Gift to the Museum of Arts and Design

5.165
BETTINA SPECKNER
Untitled
Brooch
2005
Ferrotype (found object), 18-karat red gold, sterling silver, rubies
3.75 × 2.75 × 0.25 inches
Gift to the Museum of Arts and Design

5.166
TRACY STEEPY
Raised
Brooch
2006
Silver, Corian, resin
2 × 3.25 × 0.5 inches
Gift to the Renwick Gallery, Smithsonian American Art Museum

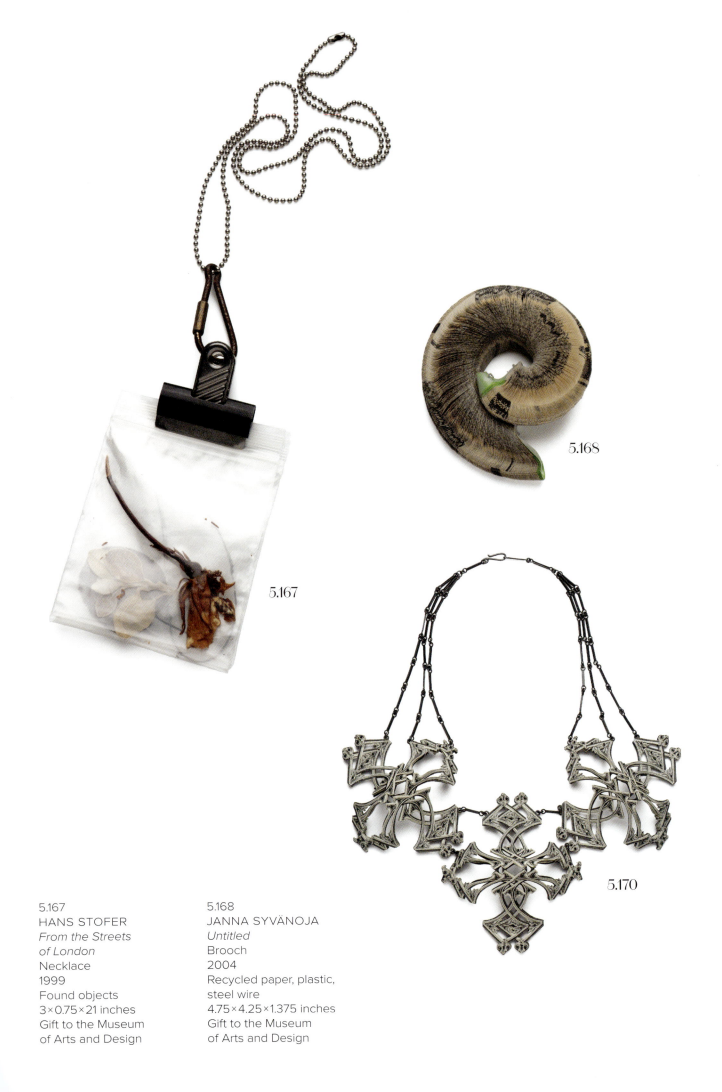

5.167
HANS STOFER
From the Streets of London
Necklace
1999
Found objects
3 × 0.75 × 21 inches
Gift to the Museum of Arts and Design

5.168
JANNA SYVÄNOJA
Untitled
Brooch
2004
Recycled paper, plastic, steel wire
4.75 × 4.25 × 1.375 inches
Gift to the Museum of Arts and Design

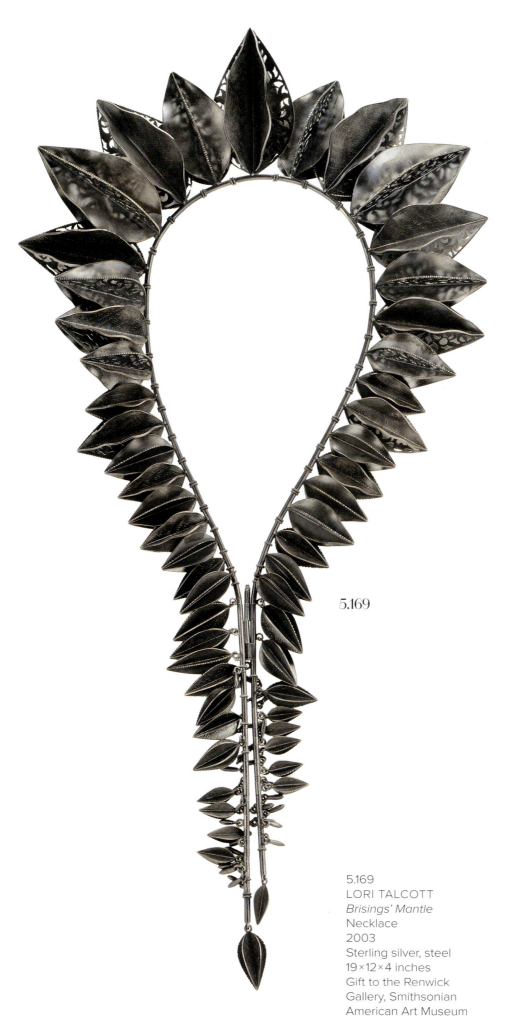

5.169

5.169
LORI TALCOTT
Brisings' Mantle
Necklace
2003
Sterling silver, steel
19 × 12 × 4 inches
Gift to the Renwick
Gallery, Smithsonian
American Art Museum

5.170
LAUREN TICKLE
$192 Currency Converted
Necklace
2015
US dollars, silver,
monofilament
Each element: 1.75 × 1 ×
0.875 inches
Susan Beech Collection

WEARING IS AT THE CORE OF MY COLLECTING ACTIVITIES, BUT IT DOESN'T MEAN THAT EVERYTHING NEEDS TO BE WEARABLE.

IT JUST NEEDS THE POSSIBILITY OF WEARABILITY. WHEN A PIECE ARRIVES, I PUT IT ON AND WEAR IT AROUND THE HOUSE TO SEE HOW COMFORTABLE IT IS, AND TO WORK OUT HOW I FEEL ABOUT IT. I MAY OR MAY NOT END UP WEARING IT OUT OF THE HOUSE. THERE ARE ONLY A FEW WORKS IN MY COLLECTION THAT CAN'T BE WORN, MOSTLY BECAUSE OF SIZE OR WEIGHT. THERE ARE OTHERS THAT I PROBABLY WILL NEVER WEAR, EVEN THOUGH THEY ARE ENTIRELY WEARABLE. I HAVE A NUMBER OF GLASS NECKPIECES THAT ARE FRAGILE, OR THEY FEEL LIKE THEY ARE FRAGILE. SOME NECKPIECES AND BROOCHES ARE HARD TO WEAR BECAUSE THEY GET IN THE WAY OF A CAR SEAT BELT OR HAVE SOME OTHER KIND OF PRACTICAL IMPEDIMENT.

—SUSAN BEECH

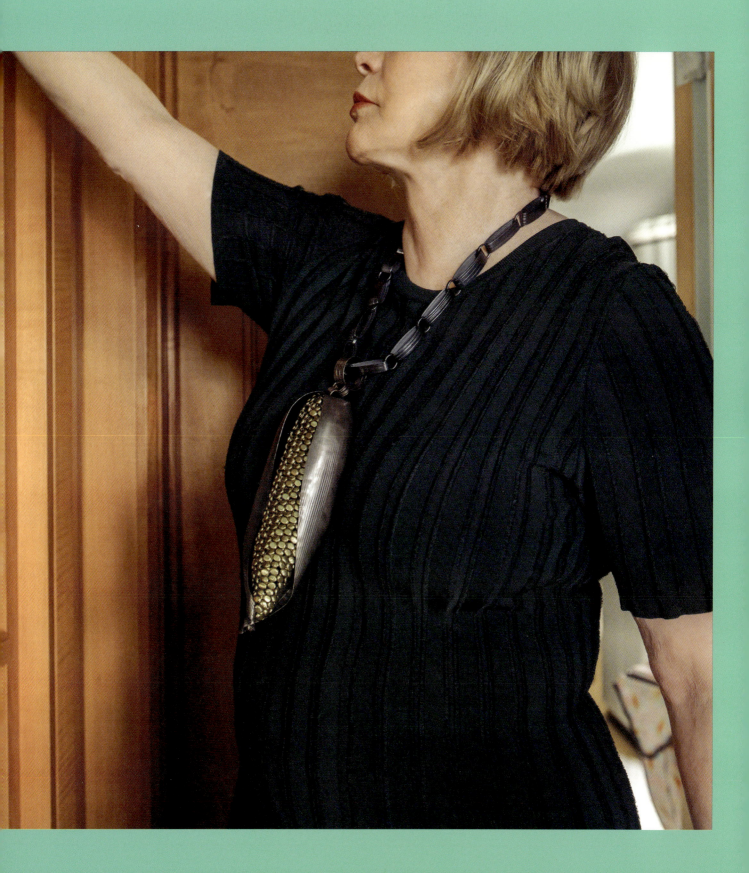

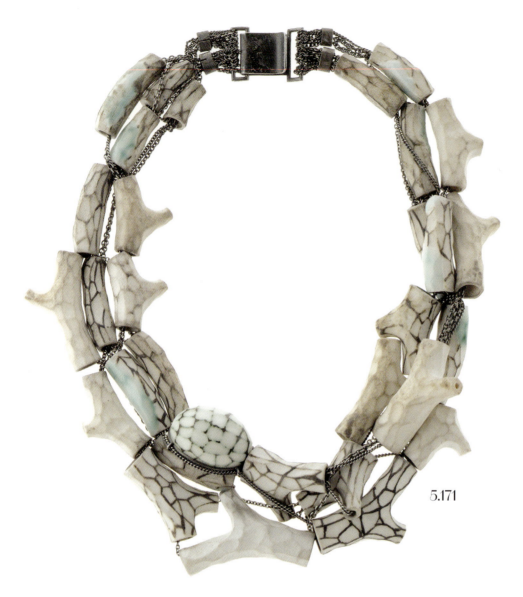

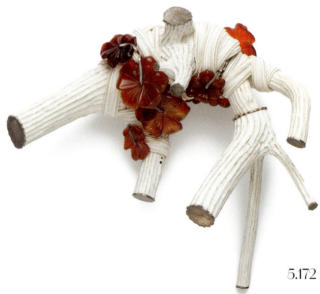

5.171
TERHI TOLVANEN
Zig-Zag
Necklace
2007
Porcelain, silver
8 × 6.5 × 1 inches
Gift to the Museum
of Arts and Design

5.172
TERHI TOLVANEN
Jardin Japonais
[Japanese Garden]
Brooch
2009
Wood, paint, silver,
carnelian, textile
4 × 4.625 × 2.25 inches
Susan Beech Collection

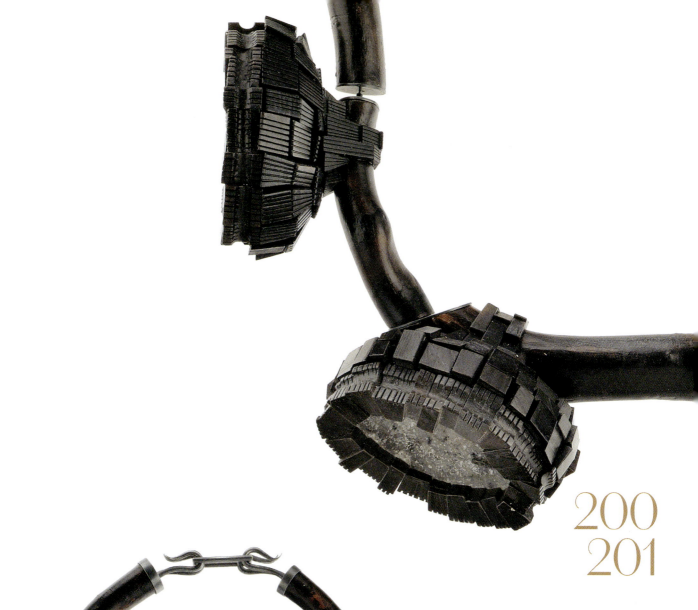

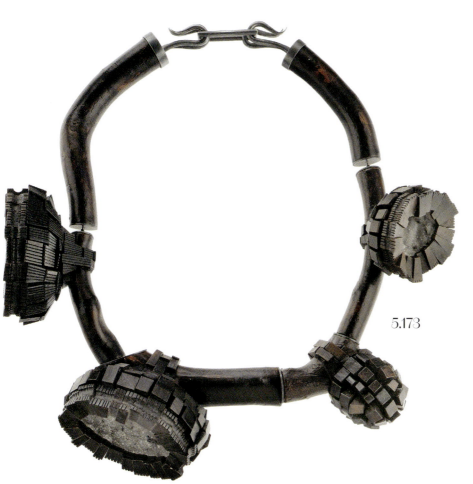

5.173
TERHI TOLVANEN
Rolexia
Necklace
2009
Agate, wood, paint, silver
9.5 × 9 × 2.5 inches
Susan Beech Collection

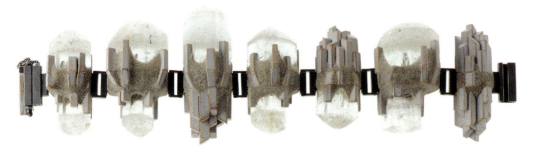

5.175

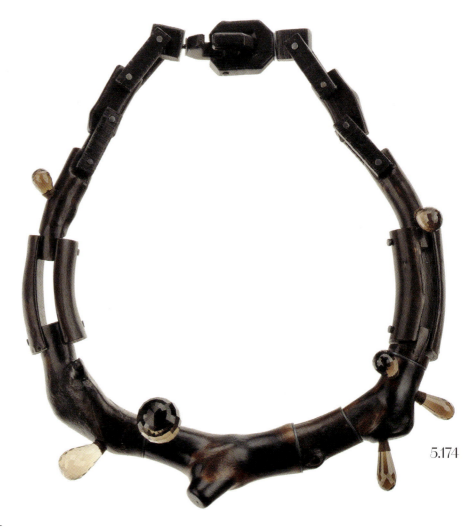

5.174

5.174
TERHI TOLVANEN
Chaine [Chain]
Necklace
2009
Smoky quartz, mixed wood, silver
8.5 × 7 × 1.75 inches
Gift to the Museum of Arts and Design

5.175
TERHI TOLVANEN
Skyline
Bracelet
2012
Silver, aquamarine, cherry wood, cement, paint
9 × 2.75 × 1.125 inches
Gift to the Museum of Arts and Design

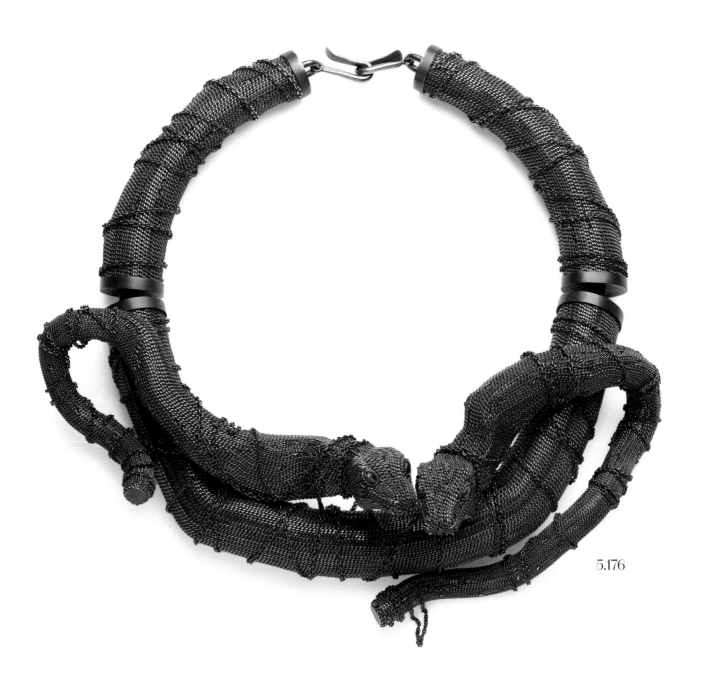

5.176
TERHI TOLVANEN
Jungle Twins
Necklace
2014
Silver, wood, hawk's-eye
7.8 inches long
Susan Beech Collection

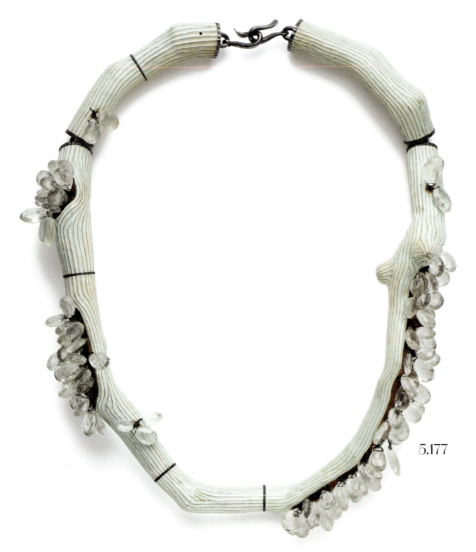

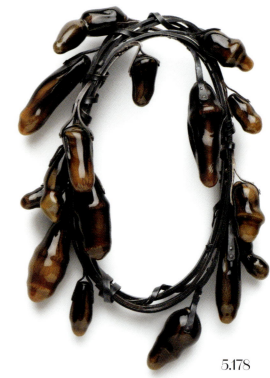

5.177
TERHI TOLVANEN
Jungle Scenery 2
Necklace
2014
Ivy wood, prasiolite, silver, paint
9 × 7.5 × 1.25 inches
Gift to the Museum of Arts and Design

5.178
TERHI TOLVANEN
Jungle Garland
Brooch
2014
Silver, wood, silk, lacquer
5.25 × 3.5 × 1.25 inches
Gift to the Museum of Arts and Design

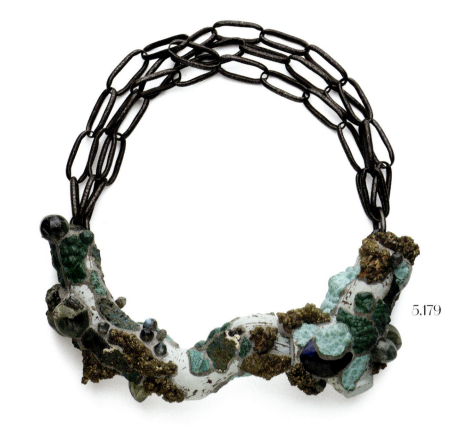

5.179

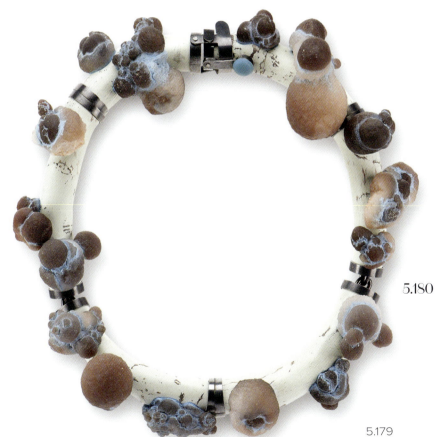

5.180

5.179
TERHI TOLVANEN
Mossy Branch
Necklace
2015
Malachite-chrysocolla,
labradorite, quartz,
prehnite, hazelnut wood,
cement, steel, paint
8.26 inches long
Gift to the Museum
of Arts and Design

5.180
TERHI TOLVANEN
Seeds
Necklace
2016
Silver, chalcedony,
reconstructed opal,
wood, paint
8.25 × 8.5 × 2.5 inches
Gift to the Museum
of Arts and Design

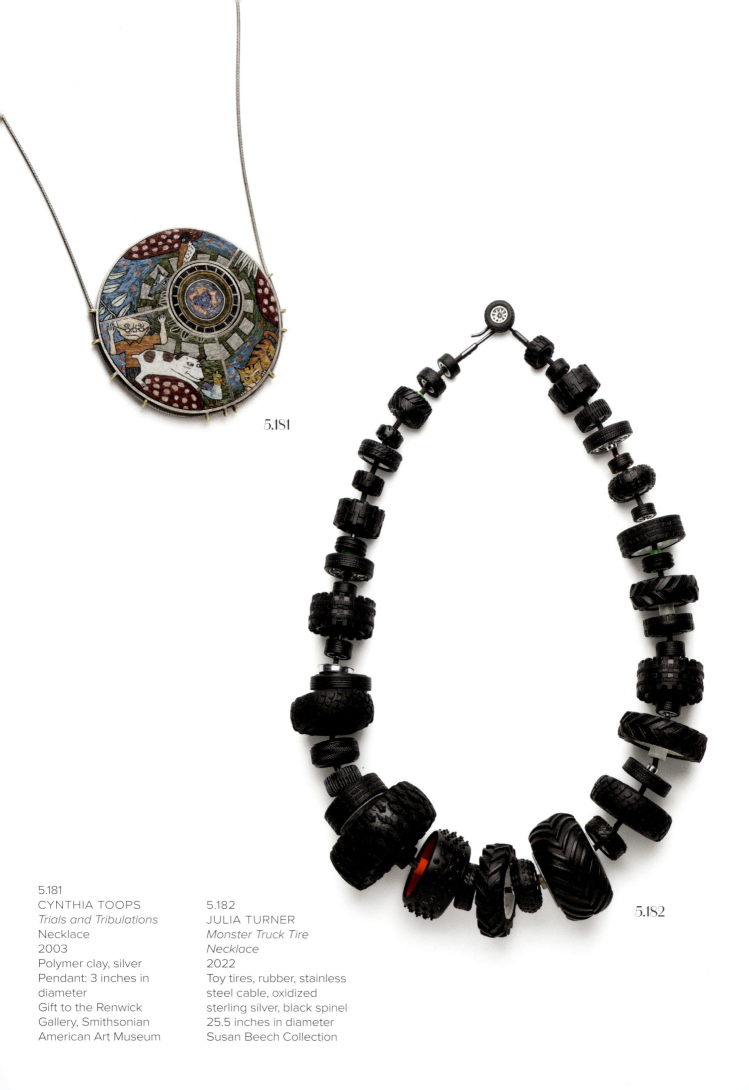

5.181
CYNTHIA TOOPS
Trials and Tribulations
Necklace
2003
Polymer clay, silver
Pendant: 3 inches in diameter
Gift to the Renwick Gallery, Smithsonian American Art Museum

5.182
JULIA TURNER
Monster Truck Tire Necklace
2022
Toy tires, rubber, stainless steel cable, oxidized sterling silver, black spinel
25.5 inches in diameter
Susan Beech Collection

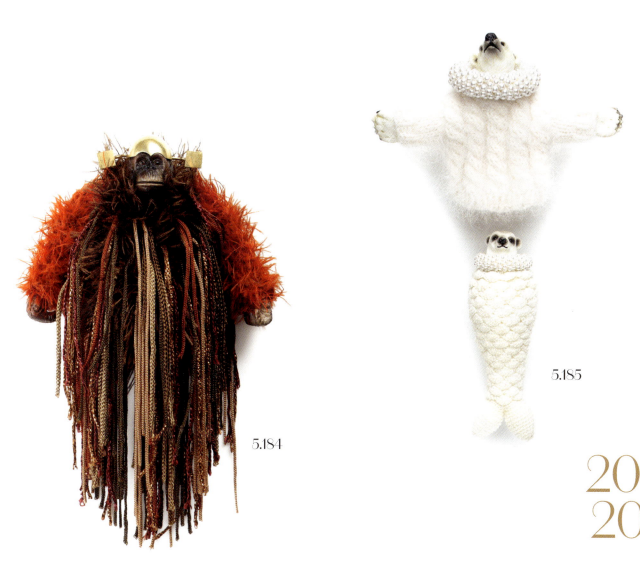

5.183
TARJA TUUPANEN
Brooch
2009
Cachalong, sterling silver
5 × 4 × 0.25 inches
Gift to the Museum
of Arts and Design

5.184
FELIEKE VAN DER LEEST
Zeeuws Meisje
[Zealand Girl]
Brooch
2004
Textile, plastic animal,
18-karat gold
6 × 4 × 2 inches
Gift to the Museum
of Arts and Design

5.185
FELIEKE VAN DER LEEST
Pregnant Polar Bearmaid
Object with brooch
2005
Textile, plastic animals,
silver, plastic beads
4 × 1.375 × 1.125 inches
Gift to the Museum
of Arts and Design

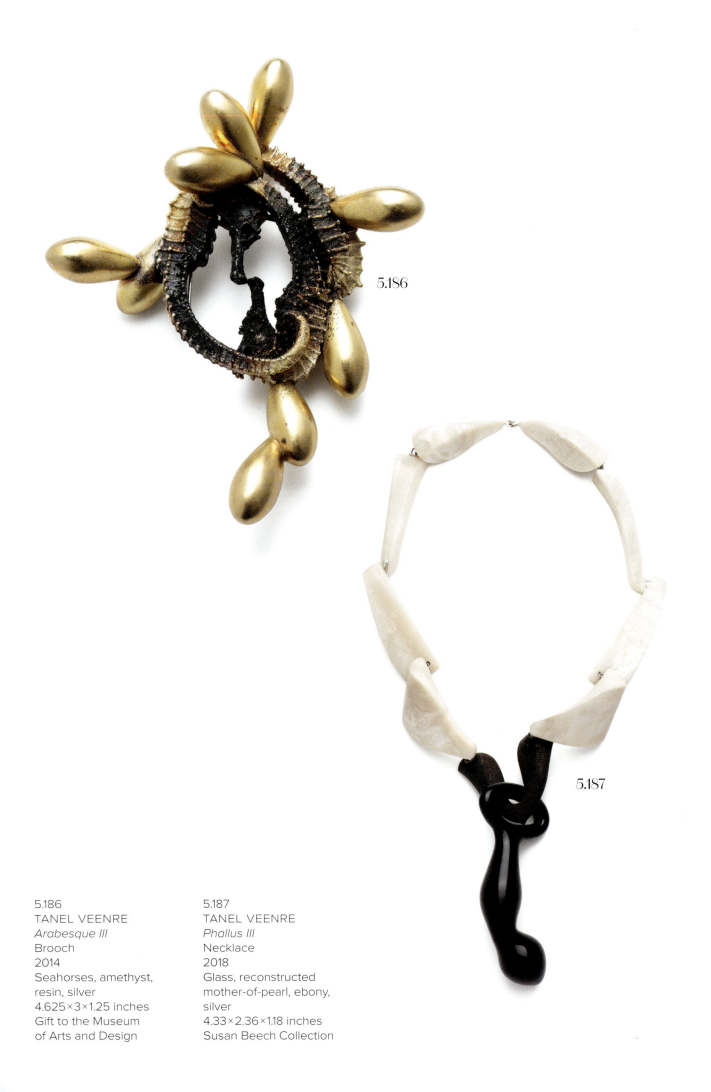

5.186
TANEL VEENRE
Arabesque III
Brooch
2014
Seahorses, amethyst, resin, silver
4.625 × 3 × 1.25 inches
Gift to the Museum of Arts and Design

5.187
TANEL VEENRE
Phallus III
Necklace
2018
Glass, reconstructed mother-of-pearl, ebony, silver
4.33 × 2.36 × 1.18 inches
Susan Beech Collection

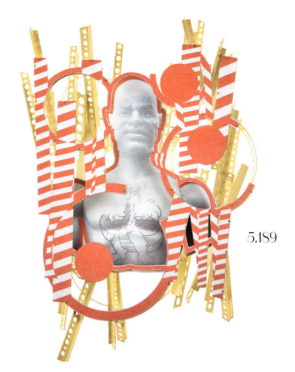

5.189

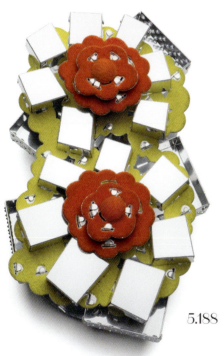

5.188

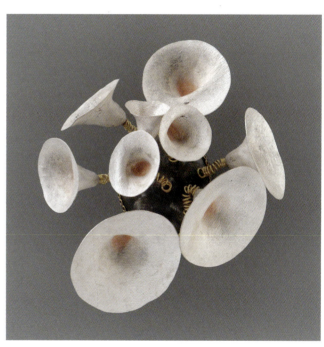

5.190

5.188
NORMAN WEBER
Preziose #1
[Precious #1]
Brooch
1999
Aluminum, flock, synthetic stones, steel, 18-karat gold
4.92×2.95×1.42 inches
Gift to the Museum of Arts and Design

5.189
NORMAN WEBER
Portrait #5
Brooch
2006
Silver, lacquer, digital print
6.25×4.5×2 inches
Gift to the Museum of Arts and Design

5.190
HEATHER WHITE VAN STOLK
Botanical Fiction: Trumpet Flower Corsage
Brooch
2004
22-karat gold, sterling silver, nickel, oil paint
4.5×4×2 inches
Gift to the Renwick Gallery, Smithsonian American Art Museum

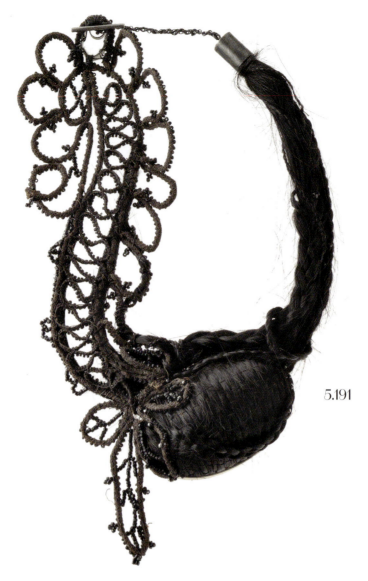
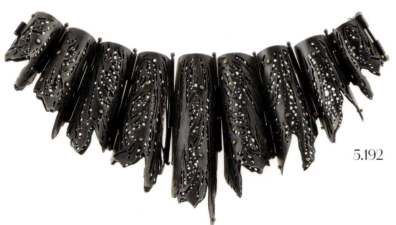
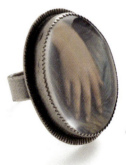

5.191
FRANCIS WILLEMSTIJN
Hair
Necklace
2006
Human hair, glass, jet, silver, textile
10 × 6.875 × 1 inches
Gift to the Museum of Arts and Design

5.192
FRANCIS WILLEMSTIJN
Tulips
Bracelet
2006
Silver, gold
3.125 × 3.5 × 1.75 inches
Gift to the Museum of Arts and Design

5.193
ROBERTA AND DAVE WILLIAMSON
Ring #34
2008
Sterling silver, photograph, glass
1.313 × 2 × 1.188 inches
Gift to the Renwick Gallery, Smithsonian American Art Museum

5.194
NANCY WORDEN
Lifting Weights
Necklace
2004
Silver, 14-karat white gold, brass, horn, ebony piano keys, coins, bone, lead weights, glass eyes, cotton cord
20 × 10.5 × 0.75 inches
Gift to the Renwick Gallery, Smithsonian American Art Museum

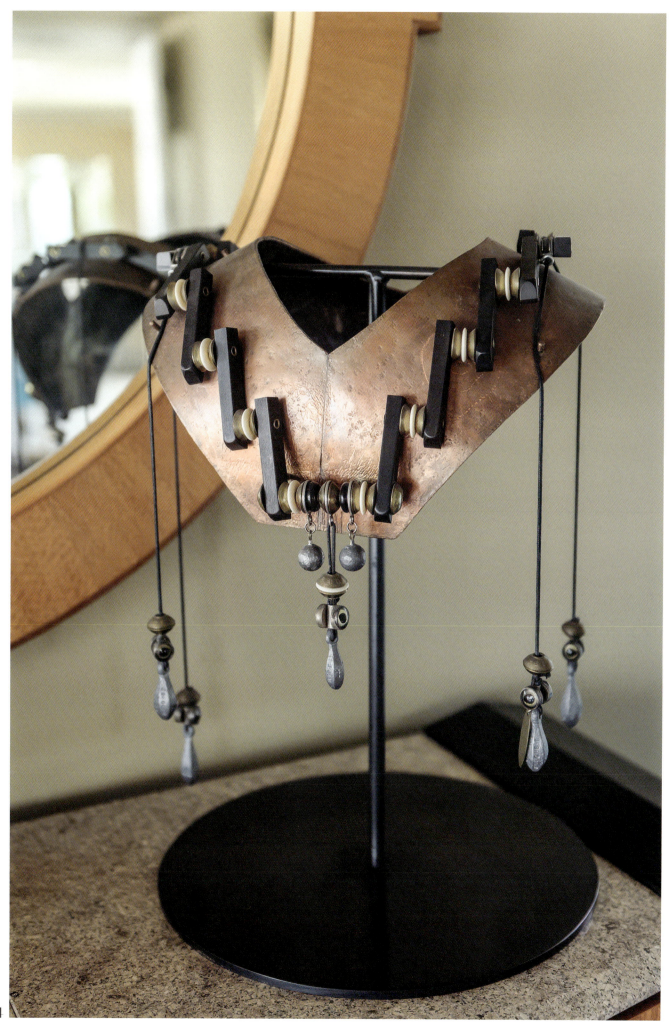

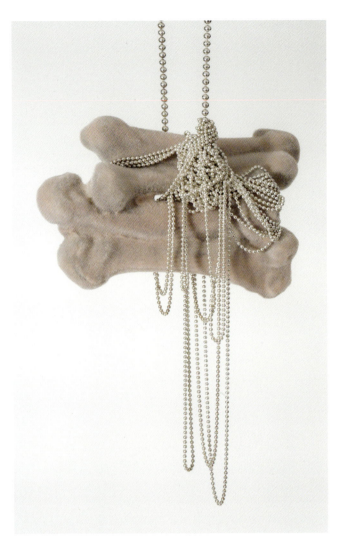

5.198

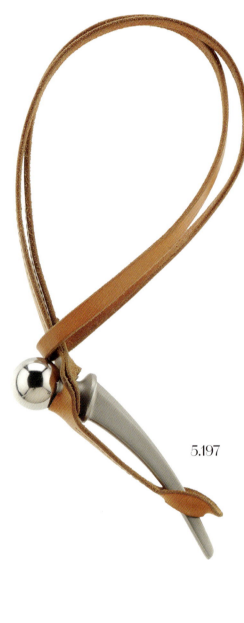

5.197

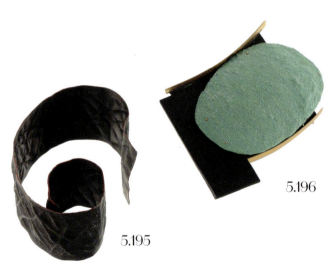

5.196

5.195

5.195
ANNAMARIA ZANELLA
Untitled
Bracelet
2005
Silver, enamel paint
2×3×2.25 inches
Gift to the Museum
of Arts and Design

5.196
ANNAMARIA ZANELLA
Penelope
Brooch
2006
Gold, silver, ebony, copper
3.5×2.75×0.5 inches
Gift to the Museum
of Arts and Design

5.197
CHRISTOPH ZELLWEGER
Hip Piece #2401
Second-hand hip
replacement
Neckpiece
2002
Photo-etched stainless
steel, leather
Pendant: 6×1.75×
1.25 inches
Gift to the Museum
of Arts and Design

5.198
CHRISTOPH ZELLWEGER
Relic Rosé
Pendant
2006
Mixed media, silver, flock
4×1.25×20 inches
Gift to the Museum
of Arts and Design

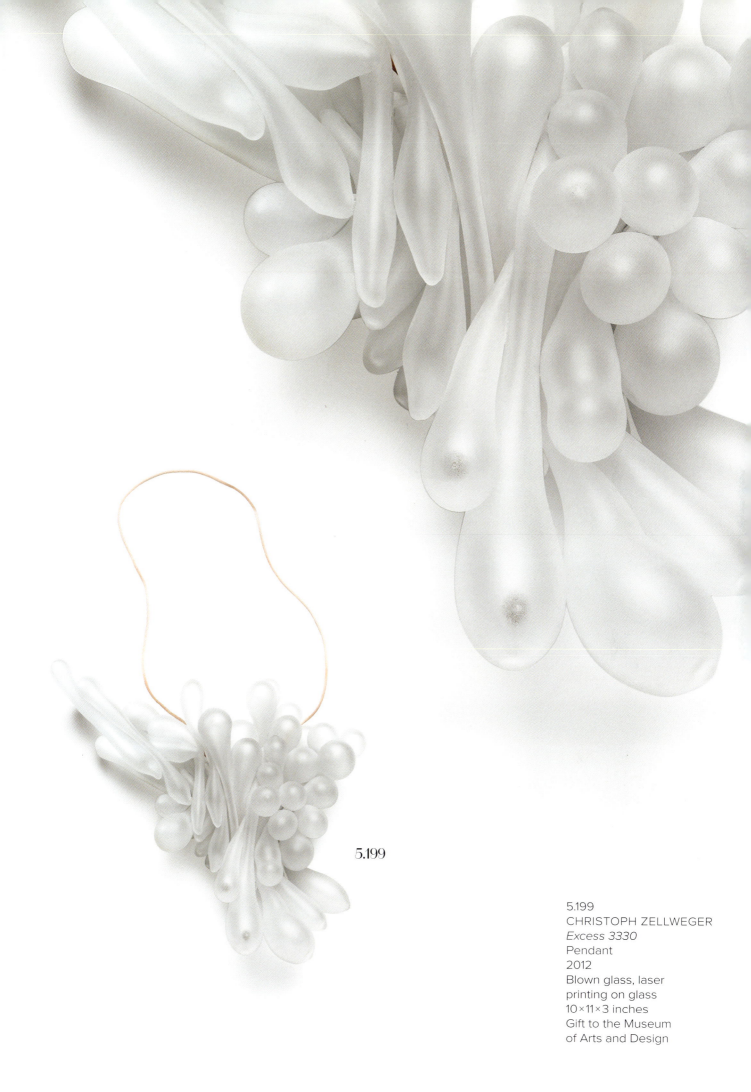

5.199
CHRISTOPH ZELLWEGER
Excess 3330
Pendant
2012
Blown glass, laser printing on glass
10 × 11 × 3 inches
Gift to the Museum of Arts and Design

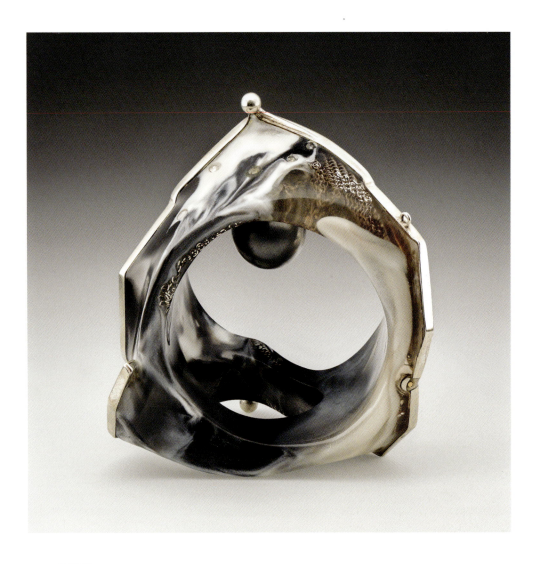

5.200

5.200
PETRA ZIMMERMANN
Untitled
Bracelet
2014
Polymethyl methacrylate, vintage handbag clasp, silver
3 × 4 × 4.75 inches
Susan Beech Collection

5.201
PETRA ZIMMERMANN
Untitled
Bracelet
2016
Polymethyl methacrylate, metal mesh handbag (silver-plated nickel silver, glass stones) with gold-plated clasp
3 × 3.75 × 2.5 inches
Gift to the Museum of Arts and Design

5.201

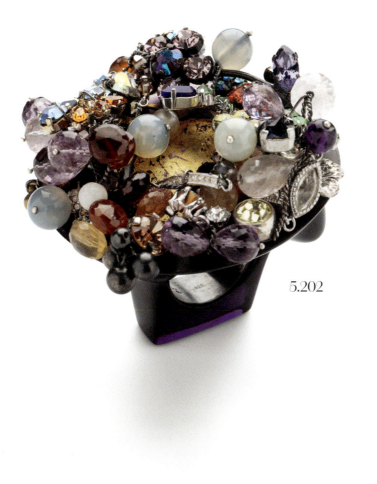

5.202

214 215

5.202
PETRA ZIMMERMANN
Untitled
Ring
2022
Costume jewelry fragments, polymethyl methacrylate, various gemstones including amethyst, rose quartz, hessonite, chalcedony, silver
3 × 1.25 × 2.125 inches
Susan Beech Collection

LIST OF JEWELRY BEING DONATED TO THE RENWICK GALLERY AND THE MUSEUM OF ARTS AND DESIGN (NOT ILLUSTRATED)

ROBERT BAINES
Endangered Pink Fallalery, Leopard
Pendant
2012
Costume jewelry, silver, powder coat
6.5 × 4 × 1.125 inches
Gift to the Museum of Arts and Design

JAMIE BENNETT
The Seventh Composed Garden
Brooch
2000
Enamel, 18-karat gold, copper, silver
3 × 1.875 × 0.5 inches
Gift to the Renwick Gallery, Smithsonian American Art Museum

JAMIE BENNETT
Untitled
Brooch
2000
Enamel, copper, gold
2.25 × 1.25 inches
Gift to the Renwick Gallery, Smithsonian American Art Museum

JAMIE BENNETT
Posteriori #18
Brooch
2008
Enamel, 18-karat gold, copper
3.625 × 2.063 × 0.5 inches
Gift to the Renwick Gallery, Smithsonian American Art Museum

ALEXANDER BLANK
Friends: Longing for Darkness (Rat)
Ring
2010–2011
Rigid foam
2.75 × 1.5 × 1.5 inches
Gift to the Museum of Arts and Design

ALEXANDER BLANK
Jimmy
Brooch
2013
High-density foam, silver, graphite
3 × 3 × 0.5 inches
Gift to the Museum of Arts and Design

LIV BLÅVARP
Untitled
Bracelet
1986
Ebony, mahogany, citrus wood
3.25 × 2.625 × 1.75 inches
Gift to the Museum of Arts and Design

IRIS BODEMER
Untitled
Brooch
2006
Agate, raffia
3.5 × 3.125 × 0.375 inches
Gift to the Museum of Arts and Design

HELEN BRITTON
Ruby Garden
Brooch
2005
Hand-engraved painted silver, rubies
2.75 × 1.5 × 2.2 inches
Gift to the Museum of Arts and Design

HELEN BRITTON
New Industrial
Bracelet
2013
Silver, paint
3.25 × 2.5 × 1.5 inches
Gift to the Museum of Arts and Design

LOLA BROOKS
turquoiseapplejade
Pendant
2009
Vintage rhinestones, 14-karat green gold, stainless steel
2 × 1.5 × 2.75 inches
Gift to the Renwick Gallery, Smithsonian American Art Museum

KATHLEEN BROWNE
Court Date Corsage
Brooch
2006
Fine silver, sterling silver, vintage rhinestones, vitreous enamel
8.5 × 6.5 × 0.5 inches
Gift to the Renwick Gallery, Smithsonian American Art Museum

RAÏSSA BUMP
Cascade
Brooch
2012
Sterling silver, vintage glass beads
5.25 × 4.25 × 2.5 inches
Gift to the Renwick Gallery, Smithsonian American Art Museum

PETER CHANG
Untitled
Brooch
1999
Resin, PVC, sterling silver
3.5 × 2.75 × 0.5 inches
Gift to the Museum of Arts and Design

MARILYN DA SILVA
Hung Out to Dry I & II
Candleholders
1996
Copper, brass, sterling silver, gesso, colored pencil
Each: 3 × 6 × 5 inches
Gift to the Renwick Gallery, Smithsonian American Art Museum

MARILYN DA SILVA
Hung Out to Dry V & VI
Candelabra
1997
Copper, brass, sterling silver, nickel, gesso, colored pencil
Each: 12 × 13 × 13 inches
Gift to the Renwick Gallery, Smithsonian American Art Museum

JANE DODD
Wilderness
Brooch
2013
Cow bone, sterling silver
2.75 × 1 × 1.5 inches
Gift to the Museum
of Arts and Design

BEN DORY
Garnet Ring
2018
Stainless steel, garnet
1.625 × 1 × 1 inches
Gift to the Renwick
Gallery, Smithsonian
American Art Museum

IRIS EICHENBERG
Weiss
Necklace
2005
Porcelain, silver, cotton, leather, lead
7.5 × 5 × 2.375 inches
Gift to the Museum
of Arts and Design

FORD AND FORLANO
Untitled
Bracelet
2004
Polymer clay, sterling silver
4.25 × 3.75 × 1.375 inches
Gift to the Renwick
Gallery, Smithsonian
American Art Museum

FORD AND FORLANO
Untitled
Bracelet
2004
Polymer clay, sterling silver
3.875 × 3.5 × 0.813 inches
Gift to the Renwick
Gallery, Smithsonian
American Art Museum

LISA GRALNICK
Untitled
Brooch
2002
18-karat gold
2.625 inches in diameter × 0.625 inches
Gift to the Renwick
Gallery, Smithsonian
American Art Museum

ADAM GRINOVICH
Pendant Badge 6
2017
Stainless steel, cubic zirconia, paracord
3.5 × 3.5 × 0.5 inches
Gift to the Renwick
Gallery, Smithsonian
American Art Museum

ADAM GRINOVICH
Panther/Panda Ring
2017
Stainless steel, cubic zirconia
1.25 × 1.25 × 1.5 inches
Gift to the Renwick
Gallery, Smithsonian
American Art Museum

ADAM GRINOVICH
Tropical Space 1
Necklace
2021
Stainless steel, cubic zirconia
28 inches long
Gift to the Renwick
Gallery, Smithsonian
American Art Museum

HANNA HEDMAN
What You Say Is Not Always What You Have Experienced
Necklace
2008
Silver, powder coat, copper, paint
15 × 6 × 2.75 inches
Gift to the Museum
of Arts and Design

STEFAN HEUSER
Flag 1
Brooch
2008
Steel, silver, enamel, spinel
2.375 × 3.25 × 0.5 inches
Gift to the Museum
of Arts and Design

MIRJAM HILLER
Sucker
Pendant
2005
Copper, enamel, rose quartz
11 × 1.5 × 0.5 inches
Gift to the Museum
of Arts and Design

MIRJAM HILLER
Robot
Pendant
2006
Copper, enamel, agate
24 × 3 × 1.2 inches
Susan Beech Collection

PETER HOOGEBOOM
Satanic Cuff
1996
Ceramic, silver, silk
11 × 5 × 0.875 inches
Gift to the Museum
of Arts and Design

MARIAN HOSKING
Blue Bell
Brooch
2001
Silver
2.75 inches in diameter
Gift to the Museum
of Arts and Design

IDIOTS
I Earned My Wings
Necklace
2013
Taxidermy parakeet, felt, wool, brass, glass beads, brass
15 × 8 × 2.25 inches
Gift to the Museum
of Arts and Design

SERGEY JIVETIN
Gorbachev's Knot
Brooch
2007
Jeweler's saw blades
2.75 × 2.75 × 0.75 inches
Gift to the Renwick
Gallery, Smithsonian
American Art Museum

JIMIN KIM
Untitled
Brooch
2008
Paper, sterling silver
5.5 × 3.5 × 3.5 inches
Gift to the Museum
of Arts and Design

ANYA KIVARKIS
Untitled Brooch #1, from the *Blind Spot* series
2007
Sterling silver, 14-karat palladium white gold, enamel auto paint
3.25 × 1.5 × 1 inches
Gift to the Renwick
Gallery, Smithsonian
American Art Museum

DANIEL KRUGER
12.03
Necklace
2012
Sterling silver
Pendant: 6.75 × 4.75 × 1 inches
Gift to the Museum
of Arts and Design

AGNES LARSSON
Carbo
Necklace
2010
Carbon, horsehair
Pendant: 7.75 × 3.875 × 1.25 inches
Gift to the Museum of Arts and Design

AGNES LARSSON
Remains 7
Necklace
2015
Calfskin, aluminum, horsehair
15.5 × 8.5 × 1.5 inches
Gift to the Museum of Arts and Design

JORGE MANILLA
El Beso
[The Kiss]
Necklace
2006
Hummingbird, silk, cotton, thread, porcelain, silver, wrapped coral
2.5 × 4 × 3.5 inches
Gift to the Museum of Arts and Design

JORGE MANILLA
In Between
Necklace
2014
Wood, leather, cotton thread
Pendant: 6.25 × 3 × 2.375 inches
Gift to the Museum of Arts and Design

JAYDAN MOORE
Ends
Object
2012
Found silver-plated platters
38 × 20 × 3 inches
Gift to the Renwick Gallery, Smithsonian American Art Museum

EVERT NIJLAND
Untitled
Brooch
2005
Glass, elastic, silver
4.25 × 1.5 × 2.2 inches
Gift to the Museum of Arts and Design

EVERT NIJLAND
Rouw [Mourning]
Necklace
2009
Glass, flock, silver
22.5 inches long
Gift to the Museum of Arts and Design

EMIKO OYE
Transcend Neckpiece
Convertible necklace and bracelets
2012
Repurposed and recycled LEGO, nylon-coated steel cable, sterling silver
Necklace: 15 × 5.167 × 3 inches, bracelets: 7.5 × 0.938 × 0.625 inches
Gift to the Renwick Gallery, Smithsonian American Art Museum

RUUDT PETERS
Capital
Three bracelets
1982
Etched Formica
Largest: 6.5 × 6.5 × 0.125 inches
Gift to the Museum of Arts and Design

RUUDT PETERS
Gratie
[Grace]
Brooch
1986
Gold-plated brass, ping-pong ball
5.5 × 1.25 × 0.125 inches
Gift to the Museum of Arts and Design

RUUDT PETERS
Azoth
Necklace
2004
Acrylic, silver, steel
1.25 × 2 × 1.5 inches
Gift to the Museum of Arts and Design

RUUDT PETERS
Qi
Necklace
2013
Porcelain
Pendant: 4 × 1.5 × 2 inches
Gift to the Museum of Arts and Design

SHARI PIERCE
Necklace Green, from the *Cardboard Democracy Series*
2007
Cardboard from boxes, paint (found, or incorrectly mixed colors from hardware store), metal
5 × 3.5 × 17 inches (including chain)
Gift to the Renwick Gallery, Smithsonian American Art Museum

TINA RATH
Black Beauty Collar #4
2005
Ebony, mink, 18-karat gold
7 × 7.5 × 1 inches
Gift to the Renwick Gallery, Smithsonian American Art Museum

TINA RATH
Butterfly Brooch
2017
Japanese maple, sterling silver
2.625 × 2.875 × 0.625 inches
Gift to the Renwick Gallery, Smithsonian American Art Museum

LUCY SARNEEL
Souvenir d'un Couvercle
[Souvenir of a Lid]
Necklace
2007
Zinc, porcelain, nylon
14 × 6 × 1 inches
Gift to the Museum of Arts and Design

BIBA SCHUTZ
Warrior
Bracelet
2017
Sterling silver
7 × 3 × 0.25 inches
Gift to the Renwick Gallery, Smithsonian American Art Museum

SONDRA SHERMAN
Lacrimation
Pendant
2002
14-karat palladium white gold, sterling silver, glass beads, synthetic aquamarines
7.5 × 1 inches
Gift to the Renwick Gallery, Smithsonian American Art Museum

CARINA SHOSHTARY
Carnivore 1
Brooch
2015
Graffiti, glass, oyster shells, silver, stainless steel
3.75 × 2.25 × 1 inches
Gift to the Museum of Arts and Design

VERA SIEMUND
Schinkel
Necklace
2002
Steel, silver, rock crystal, opal
13 × 3.5 × 0.75 inches
Gift to the Museum of Arts and Design

KIFF SLEMMONS
Ringmaster
Brooch
1991
Silver, beach glass
4.5 × 2.875 × 0.25 inches
Gift to the Renwick Gallery, Smithsonian American Art Museum

KIFF SLEMMONS
Rattle Tags
Necklace
2004
Key chain rings, paint, paper
17 inches long
Gift to the Renwick Gallery, Smithsonian American Art Museum

KIFF SLEMMONS
Huesos: Wreath
Necklace
2010–2011
Handmade cotton-agave paper
24 inches long
Gift to the Renwick Gallery, Smithsonian American Art Museum

LAUREN TICKLE
$64 Currency Converted
Brooch
2015
US dollars, silver, monofilament, surgical steel
4.5 × 5.5 × 1.25 inches
Gift to the Renwick Gallery, Smithsonian American Art Museum

TERHI TOLVANEN
Ronde Stipjes
[Round Dots]
Necklace
2005
Rowan wood, paint, silver
5.5 × 6 × 1.25 inches
Gift to the Museum
of Arts and Design

TERHI TOLVANEN
Swingy
Necklace
2007
Hazelnut wood,
smoky quartz, silver
7 × 8.5 × 1.75 inches
Gift to the Museum
of Arts and Design

TERHI TOLVANEN
In the Shadow
Brooch
2011
Wood, sterling silver
5.75 × 4.5 × 2.75 inches
Gift to the Museum
of Arts and Design

TERHI TOLVANEN
B&W
Necklace
2016
Faceted white and
colored pearls, heather
wood, silver
9 × 9.5 × 3 inches
Gift to the Museum
of Arts and Design

CYNTHIA TOOPS
Garden Series #1
Brooch
2000
Polymer clay, silver
1 × 2.4 × 2.2 inches
Gift to the Renwick
Gallery, Smithsonian
American Art Museum

TANEL VEENRE
Palindrome XIV
Brooch
2014
Seahorses, opal, resin,
silver, cosmic dust
4.875 × 3.25 × 1.75 inches
Gift to the Museum
of Arts and Design

NORMAN WEBER
Objekt #10 [Object #10]
Pendant
2001
Stainless steel, lacquer,
gold
3.5 × 1.25 × 3.75 inches
Gift to the Museum
of Arts and Design

NANCY WORDEN
Bracelet
2007
Steel, paint
5 × 5.25 × 2.25 inches
Gift to the Renwick
Gallery, Smithsonian
American Art Museum

PETRA ZIMMERMANN
Untitled
Bracelet
2019
Polymethyl methacrylate,
petit point embroidery,
gilded silver
6 × 5 × 4.25 inches
Gift to the Museum
of Arts and Design

ACKNOWLEDGMENTS

We owe our greatest thanks to Susan Beech, whose collection—and house—are the subject of this book, and whose commitment to supporting the field of contemporary jewelry is inspiring and worthy of celebration. Susan tolerated frequent sessions with her jewelry displayed in profusion on the dining room table, patiently answered questions, gamely agreed to be a model, and never complained, no matter how outlandish our requests or how many David Bielander snakes we tried to cram into the photographs.

Our second round of thanks goes to Tina Rath, who managed the complex process of wrangling Susan, the photographers, and the jewelry itself to realize and extend our vision of how the photographs in this book should look. Working with stylist Shana Astrachan and photographers Lenny Gonzalez (for house interiors and portraits) and Robert Diamante and John White (for studio photographs of the jewelry), Tina has helped us capture the sophisticated and flamboyant persona that Susan has created through the combination of contemporary jewelry, craft, and fine art in her Tiburon home. The other institutions and photographers who have supplied images are listed in the photography credits, and we gratefully acknowledge their contribution to the book.

Thirdly, we want to thank Toni Greenbaum and Barbara Gifford, whose texts demonstrate some of the other stories that can be told through key pieces of contemporary jewelry that Susan Beech has collected and worn. Toni's polemic about narrative jewelry and Barbara's discussion of the sometimes uncomfortable idea of beauty in contemporary jewelry are an excellent demonstration of the intellectual and cultural depth that contemporary jewelers achieve in their work.

Finally, we'd like to acknowledge all those who were involved in the production of this book, including Dirk Allgaier and project manager Greta Garle from arnoldsche Art Publishers, copy editors Nathalie Mornu and Wendy Brouwer, and designer Karina Moschke.
—SUSAN CUMMINS AND DAMIAN SKINNER

Many thanks go to Susan Cummins and Damian Skinner for suggesting the book almost two years ago. Their vision got us moving through interviews and examining the pieces in the collection together. Susan C. was constantly at my house, helping me on the computer and offering support. We had our moments and also many laughs. Damian and Susan did a masterful job of organizing the book, writing two of the essays, and working with the other authors, Toni Greenbaum and Barbara Gifford.

I am grateful to Tina Rath, who as art director helped manage the project and was also a confidante, all the while encouraging me along the way. Tina also packed up the collection and transported it from San Francisco to the Museum of Arts and Design, in New York City—a long drive. Thank you.

Thank you, too, to Lenny Gonzalez for taking such lovely photographs of me and spectacular images of the house. He was calm and patient every minute. Robert Diamante photographed much of the jewelry in a studio setting. It may look easy, but it's hard work to make the jewelry sparkle. Also, thanks to John White, who photographed parts of my collection long before we thought about a book. Shana Astrachan did a great job of working with Tina to style the images and make me look lovely.

I'd also like to thank Sienna Patti, a friend, a dealer, an appraiser, and an all-around knowledgeable person in the art jewelry field. She appraised the collection and was invaluable to me as we prepared the collection for donation. She interfaced with the Museum of Arts and Design and the Renwick Gallery, Smithsonian American Art Museum, helping me to understand the donating process and how museums make acquisitions.

I would like to acknowledge Toni Greenbaum and Barbara Gifford for their contributions to the book. I was first introduced to narrative contemporary jewelry through the Susan Cummins Gallery and later in various Seattle galleries. I admire Kiff Slemmons, Keith Lewis, and Nancy Worden for their smart, provocative take on storytelling through jewelry. I hold a special place in my heart for Nancy and her unflinching look at women's issues as well as her bravery with her personal health struggles. I agree with Barbara Gifford that beauty has been a compelling factor in all my choices. I think of my collection as strangely beautiful and, at times, challenging. When I'm wearing contemporary jewelry, I hope to draw the viewer into my world for a few moments.

Most importantly, my thanks go to Bill Beech, my long-suffering husband, who felt like his home was constantly being invaded. I acknowledge and appreciate your patience, help, and support.
—SUSAN BEECH

AUTHOR BIOGRAPHIES

SUSAN CUMMINS has been involved in the visual arts in numerous ways over the last 45 years, from working in a pottery studio, doing street fairs, running a retail shop called the Firework, in Mill Valley, California, and developing the Susan Cummins Gallery into a nationally recognized venue for regional art and contemporary art jewelry. Today she spends most of her time working as a board member of Art Jewelry Forum and the California College of the Arts. She is a co-author of *In Flux: American Jewelry and the Counterculture* (arnoldsche Art Publishers, 2020) and *North by Northwest: The Jewelry of Laurie Hall* (arnoldsche Art Publishers, 2021), as well as *Master Metalsmith: Lynda Watson: Looking Back* (Metal Museum, 2022).

TONI GREENBAUM (a.k.a Toni Lesser Wolf) is an art historian specializing in twentieth- and twenty-first-century jewelry and metalwork. She has written numerous journal articles, book chapters, and exhibition catalogs for museums, including the Montreal Museum of Fine Arts, and Bard Graduate Center Gallery, New York, and is the author of the key text *Messengers of Modernism: American Studio Jewelry 1940–1960* (Flammarion, 1996) and *Sam Kramer: Jeweler on the Edge* (arnoldsche Art Publishers, 2019). She is currently working on a book about American modernist jeweler Art Smith with co-author Joanne Hyppolite, Supervisory Curator of the African Diaspora, Smithsonian Institution, National Museum of African American History and Culture. Greenbaum lectures internationally and has taught courses in jewelry history at several New York City colleges, including Theory and Criticism of Contemporary Jewelry at Pratt Institute, Brooklyn, from 2014 to 2022.

BARBARA PARIS GIFFORD is Senior Curator of Contemporary Art, Craft, and Design at the Museum of Arts and Design in New York City. She oversees its renowned jewelry collection and has helped organize over twenty exhibitions at the museum, including *Fake News and True Love: Fourteen Stories by Robert Baines*, *The World of Anna Sui*, and *Jewelry Stories: Highlights from the Collection 1947 to Now*, for which she edited a comprehensive catalog. Most recently she presented *OUT of the Jewelry Box*, an exhibition and catalog exploring the intersection of queerness and contemporary jewelry. She is an expert in jewelry and fashion and has written on these subjects for numerous publications. Gifford holds an MA in Decorative Arts, Design History, and Material Culture from the Bard Graduate Center, New York City.

DAMIAN SKINNER is an independent curator and art historian who lives in New Zealand. He was the founding editor of Art Jewelry Forum's website. Skinner has written about contemporary jewelry in New Zealand and internationally. He is a co-author of *In Flux: American Jewelry and the Counterculture* (arnoldsche Art Publishers, 2020) and *North by Northwest: The Jewelry of Laurie Hall* (arnoldsche Art Publishers, 2021). His book *Dead Souls: Desire and Memory in the Jewelry of Keith Lewis* was published by arnoldsche Art Publishers, in 2023.

PHOTOGRAPHY CREDITS

TINA RATH: Art direction

SHANA ASTRACHAN ARTISTRY: Hair and makeup

LENNY GONZALEZ: House interiors and portraits
Cover. Frontispiece / 1.1, 1.2, 1.3, 1.4, 1.11, 1.12, 1.13, 1.14, 1.15, 1.16, 1.17, 1.18, 1.19, 1.20, 1.21, 1.22 / All Interior photographs (At Home with Susan Beech): 4.1, 4.2, 4.3, 4.4, 4.5, 4.6, 4.7, 4.11, 4.12, 4.13, 4.14, 4.15, 4.17, 4.18, 4.19, 4.20, 4.21, 4.22 / Susan Beech portraits (Contemporary Jewelry from the Susan Beech Collection) / 5.194

ROBERT DIAMANTE: Studio photographs
2.15, 2.17, 2.18, 2.23, 2.26, 2.27, 2.28 / 3.4, 3.5, 3.6, 3.8, 3.9, 3.10, 3.11, 3.12, 3.13, 3.14, 3.15, 3.16, 3.17, 3.20, 3.22, 3.24, 3.26, 3.27 / 5.2, 5.3, 5.7, 5.8, 5.9, 5.10, 5.12, 5.13, 5.14, 5.15, 5.16, 5.17, 5.18, 5.21, 5.23, 5.24, 5.25, 5.26, 5.27, 5.31, 5.32, 5.33, 5.34, 5.36, 5.37, 5.39, 5.40, 5.41, 5.43, 5.44, 5.46, 5.49, 5.50, 5.51, 5.54, 5.55, 5.56, 5.57, 5.58, 5.60, 5.61, 5.62, 5.63, 5.64, 5.67, 5.68, 5.69, 5.73, 5.74, 5.75, 5.76, 5.77, 5.78, 5.80, 5.82, 5.83, 5.84, 5.85, 5.89, 5.90, 5.91, 5.92, 5.94, 5.96, 5.100, 5.101, 5.102, 5.103, 5.104, 5.105, 5.106, 5.107, 5.108, 5.110, 5.112, 5.113, 5.114, 5.116, 5.117, 5.118, 5.119, 5.123, 5.124, 5.125, 5.127, 5.130, 5.131, 5.132, 5.133, 5.135, 5.137, 5.144, 5.145, 5.146, 5.147, 5.150, 5.152, 5.153, 5.154, 5.155, 5.156, 5.157, 5.158, 5.166, 5.167, 5.168, 5.170, 5.172, 5.176, 5.177, 5.178, 5.179, 5.181, 5.182, 5.183, 5.185, 5.186, 5.187, 5.188, 5.189, 5.193, 5.199, 5.201, 5.202

JOHN WHITE: Studio photographs
1.6, 1.9, 1.10 / 2.7, 2.8, 2.9, 2.10, 2.11, 2.12, 2.14, 2.21, 2.22, 2.24 / 3.1, 3.2, 3.3, 3.7, 3.18, 3.23, 3.25 / 5.1, 5.4, 5.5, 5.6, 5.11, 5.19, 5.20, 5.22, 5.28, 5.29, 5.30, 5.35, 5.42, 5.45, 5.47, 5.48, 5.52, 5.53, 5.59, 5.65, 5.66, 5.70, 5.71, 5.72, 5.79, 5.81, 5.86, 5.87, 5.88, 5.93, 5.97, 5.98, 5.99, 5.109, 5.111, 5.115, 5.120, 5.121, 5.122, 5.126, 5.128, 5.129, 5.134, 5.136, 5.140, 5.141, 5.142, 5.143, 5.148, 5.149, 5.151, 5.160, 5.161, 5.162, 5.163, 5.164, 5.165, 5.169, 5.171, 5.173, 5.174, 5.175, 5.180, 5.184, 5.190, 5.191, 5.192, 5.195, 5.196, 5.197, 5.200

OTHER IMAGES
1.6, courtesy Susan Beech / 1.7, 1.8, courtesy Mint Museum / 2.1, Chad Redmon, courtesy Deedie Rose / 2.2, 2.4, 2.5, 2.6, A. Lorenzo, courtesy Die Neue Sammlung – The Design Museum / 2.3, Eva Jünger, courtesy Die Neue Sammlung – The Design Museum / 2.13, courtesy Will Reed / 2.16, courtesy Keith Lewis / 2.19, 2.20, courtesy Lauren Kalman / 2.25, courtesy Hamish McKay Gallery, New Zealand / 3.19, courtesy Museum of Arts and Design / 3.21, courtesy Gijs Bakker / 4.8, 4.9, 4.10, courtesy Sharon Campbell / 4.16, courtesy Julie Heffernan / 5.38, M. Lee Fatherree, courtesy Marilyn da Silva / 5.95, courtesy Anya Kivarkis / 5.159, courtesy Vera Siemund / 5.198, courtesy Christoph Zellweger

©2025, the authors, the artists, and arnoldsche Art Publishers

All rights reserved. No part of this work may be reproduced or used in any form or by any means without written permission from the copyright holders.
www.arnoldsche.com

EDITOR
Damian Skinner

AUTHORS
Susan Cummins
Barbara Paris Gifford
Toni Greenbaum
Damian Skinner

PHOTOGRAPHERS
Lenny Gonzalez
Robert Diamante
John White

COPY EDITORS
Nathalie Mornu
Wendy Brouwer

GRAPHIC DESIGNER
Karina Moschke

OFFSET REPRODUCTIONS
Paladin – Design- und Werbemanufaktur

PRINTED AND BOUND BY
GPS Group, Villach

PAPER
150 g/m² Magno Volume

ARNOLDSCHE PROJECT MANAGER
Greta Garle

BIBLIOGRAPHIC INFORMATION PUBLISHED BY
THE DEUTSCHE NATIONALBIBLIOTHEK
The Deutsche Nationalbibliothek lists this publication in the Deutsche Nationalbibliografie; detailed bibliographic data are available at www.dnb.de.

ISBN 978-3-89790-733-1

Made in Europe, 2025